Exploring Photography

by

RICHARD J. WALKER

and

ROBERT E. WALKER

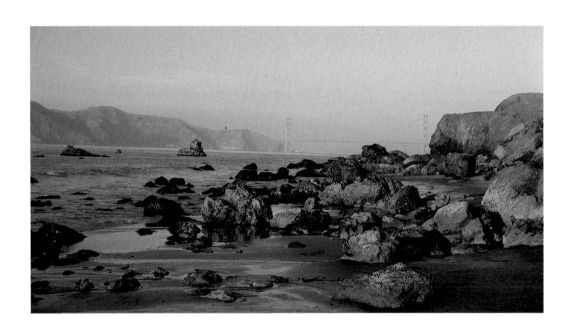

South Holland, Illinois

THE GOODHEART-WILLCOX COMPANY, INC.

Publishers

Library of Congress Catalog Card Number 87-12140
International Standard Book Number 0-87006-879-2

1234567890-91-0987654321

Library of Congress Cataloging in Publication Data

Walker, Richard J.
 Exploring photography.

 Includes index.
 1. Photography. I. Walker, Robert E.
 II. Title.
 TR146.W167 1987 770 87-12140
 ISBN 0-87006-879-2

INTRODUCTION

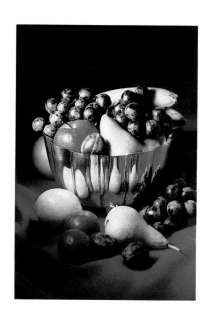

EXPLORING PHOTOGRAPHY is designed to teach you the fundamentals of photography. As you study the text, you will become familiar with photographic equipment, materials, methods, and processes. Numerous photographs and line drawings are used to support the text in explaining the principles and describing the techniques.

Photography is simply making pictures with light. Your camera controls light to record images on the light-sensitive material called film. The resulting photographs are powerful tools of communication and beauty which can cross language and cultural barriers.

Photography can provide you with close-up views of far away places such as the surface of Mars or the moons of Jupiter. Photography can also reveal microscopic living cells or individual molecules. Tomorrow's history is being recorded today with photography.

EXPLORING PHOTOGRAPHY will help you develop the skills to take and print good pictures. Your photographs will allow you to show your creativity and originality. The study of photography may lead you to a popular hobby or a rewarding career.

Richard Walker
Robert Walker

CONTENTS

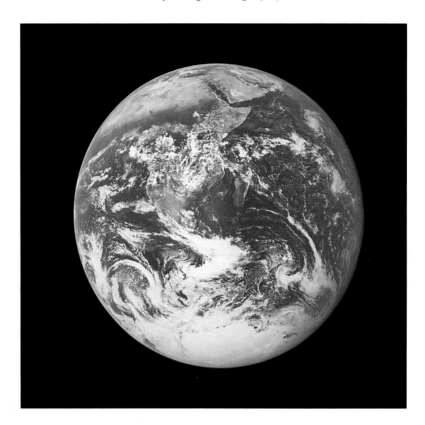

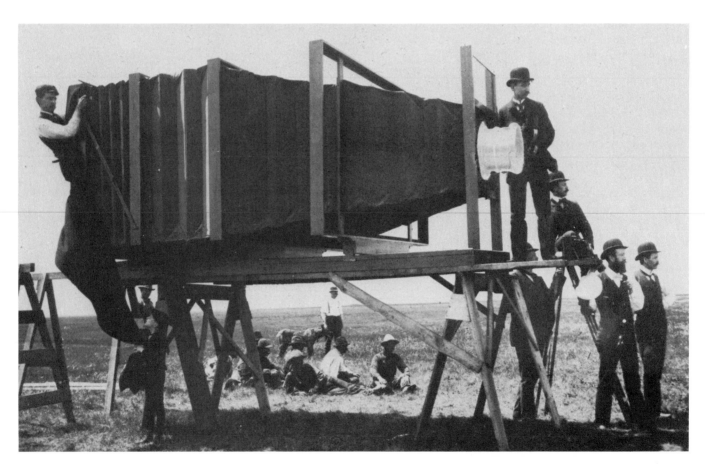

Photography today and yesterday. A difference of more than 80 years of photography separates these two illustrations. Top. Famous color photograph taken from the moon shows Earth extending from the Mediterranean Sea area to the South Pole ice cap. (NASA) Bottom. This huge camera came out of the late 19th century during a craze for unusual cameras. Rear section housed a darkroom! (Div. of Photographic History, Smithsonian Institution)

1 HISTORY OF PHOTOGRAPHY

After studying this chapter you will be able to:
□ Describe early attempts to produce photographic images.
□ Name important inventors and the inventions which led to the present technological development of photography.
□ Trace the development of film and cameras from the 1500s to the present.

Photography took several hundred years to reach its present state. No one person can be credited with its invention. As inventors worked on new processes and improvements in equipment, there were many failures. Most failed because the new techniques were too complex, required great skill or produced results that were not clear, and/or permanent.

CAMERA OBSCURA

The principle of the camera was known before other photographic processes were discovered. The CAMERA OBSCURA (dark chamber), Fig. 1-1, appeared in the early 1500s. (The Chinese knew of it as early as the fourth century.)

The first camera obscura was a darkened room with a convex lens inserted in one wall. (Convex means curved outward like the outside of a circle.) The image or scene outside the wall passed through the lens and was projected (pictured) on the opposite wall in full color. However, the image was smaller and turned upside down.

The camera obscura made it easy for anyone to sketch scenes. No artistic talent was needed. A sheet of paper was placed where the image appeared. The

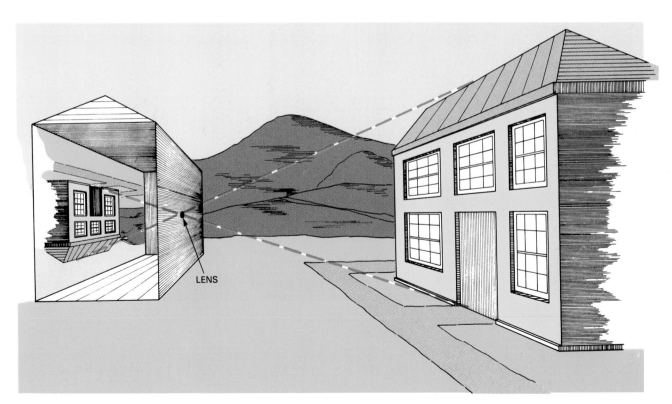

LENS

Fig. 1-1. Drawing made from an old engraving showing a camera obscura. Small house on left has a lens in the wall. Image outside wall passed through lens and was projected on the opposite wall in full color. Building was carried to scene or structure that was to be sketched.

scene could be traced and the colors filled in.

By the 1660s, the camera obscura had shrunk to the size of a portable box. A mirror reflected the image onto a horizontal ground glass surface, Fig. 1-2.

FIRST PHOTOGRAPHIC DISCOVERY

The first break-through in light-sensitive material came in 1725. A German physicist, Johann Schulze, found that when certain silver salts were exposed to light they changed color. He placed a mixture of chalk and silver in a clear glass container. (The mixture had been dissolved in nitric acid.) Wherever light struck the liquid mixture it caused it to change from white to dark purple. He could "print" letters and shapes by attaching paper stencils to the outside of the container. The images were not permanent. They broke up when the liquid was disturbed.

IMAGE ON A LIGHT-SENSITIVE SURFACE

Joseph Niepce, a Frenchman, was one of the first experimenters in photography. He attempted to produce an image on a light-sensitive material. In 1816 he made a negative image in a camera like the basic camera obscura. The image appeared on paper after it was soaked in silver chloride. This is a light-sensitive silver salt. However, the image was very faint and did not last.

Then Niepce found that bitumen of Judea (a kind of asphalt), when dissolved in a solvent, made a varnish that was sensitive to light. In 1826, using this special varnish, he produced a very faint image on a polished metal plate.

A thin coating of the varnish-like material was spread over the plate. It was then exposed in a modified camera obscura. Exposure time was eight hours. It is credited with being the world's first photograph.

FIRST PRACTICAL PHOTOGRAPH

A co-worker of Niepce, Louis Daguerre, in 1835, discovered that a highly polished silver sheet could be made light-sensitive if exposed to iodine vapor. When an exposure was made in a camera obscura, however, no image appeared.

He later discovered accidentally that the image was latent. (Latent means the image is there but is not yet visible.) It was made to appear by heating the sheet with the fumes of hot mercury. This "developing" process greatly magnified the silver iodide's sensitivity to light.

He found that the image could be made permanent by removing the remaining light-sensitive particles. (If left, they would eventually darken and destroy the image.) The particles were removed or "fixed" with a hot salt solution.

Daguerre patented his idea in 1839. This process resulted in photographs called "daguerreotypes," Fig. 1-3. This was the first practical photographic process. It proved to be very expensive and complicated. Fig. 1-4 shows a camera of that time. It was a simple box with a hand-operated flap for a shutter. Figs. 1-5, and 1-6 show other equipment needed for making daguerreotype prints. In spite of its disadvantages the process was popular until the mid 1870s.

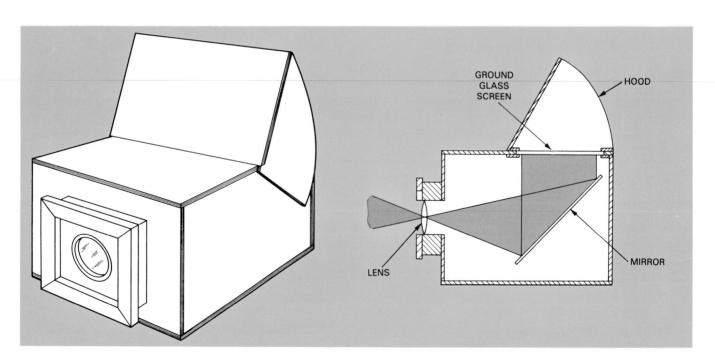

Fig. 1-2. Portable camera obscura of the 1660s had shrunk to the size of a small box. Image was traced on a thin sheet of paper over the ground glass.

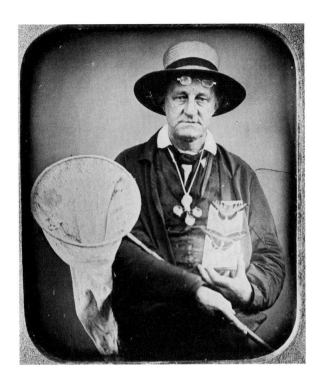

Fig. 1-3. Earliest photographs were printed on metal plates called "daguerreotypes" after the inventor. This photograph, called the "Lepidopterist," was taken around 1850. (Div. of Photographic History, Smithsonian Institution)

THE PRINT COMES OF AGE

William Fox Talbot of England was also working on what he hoped would be a practical photographic process in 1835. Unlike Daguerre, who used sensitized metal plates, Talbot made negative images on treated paper. The paper had been coated with silver chloride. This is close to what Niepce had done. Talbot, however, made a positive print from the paper negative.

The paper negative was waxed to make it

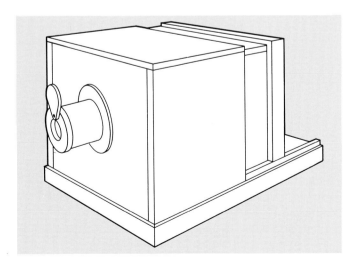

Fig. 1-4. Daguerreotype camera of the mid 1850s had simple flap arrangement for a shutter.

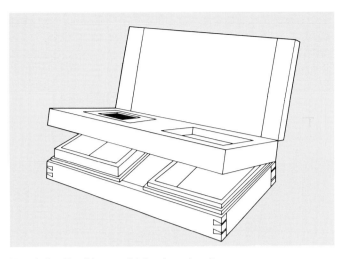

Fig. 1-5. Double sensitizing box for daguerreotype process. A highly polished silver plate was made light-sensitive by being exposed to iodine vapor in the box.

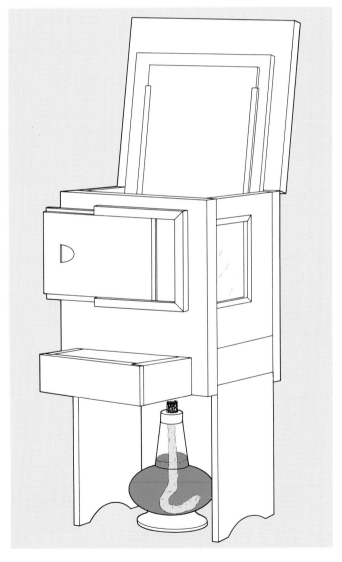

Fig. 1-6. Mercury vapor box for developing daguerreotypes. The latent image on the exposed silver plate was made to appear by heating the sheet with the fumes of heated mercury. The picture was then fixed with a hot salt solution.

transparent. Another sheet of sensitized paper was placed under the waxed negative. A bright light exposed the paper. When the right density was reached, the paper print was fixed, washed, and dried. At last, duplicate prints could be made. Daguerre's process needed a separate exposure for each picture.

Talbot used a special version of the camera obscura, Fig. 1-7, to make his negatives. He patented the process in 1841.

This technique of making a positive print from a negative is the basis of modern photography. The prints were called Calotypes or Talbotypes, Fig. 1-8.

Talbot's process did not produce prints as good as daguerreotypes. The lower quality was caused by the grain or texture of the paper negative. This defect was transmitted to the print.

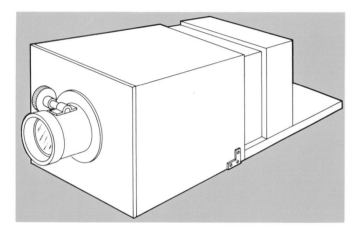

Fig. 1-7. Type of camera used by Talbot from 1835 to 1840. It produced a paper negative.

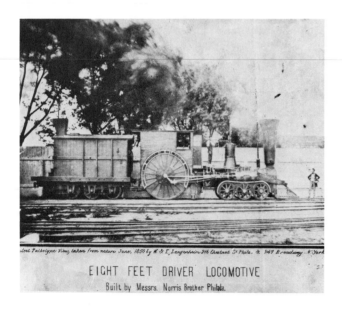

Fig. 1-8. This photograph was produced in 1850 using a Calotype paper negative. Compared with the daguerreotype of metal shown in Fig. 1-3, it is very poor quality indeed. (Div. of Photographic History, Smithsonian Institution)

NEW LENSES AND CAMERAS

As photographic processes improved, so did the lens and camera design. Lenses with up to four elements were made. They transmitted up to 16 times more light to the film than the simple lenses used in the first cameras. The increased light made shorter exposures (less than 60 seconds) possible. Portrait photography became popular.

Cameras, Fig. 1-9, were more precise and smaller than the early modified (changed) or redesigned camera obscuras.

Fig. 1-9. Improved camera used to make Talbotypes. Lens was focused by moving it in or out. The back opened to allow loading of sensitized paper (negative). Exposure was made by withdrawing wooden "shutter."

WET PLATE PHOTOGRAPHY

The Calotype negative-to-positive print process had many advantages over the daguerreotype. Using paper as a negative, however, greatly reduced print quality. Glass was next tried as a negative base.

In 1851, an Englishman, Frederick Scott Archer, discovered the first practical means of coating glass plates. He used a plastic-like substance called COLLODION.

Collodion containing potassium iodide was flowed evenly over a carefully cleaned glass plate. When the collodion had dried to a "tacky" state, a bath in silver nitrate sensitized it to light.

The wet plate was loaded into the camera and exposed immediately. Exposed plates also had to be developed, fixed, and washed immediately. If the collodion dried before the sequence was completed, it became water resistant and could not be developed.

This was called the WET COLLODION process. Because the plates had to be exposed and developed while still wet, photographers had to take their darkrooms along when they took pictures, Fig. 1-10.

Glass negatives produced high quality prints because they could record fine details and register slight differences in tones.

TINTYPES

A variation of the wet collodion process produced a direct positive on a metal (tinplate) base. They were called "tintypes" or ferrotypes. This technique was used by itinerant (traveling) photographers who brought photography to the amateur.

DRY-PLATE PHOTOGRAPHY

One of photography's greatest advancements came in 1871. A British physician, Richard L. Maddox, made the first successful dry-plate negative. He replaced the "wet" collodion coat with a thin coating of gelatin and silver nitrate. After drying, the plate retained its sensitivity to light for some time.

The most important advantage changed photography forever. The plate could be developed anytime after exposure. Photographs could be taken almost anywhere. A cumbersome, portable darkroom was no longer needed.

This advancement made the commercial manufacture of photographic plates possible. It was found, by accident, that heating the plates to dry the gelatin greatly increased their sensitivity to light. Exposure times were further reduced.

FIRST COLOR PHOTOGRAPHY

Photographers and experimenters were still trying to copy nature in full color. In 1861, James Maxwell demonstrated the first color photographs. The technique, while it produced color, was not practical.

ROLL FILM INTRODUCED

The photographic industry started to grow rapidly in the 1880s. It was then that flexible roll film was introduced. The light-sensitive gelatin was coated on a paper backing that protected it from unwanted light. After developing, the gelatin was stripped from the paper backing and attached to a glass plate for printing.

In 1888, using film of this type, an American, George Eastman, introduced a 100-shot box camera, Fig. 1-11. The camera and film were returned to Eastman for processing. Along with the prints, he

returned the camera. It was reloaded, ready to take another 100 pictures.

Eastman launched the sale of the camera with the slogan, "You press the button, we do the rest." The trademark, Kodak, was introduced at the same time as the camera.

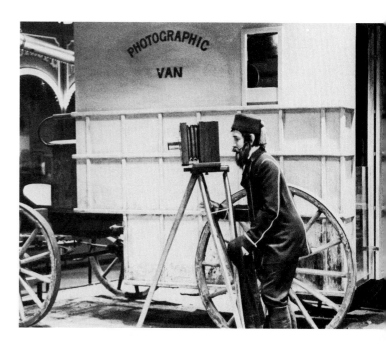

Fig. 1-10. Photographers using the wet collodion process had to take their darkrooms wherever they took pictures. Typical darkroom was mounted on a horse drawn wagon. (Div. of Photographic History, Smithsonian Institution)

Fig. 1-11. The Eastman 100-shot box camera of 1888. After exposure, the camera and film were sent to Eastman for processing. It was returned with the prints, ready to take another 100 pictures.

In 1889, Eastman replaced the paper backing with a clear, flexible celluloid film. Prints were easier to make because the gelatin did not have to be stripped from the celluloid to make the print. Processing kits made it possible to develop the film at home.

This camera made photography popular. Anyone could take a picture. To encourage children in the hobby, Eastman brought out the first Kodak "Brownie" camera in 1900, Fig. 1-12.

The pocket camera is not a new idea. Eastman produced several in the late 1800s, Fig. 1-13. The folding pocket camera, Fig. 1-14, remained in use for more than 60 years.

MAJOR ADVANCEMENTS

Movie film was introduced before the turn of the century. Thomas Edison used the new flexible plastic film in his 1891 invention of the motion picture.

Commercial color film became available in 1907. This film, French Autochrome, was followed by other color film. In the mid 1930s, Kodak introduced a color film. This film made it possible for the amateur photographer to take color pictures at a reasonable price.

During the early 1900s, film and camera design improved. So did process and printing techniques. Accurate shutters with timing mechanisms became available.

The flash bulb was invented in the 1930s and the electronic flash unit followed close behind. Until this time, the photographer had to "fire" highly flammable magnesium powder to take "flash" pictures.

Later developments include Polaroid instant photography in 1947. It was created by Edwin Land.

Fig. 1-13. Eastman brought out this "pocket camera" in the late 1890s.

The process could produce a finished black and white print in 60 seconds.

In 1963, Land brought out instant color film. Instant motion pictures are another of his inventions. He introduced them in 1978. Color home movies can be viewed minutes after they are taken.

Today, photography is improving. Photographs taken from hundreds of miles in space are sharp enough to see license numbers on automobiles.

Cameras for amateur photographers are completely automatic, Fig. 1-15. The camera need only be aimed. A tiny computer in the camera measures the light, sets the aperture and shutter speed, and focuses the camera an instant after the shutter is tripped. If there is not enough light, it will automatically trigger an electronic flash unit.

Film quality and sensitivity to light have improved through the years. Both black and white films and color films have been refined from ISO 12 speed in the early days (not very sensitive to light) to ISO 1000 speeds and higher today (very sensitive to light), Fig. 1-16. Color film and prints can now be processed at home almost as easily as black and white film.

WORDS TO KNOW

Bitumen, Calotypes, camera obscura, collodion, daguerreotype, ferrotypes, image, latent image, Polaroid photography, positive print, Talbotype, tintype, wet collodion process.

TEST YOUR KNOWLEDGE — CHAPTER 1

1. Photography, like many technical accomplishments, took: (Check the correct answer/s.)
 a. About 50 years to reach its present state.
 b. 100 years to reach its present state.
 c. Several hundred years to reach its present state.
 d. All of the above.

Fig. 1-12. First Kodak Brownie camera. Brought out in 1900, it used film made from clear, flexible celluloid.

Fig. 1-14. The folding pocket camera, also introduced in the late 1890s remained in use for more than 60 years.

2. The camera was invented before the photographic processes. The first cameras were called _____.

3. How was the above device used since there was no film?

4. The Daguerreotype was the first practical photographic process. Describe the process.

MATCHING TEST: On a separate sheet of paper, match the appropriate definition in the right hand column with the name or term in the left hand column. Place the correct letter opposite the number.

5. _____Camera Obscura.

6. _____Joseph Niepce.

7. _____Daguerreotypes.

8. _____William Talbot.

9. _____Wet collodion process.

10. _____Ferrotype.

11. _____Richard Maddox.

12. _____100-shot box camera.

13. _____Clean, flexible celluloid film.

14. _____Edwin Land.

a. Invented instant photography.
b. Print made on piece of tinplate.
c. First camera.
d. First practical photographic process.
e. Is credited with producing the photograph.
f. Had to be returned to Eastman to be developed and printed.
g. With this process, all photographers had to take their darkrooms wherever they took pictures.
h. Replaced paper-backed film.
i. Invented the Calotype process.
j. Invented the dry-plate negative.

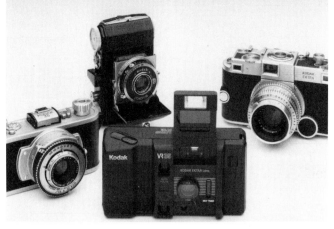

Fig. 1-15. On the automatic focusing camera (foreground), all settings are handled by a miniature computer in the camera. Older cameras (background) required the photographer to make all adjustments. (Eastman Kodak Co.)

Fig. 1-16. Today's film give the photographer a full range of choices between high speeds (ISO 1000) and fine grain characteristics (ISO 25).

THINGS TO DO

1. Prepare a brief outline on the history of photography.
2. Write a term paper on the many uses of modern photography.
3. Invite a professional photographer to talk to your class.
4. Research job opportunities in the photographic industry.
5. Plan a class visit to a museum or gallery displaying early photographs. Carefully compare the qualities of each type of print. Be prepared to discuss them in class.
6. Write a paper on Dr. Edwin Land, inventor of the Polaroid instant photo process. Discuss his many discoveries relating to photography.
7. Demonstrate instant photography.
8. Have a class discussion on the many uses of photography today. If possible, secure examples of these uses. Prepare a bulletin board or display case using them as the theme.

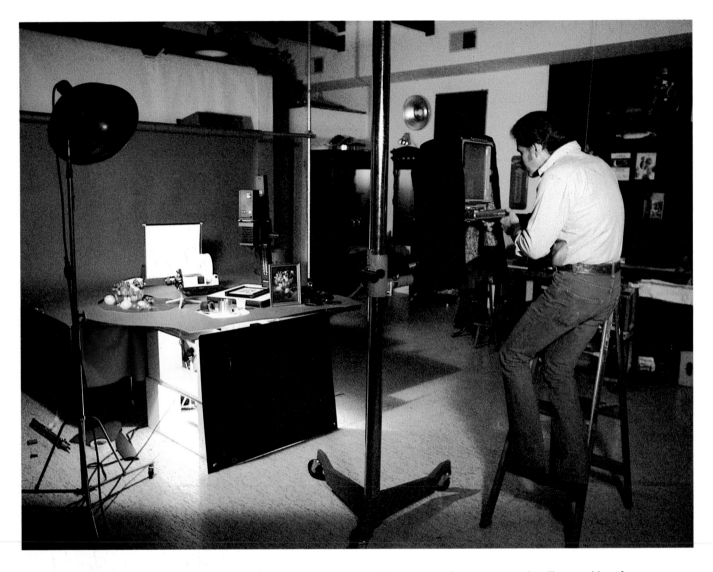

Professional photography is a very exacting but absorbing career for persons who like working for themselves or for a small business.

2 CAREERS IN PHOTOGRAPHY

After studying this chapter you will be able to:
☐ List nine separate areas of photography that offer career opportunities for the professional photographer.
☐ Describe, in general, the work performed by a photographer.
☐ Describe working conditions for some photographic careers.
☐ Explain the work of a camera repair technician.
☐ List related careers which require some knowledge of photographic equipment and materials.
☐ List and find several sources of additional information about photographic careers.

In the field of photography there are many chances to carve out a satisfying career. The list of jobs grows and changes every day as new uses are found for photographs and motion pictures.

If you have been reading photography magazines, you already know about the exciting changes in equipment. Electronics and optics are producing cameras only dreamed about yesterday. Using and keeping such equipment in repair will take people with talent and skill. It is an exciting career area for those who like cameras.

Some persons make their living just taking pictures. They are called professional photographers. Many other skilled and semiskilled people also make their living at tasks related to photography. They provide services such as:
1. Developing and printing of pictures taken by professionals and amateurs.
2. Repairing and maintaining all kinds of photographic equipment.
3. Selling and distributing equipment.

PROFESSIONAL PHOTOGRAPHERS

Professionals use still cameras and movie cameras to take pictures. Their job is to film people, events, and products. Some use photography as an art form and take picures of people and scenery for artistic purposes. Their work may be used to decorate walls or to illustrate magazines and books.

We see the work of professionals also in newspapers and on television or the movie screen. There are other professionals whose work the public may never see.

PHOTOGRAPHY IN THE ARMED FORCES

The military uses both men and women as photographers, Fig. 2-1. Their duties range from taking pictures for publicity to doing aerial photography. Aerial photographs are important for reconnaissance. (In reconnaissance, experts study the photographs to get military information.)

The armed forces also produce many training and documentary films. These present facts about the military. The person in Fig. 2-2 is working on a film. Many professional photographers learned their craft while serving in a branch of the military service.

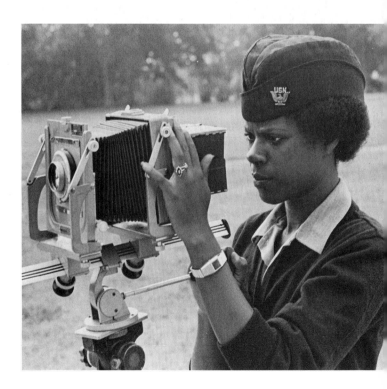

Fig. 2-1. The military trains and uses many women and men as photographers. This recruit is on assignment using a graphic view camera. (U.S. Navy)

15

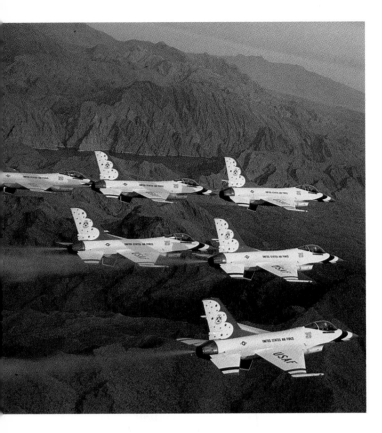

Fig. 2-2. The armed forces use photography for advertising and promotional literature. (U.S. Air Force Thunderbirds)

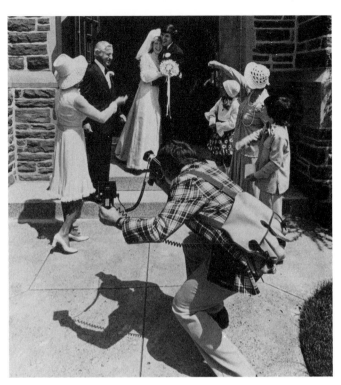

Fig. 2-3. The commercial wedding photographer is often the portrait photographer from the community. (The School of Modern Photography)

WEDDING AND PORTRAIT PHOTOGRAPHERS

Wedding photography, Fig. 2-3, can be part-time or full-time work. The commercial wedding photographer is often the local portrait photographer. Most weddings take place on weekends.

Photographic studios earn most of their income from portrait work. Clients can often be retained for years while families grow up. Portraits can be made in a studio or on location.

ARCHITECTURAL PHOTOGRAPHERS

Architectural photographs are taken on site. This kind of camera work involves taking pictures of buildings and building interiors. Clients include architects, designers, builders, interior decorators, real estate offices, and building owners. A large part of the work is in making photographs to show construction progress, Fig. 2-4.

FASHION PHOTOGRAPHERS

Fashion photography, Fig. 2-5, is not restricted to garment making centers and a few magazines. Most of it is done by commercial photographers. They find work in all large cities and in many smaller towns. Local clothing retailers and department stores sometimes use fashion photographs for advertising. Fashion photographers work in studios or on location.

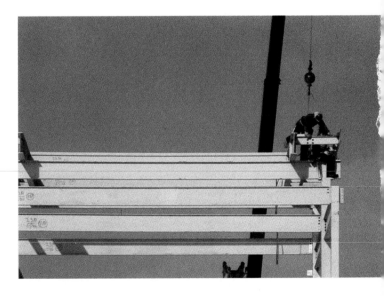

Fig. 2-4. Much of the work done in architectural photography is used to show construction progress. The photographer may work at ground level or many stories up.

NEWSPAPER AND TELEVISION PHOTOGRAPHERS

Nearly all newspapers today have a staff of photographers. They "shoot" (take pictures of) sports events, fast-breaking news such as disasters and other happenings of public interest. See Fig. 2-6.

Press photographers are expected to work under

almost any kind of conditions. News assignments may take them out in blizzards or floods. They may be called upon to photograph unpleasant scenes and disasters. Sometimes the location is dangerous.

Whatever the circumstances, the photographer must work fast and get good results. There is never a chance to return and reshoot a picture that does not turn out. Their employers are depending upon them to return with good pictures that tell the story.

Television stations employ several types of photographers. Some stories are recorded on film and require photographers familiar with this technique.

Many stations now use electronic video equipment that records and/or transmits live reports made at the scene, Fig. 2-7. Studio camera technicians are responsible for shooting and/or recording studio programs, Fig. 2-8. Stations often employ still photographers, usually free-lance, to shoot scenes for backgrounds and special purposes.

Newspaper and television photographers and technicians, almost equally divided between men and women, do not work normal hours. They must be ready to go almost anywhere, at any time of the day or night to cover a story as it is happening.

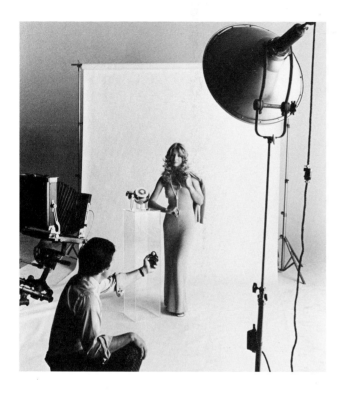

Fig. 2-5. Fashion photographers work in a studio or on location. (The School of Modern Photography)

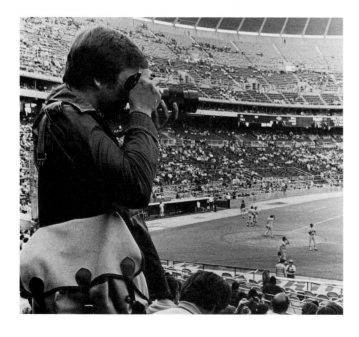

Fig. 2-6. Nearly all newspapers and magazines have staff photographers. Their assignments include covering sports events. (The School of Modern Photography)

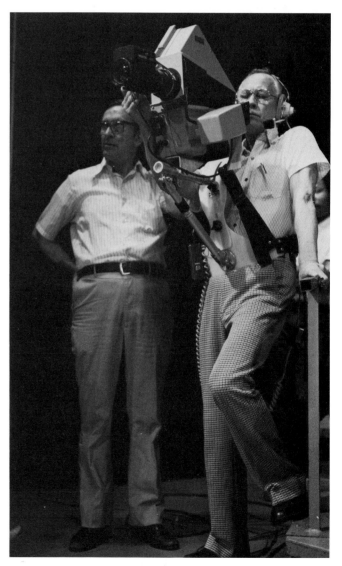

Fig. 2-7. Television camera personnel must be ready to cover fast-breaking news stories day or night. They must be in excellent physical condition because the camera equipment is heavy and must be carried over all types of terrain. (WBAL-TV, Channel 11, Baltimore, MD)

17

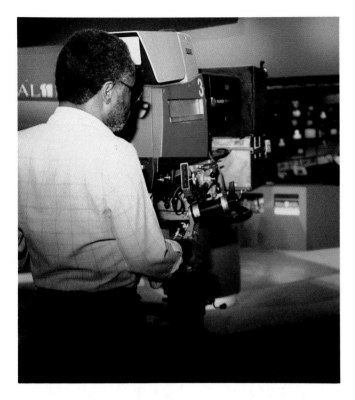

Fig. 2-8. Studio camera technicians are responsible for shooting and/or recording studio programs. They must be able to understand and carry out instructions. (WBAL-TV, Channel 11, Baltimore, MD)

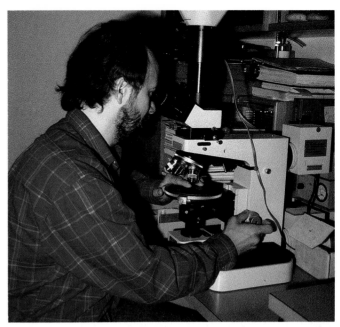

Fig. 2-9. Scientists in medical research use light microscopes to photograph cell structures in search of information that will lead to the prevention and cure of diseases. (Johns Hopkins Hospital, Baltimore, MD)

MOTION PICTURE PHOTOGRAPHERS

Thousands of motion pictures are produced each year. They include training films, advertising films, educational films, and films for entertainment.

Motion picture photography has become a highly specialized profession. Special effects seen in many motion pictures require computer controlled cameras. They are operated by technicians who possess great skill and creativity.

SCIENTIFIC PHOTOGRAPHY

Photography is used in all scientific fields. The photographer may be a marine biologist diving to record marine life. An ecologist may use aerial photography to study forests and wetlands.

Scientists use light microscopes, Fig. 2-9, to photograph cell structures. Geologists use the scanning electron microscope to study rocks and minerals, Fig. 2-10.

Medical photographers may record diseased organs or document new surgical procedures in the operating room. Many large hospitals have training programs in medical photography.

LAW ENFORCEMENT PHOTOGRAPHY

Nearly all law enforcement agencies now use photography. Much of this work is done by regular police officers. Pictures must accompany accident

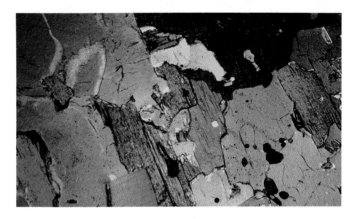

Fig. 2-10. Geologists use the scanning electron microscope to photograph rocks and minerals. This is a photograph of Virginia limestone magnified 15,000 times. (Pat Cowan)

reports and routine crime reports. More and more, this kind of work is being handled by specialists. Many states have training programs for this area of professional camera work.

Crime lab photographers take pictures used as evidence to solve crimes. Their work may include ballistic photography and infrared photography to reveal "filed down" serial numbers.

The fire marshal's office uses photography to determine whether a fire was caused by arson or by other means. See Fig. 2-11.

FREE-LANCE PHOTOGRAPHERS

Free-lance photographers, as you might guess, work for themselves. Assignments may relate to many

of the fields already mentioned. Many work for magazines, travel bureaus, corporations, banks, and industry, Fig. 2-12.

You may want to start your career in photography by free-lancing. This can begin as part-time work photographing weddings or baptisms for friends, bar mitzvahs, school plays, or selling photographs at a local art show. The authors of this book are free-lance photographers.

Not all photography careers are directly involved in taking the picture. The field includes processing of film and paper, maintenance of equipment, and sales work. Taken together, these people make up a small army of skilled and semiskilled workers.

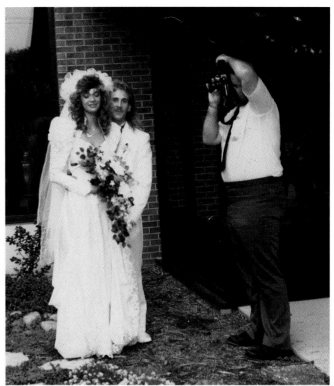

Fig. 2-12. Free-lance photography is one way to start your career. You will work for yourself. Some begin part-time by photographing friends' weddings, baptisms and children's parties. Travel photographers are often free-lance. Their work is used in travel magazines and literature.

Fig. 2-11. The fire marshal's office uses photography to help determine whether a fire resulted from arson or other causes.

PHOTOGRAPHIC EQUIPMENT REPAIR TECHNICIAN

Anything mechanical will eventually break down. Cameras must be maintained if they are to do the job they were designed to do. Camera repair technicians, Fig. 2-13, are highly skilled. They must be familiar with repair of complex mechanical, electronic, and optical photographic equipment. All camera importers (most of our cameras come from overseas) have staffs of repair personnel. Most large camera stores have at least one such technician on staff.

Training as a repair technician usually takes up to a year at a good school. Schooling may take even longer if the profession is learned through a correspondence course. All technicians will need frequent refresher courses. Technology is constantly changing. Cameras are much more complex than they were only a few years ago.

At present there is a shortage of well-trained photographic repair technicians. Pay is good.

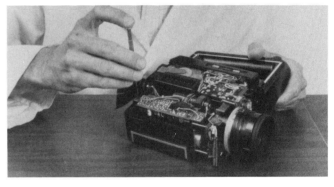

Fig. 2-13. Camera repair technicians are highly skilled. They must be familiar with repair of highly complex equipment. (National Camera, Inc.)

RETAIL SALES PERSONNEL

Since photography is an interesting and popular leisure time activity, there are many stores selling cameras, photographic equipment and supplies. Almost everyone that goes on a trip or vacation takes a camera and some equipment along.

A retail clerk is pictured in Fig. 2-14. The good clerk or salesperson is familiar with the products he or she sells. Responsibilities include advising customers on the proper operation of the equipment purchased.

Fig. 2-14. Photographic retail clerks must be familiar with the products they sell. In addition to selling, clerks demonstrate to customers the proper way to operate equipment they purchase. Most users are advanced amateur photographers or freelancers. (Polaroid Corp.)

FILM PROCESSING AND PRINTING

An exposed roll of film is only part way to the finished product. It must be processed and printed. This work is often done by a custom laboratory on automated processing machinery.

In the custom lab, technicians process the film to the exact needs of the photographer. Their training is lengthy. At present, there is a shortage of these skills. Pay is much better than average.

Most film processing, however, is done on automated machinery. The exposed film is inserted at one end of a machine and a finished negative or transparency is delivered at the other end, Fig. 2-15.

Machine processing for both film and prints requires skilled workers. Chemicals must constantly be replenished. Keeping exact temperatures is important.

LEADERSHIP IN PHOTOGRAPHY

Most careers in photography require skilled and knowledgeable persons. However, another quality is required in this or virtually any other profession. This quality is LEADERSHIP.

Leadership is the ability to be a leader. A LEADER is a person who is in command. The quality of leadership usually determines whether an organization, a company, or a business will be a success or failure.

Fig. 2-15. Machine processing of films and prints requires the supervision of skilled workers. Operators must be able to troubleshoot and correct problems that could ruin film. (Eastman Kodak Co.)

QUALITIES OF A GOOD LEADERS

What motivates people to work happily and enthusiastically for one leader and be unhappy and work very little for another person in the same situation? No one really knows. This motivation toward a person is seldom based on salary or working conditions.

Who might be a strong leader? There are no tests. Strong leaders do seem to have the following qualities:

Vision. Know what needs to be done and what must be done. Has both short- and long-term goals. Is never satisfied with the existing situation or condition. Always looks to improve conditions. Plans and achieves goals. Enjoys the challenge of leadership and can inspire others.

Communication. Can communicate with other people to gain assistance and cooperation. Can harness the ideas and energies of others to achieve a final goal or result.

Persistence. Stays on course regardless of obstacles. Is flexible enough to make changes with new ideas. Willing and able to work long hours to meet goals.

Organizational abilities. Knows how to organize and direct. Learns from mistakes and builds upon the learned knowledge. Must be tactful. Must be able to compromise or negotiate with others.

Responsiblity. Must accept responsibility without excuses. Gives credit or recognition to others when deserved or warranted.

Delegates authority. Allows other to take on leadership roles. Makes assignments to others. Helps others develop leadership skills.

GETTING LEADERSHIP EXPERIENCE

How can you get experience in leadership? One way is through clubs in school. Other activities such as the school paper or yearbook are helpful. Many community groups seek volunteers and often look for people to "take charge."

WHAT TO EXPECT AS A LEADER

A leader is expected to set a good example. A leader must get all members of a group involved in the activities. This requires encouragement, tact, and persuasion.

A leader does not have the answer for every problem. Others must be motivated to give suggestions and solutions.

Leadership is not easy and may in fact be difficult at times. Unpopular decisions must be made. People, even friends, may have to be criticized, reprimanded, or dismissed for incompetence.

If you think you have the qualities of a leader, or think you can develop them, then join groups where you can become a leader. Just remember, unpleasant tasks come with leadrship. Or the positive side, the rewards can be enormous.

HOW TO GET A JOB

After graduation from high school or college, your obtaiing a first full time job will be a very important task. Of course, the search should start before graduation.

Ask yourself the following questions:
1. What do I like to do?
2. What can I do with some degree of success?
3. What have I done that others have commended me for doing well?
4. What things do I not like to do?
5. Can I work for someone else?
6. What jobs have I held? Why did I leave?
7. What skills have I acquired?

Start by listing your areas of interest. Seek out information on them. Use sources such as reading, talking with people doing this work, and visiting companies.

How do you find job? Jobs are always available. Workers get promoted; they retire; they transfer. Business expands and technology creates new jobs. *Track them down!* Only a fraction of the jobs are advertised.

Make a job application in person. Be specific on the type of job you seek. Do not ask: "What openings do you have?"

Prepare a RESUME in advance. This is a summary of your education and work experience. Submit this along with an application. A resume may contain additional important information.

There are many books on resume writing. It should include:
1. Your full name.
2. Full address, zip code and a phone number where you can be contacted.
3. Date of birth.
4. Your social security number.
5. Places you have worked. Start with the most recent and include:
 a. Company or business name and address.
 b. Dates employed.
 c. Immediate supervisor's name.
 d. Position held and a brief description of responsiblities.
 e. Reason for leaving.
6. Schooling and other special training or courses. Include dates.
7. List equipment you can operate.
8. You may include references or state that references will be supplied upon request. *Always ask permission before using a person for a reference.*

Type the resume on a good quality of paper.

Once you obtain an interview, you have to sell yourself. Here are some checkpoints:
1. Learn something about the company and act interested.
2. You should be well groomed, suitably dressed, and

makeup should be in good taste.
3. Be prompt. Show up a few minutes early.
4. Do not smoke or chew gum.
5. Sit up straight and use proper grammar.
6. Answer questions directly and truthfully.
7. Do not be afraid to ask questions.
8. Ask when you should expect a follow-up.

ON YOUR OWN

For those wishing to start their own business, there is ENTREPRENEURSHIP. An ENTREPRENEUR is someone who starts a business. An entrepreneur must see an opportunity for need, have vision, and be able to run a business.

Perhaps one of the most important skills for a successful business owner is selling skill. The owner must sell the customers, the employees, vendors, suppliers, landlords, and financial backers.

A MARKET

A potential business owner must identify a market. This can be either a new market or a new angle on an existing market. Others may not agree with what you feel is a new market. It is important to do research first. Customers must be identified, as must potential for future growth.

FINANCIALS

Once a market is identified, you must have the capital or money to start the business. You must convince partners, a bank, or other lending institutions that you will be a success. You must have a plan. This will identify the product or service. You must figure out your break-even point, how to repay loans, and meet fixed overhead such as salary and rent. You must state how long it will be until you make a profit. You will need to reveal plans for future growth.

Remember that many new businesses are out of business within the first three years. Details are overlooked, poor judgement was used, or the market just did not exist. Remember that a good leader can avoid these shortcomings and become successful.

GETTING INFORMATION ABOUT OCCUPATIONS

You can get more information on jobs in the photographic industry from many sources. The guidance office and your school's photography instructor are the closest.

Most photographic occupations are described in the *Occupational Outlook Handbook* and *Dictionary of Occupational Titles* published by the U.S. Department of Labor. These books are usually available in school or public libraries and in guidance offices. offices.

Local community colleges will furnish information on their photographic courses. Photographic magazines also carry advertisements for training programs.

Many colleges and universities also offer professional photography programs. Some offer advanced courses leading to master's and doctoral degrees in various phases of photography.

Another excellent source of information is the local state employment service. They can direct you to local opportunities in photography. In addition they have the names and addresses of firms offering training.

Many photographers, as mentioned before, receive their training in the armed forces of the United States. Others learn on-the-job, working with a professional photographer. Training can last two or more years.

Whatever method you choose to gain entry into the field of photography, it will take work and study. Becoming skillful in this profession requires many hours of work with different cameras and photographic equipment. However, if you enjoy photography, it will not seem like work at all.

WORDS TO KNOW

Custom lab, fashion photography, portrait photography, repair technician, retail sales person, studio photography leadership, entrepreneur.

TEST YOUR KNOWLEDGE — CHAPTER 2

1. Persons who make their living by taking pictures are called _____.
2. List five types of photographers. Briefly describe each job.
3. List two nonpicture-taking jobs in photography. Briefly describe each job.
4. Name six qualities of a good leader.
5. An _____ is someone who starts a business.
6. Where can you get information about occupations in photography?

THINGS TO DO

1. Invite local free-lance, portrait, and newspaper photographers to discuss their work with the class.
2. Plan a field trip to a television station. Find how photographic techniques are used at the studio. Secure job descriptions for jobs requiring photographic skills.
3. Plan a visit to a film processing laboratory.
4. Show a motion picture video or film strip on some phase of photograhy. Lead a discussion on the contents of the film.
5. Invite a distributor of video recording equipment to demonstrate how the video recorder can be used to best advantage.
6. Invite a representative from the local office of the government employment service to discuss employment opportunities in photographic occupations.
7. Study the "help wanted" columns in your daily and Sunday newspaper for two weeks. Prepare a list of photographic jobs advertised during that period.

3 LENSES

After studying this chapter you will be able to:
- List two simple rules of light and optics.
- Define transmitted light and tell why it is important to photography.
- Describe the types of lens and how each transmits light.
- Explain ''focal length,'' ''aperture,'' and ''f-numbers.''
- Describe the four different types of lens mounts.

A LENS is a transparent (see through) material that has at least one curved surface, Fig. 3-1. When it enters the camera, light passes through a lens. The lens collects and bends light rays. The rays are bent so they form a sharp image on the film, Fig. 3-2. A lens can be made of plastic or special optical glass.

SIMPLE RULES OF LIGHT AND OPTICS

To understand how a lens works, some basic rules of light and optics (vision) must be known:

Fig. 3-1. A lens is a transparent glass or plastic disc with at least one curved surface. Light passes through it.

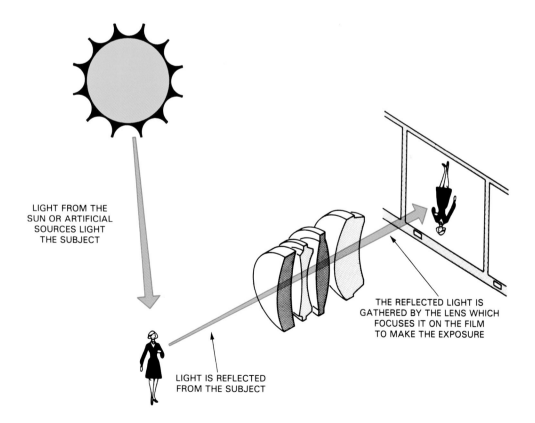

LIGHT FROM THE SUN OR ARTIFICIAL SOURCES LIGHT THE SUBJECT

LIGHT IS REFLECTED FROM THE SUBJECT

THE REFLECTED LIGHT IS GATHERED BY THE LENS WHICH FOCUSES IT ON THE FILM TO MAKE THE EXPOSURE

Fig. 3-2. The lens collects and bends light rays so they form a sharp image on the film.

1. Light usually travels in straight lines, called rays, Fig. 3-3.
2. Light rays can be transmitted, absorbed, and reflected as shown in Fig. 3-4.

We are mostly concerned with transmitted light in the study of camera lenses. This is the light that passes through the lens.

TRANSMITTED LIGHT

Light rays can travel through a transparent or clear material such as water, glass, and plastic. The light rays, however, may be bent as they pass through.

This bending of light is known as REFRACTION, Fig. 3-5. The principle of refraction makes it possible to design lenses that can make an object appear larger or smaller.

Fig. 3-3. Light rays usually travel in straight lines but they are not always traveling parallel to one another.

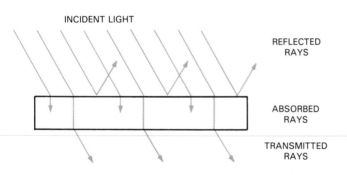

Fig. 3-4. Light rays can be transmitted, absorbed, and reflected.

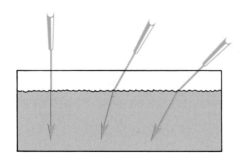

Fig. 3-5. The bending of light rays is called refraction. Refraction can be shown by placing a straight object like an arrow in water.

THE PINHOLE CAMERA

A simple pinhole camera, Fig. 3-6, can make photographs without a lens. Light reflected from the subject enters through the pinhole. It travels through the empty space inside the camera to form an image on the film. The tiny pinhole allows light rays to travel in a straight line from the subject being photographed to the film. An inverted (upside-down) image strikes the film, Fig. 3-7.

If the pinhole is made larger it admits more light, but rays passing through the pinhole scatter, Fig. 3-8.

Fig. 3-6. These pinhole cameras can make photographs without using a lens.

Fig. 3-7. A pinhole camera produces an upside-down image on the film.

The image is not very sharp. Fig. 3-9 shows photographs taken with a pinhole camera.

Such cameras are not very practical for general photography. The results are poor especially if there is any movement.

KINDS OF LENSES

The pinhole can be replaced with a SIMPLE LENS, Fig. 3-10. Since more light can enter the camera, exposure time is reduced. However, a shutter is now needed.

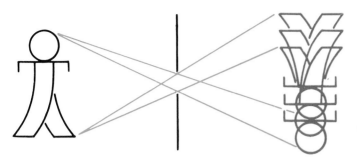

Fig. 3-8. While enlarging the pinhole admits more light, the image produced is fuzzy.

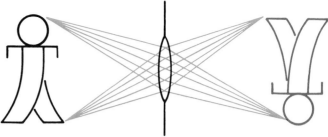

Fig. 3-10. A simple lens is more practical than a pinhole. It allows more light to strike the film.

The shutter is a light control device placed in or behind the lens. It can be opened for carefully measured lengths of time. Light falling on the film can be controlled to fractions of a second. Most inexpensive cameras have simple lenses.

Light striking the surface of an object is called INCIDENT light. See Fig. 3-4. A light ray passing through a sheet of glass changes its path as it enters the glass. However, it exits (leaves) traveling in the same direction as when it entered, Fig. 3-11.

This only happens when the glass surfaces are parallel. If the surfaces are not parallel, as in a PRISM, the rays will be refracted or bent at each surface, Fig. 3-12.

The simple lens can be compared to two prisms placed base-to-base, Fig. 3-13. See how the light rays pass through the prisms? They do not converge (come together) at the same point.

However, by rounding the prisms according to certain laws of OPTICS (the science of vision) the rays passing through the lens are made to converge or FOCUS at the same spot. This common spot is called

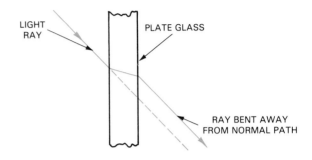

Fig. 3-11. Light rays passing through a sheet of glass bend but exit (leave) traveling parallel to the incident light.

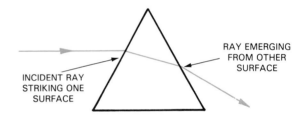

Fig. 3-12. Light rays passing through a prism are bent at each surface.

Fig. 3-9. Pictures made with pinhole camera. A—Exposure using small opening. B—Exposure after pinhole has been enlarged.

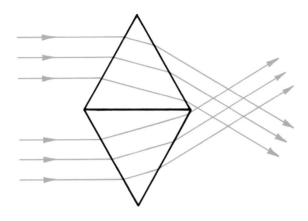

Fig. 3-13. A simple lens acts like two prisms placed base-to-base.

the IMAGE POINT. The film in the camera is at this point, Fig. 3-14.

A SIMPLE LENS is made of a single piece of glass or plastic. It may not meet all of the requirements for good photographs. Several lenses that refract light differently may be necessary to correct defects.

THE COMPOUND LENS

A compound lens is made up of two or more simple lenses as shown in Fig. 3-15. Each simple lens in a compound lens is called an ELEMENT.

Individual lenses are classified into two major groups:
1. A POSITIVE or CONVERGENT lens is thicker at the center and gathers light, Fig. 3-16. (Convergent means it bends the light inward.)
2. A NEGATIVE or DIVERGENT lens is thicker at the edges and spreads light, Fig. 3-17. (It is called divergent because it bends light outward.)

LENS ABERRATIONS

Defects or flaws in a lens are called aberrations. These defects are not, in most cases, the result of a

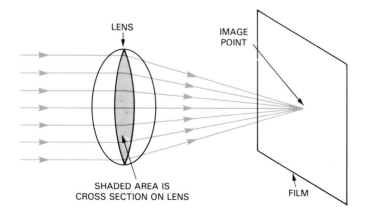

Fig. 3-14. When a lens is properly designed, light rays passing through will converge or focus at the same spot. Film is placed at this spot called the image point.

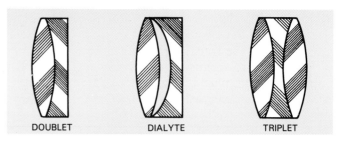

Fig. 3-15. A compound lens consists of two or more simple lenses. Each simple lens is called an element.

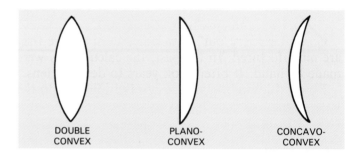

Fig. 3-16. A positive or convergent lens is thicker at the center and bends light inwards.

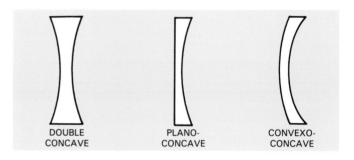

Fig. 3-17. A negative or divergent lens is thicker at the edges and spreads light.

manufacturer's carelessness. They are caused by the behavior of light. A lensmaker can correct for most aberrations by using many elements.

COATED LENSES

Modern lenses are also coated to protect against stray light. A thin layer of a chemical substance, usually magnesium fluoride, may eliminate all but about one percent of these reflections. The amber, blue, or magenta tints seen on a lens indicate the presence of this coating.

LENS QUALITY

Lens quality depends upon:
1. The characteristics of the optical glass used.
2. Lens design.

Making optical glass is an exacting process. Mixing one batch often requires weeks. Even with rigid controls, most of the batch cannot be used to make quali-

ty lenses. The glass that can be used is remelted and cast in molds. The rough glass casting is ground and polished into the finished product.

With modern technology most low-cost lenses can be molded from plastic. Plastic lenses are used mainly in inexpensive cameras.

LENS FORMULAS

A lens is made from a design or formula. The formula gives:
1. The type of glass.
2. Curvature.
3. Placement and spacing of the elements.

Computers "try out" new lenses even before they are manufactured. In the past, the calculations were made by hand. It often took years to design a lens.

Finished lens elements are precisely fitted into the lens barrel. The lens barrel is carefully fitted to the camera body.

FOCAL LENGTH OF A LENS

All lenses have a focal length. This is the distance between the lens and the point where the photographic subject (located at infinity) is in sharp focus on the film, Fig. 3-18. Usually, focal length is given in

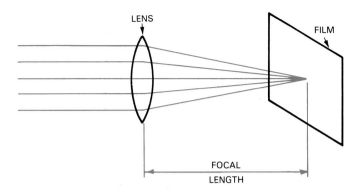

Fig. 3-18. Focal length is the distance between the lens and the focal point (film surface) when the lens is set at infinity.

millimetres (mm) but some are shown in centimetres (cm) and inches.

LENS ANGLE OF VIEW

The focal length also indicates the angle of view of the lens and the IMAGE SIZE that will appear on the film. Angle of view is the largest angle of light rays that will pass through the lens and form an image of acceptable quality on the film, Fig. 3-19. The film surface is called the FOCAL PLANE.

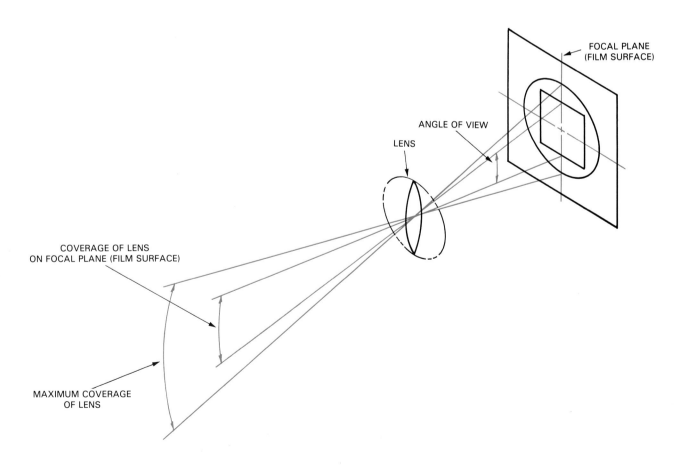

Fig. 3-19. The angle of view is the largest angle of light rays that will form an image on the film.

IMAGE SIZE

Image size is the size of the subject produced on the film. It can be changed by moving either the camera or subject.

To change image size without this movement, a lens of a different focal length must be used. A longer focal length will increase size but will narrow the angle of view. A shorter focal length will decrease image size and will expand the angle of view. See Fig. 3-20. A 100 mm lens will produce an image twice the size of a 50 mm lens.

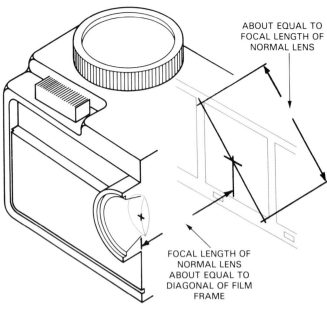

Fig. 3-21. The focal length of a "normal" lens for a particular camera is about the same as the length of the film's diagonal.

APERTURE CONTROL

The lens aperture is a circular opening in a diaphragm usually located between the lens elements, Fig. 3-22. On a camera, the diaphragm is a cover made up of metal. Its openings control the amount of light that can pass through the lens to the film. A large aperture opening will admit more light than a small aperture opening.

Aperture size is specified by f-stops. The f-stops are shown as f-numbers on the lens barrel, Fig. 3-23.

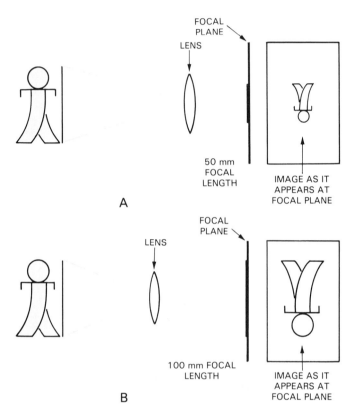

Fig. 3-20. Focal length of lens affects image size. A—Lens with short focal length produces small image on film. B—Lens with long focal length causes large image on film.

A normal lens produces an image about the same as it would appear to the human eye. The angle of view is almost the same as is seen by the eye.

SELECTING A NORMAL LENS

The focal length of a "normal" lens is about equal to the diagonal of the film frame, Fig. 3-21. Frame size of a 35 mm camera is 24 mm by 36 mm. The diagonal of the frame is 43 mm. A lens with a focal length in the range of 40 mm to 55 mm is considered normal for a 35 mm camera.

A 2 1/4 in. by 2 1/4 in. (6 cm by 6 cm) camera has a frame diagonal of 85 mm. Any lens in the range of 75 mm to 85 mm is considered a normal lens for this camera size.

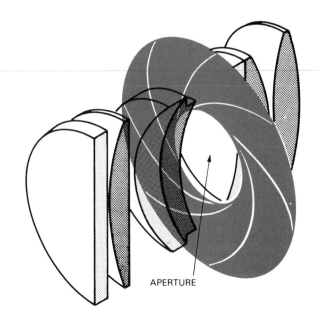

Fig. 3-22. The aperture of a lens is found in a diaphragm-like device between the lens elements. The amount of light passing through the lens to the film is controlled by making the aperture larger or smaller.

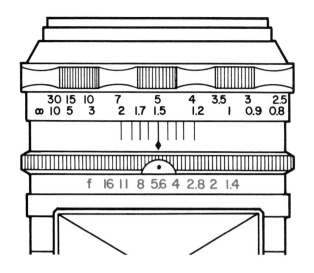

Fig. 3-23. Aperture size is specified by f-stops. They appear as f-numbers on the lens barrel.

The "f" stands for FRACTION. The larger the f-number the smaller the aperture opening, Fig. 3-24. For example, an f/8 (1/8) aperture is smaller than an f/4 (1/4) aperture opening.

A lens with a maximum f-number aperture opening of f/1.4 or f/2.0 is considered a FAST lens. A fast lens allows a great amount of light to pass through to the film. This permits satisfactory photographs to be taken in dim light.

Closing the lens aperture by one f-stop, f/2.8 to f/4, for example, reduces the light reaching the film by one-half, Fig. 3-25. Reducing the size of the lens aperture is called STOPPING DOWN. The same f-number on any lens of any focal length will allow the same amount of light to reach the film.

AUTO LENSES

Most modern lenses have an automatic aperture diaphragm. That is, the diaphragm remains wide open until the shutter release is pressed. At that instant, it closes to the selected aperture (f-number). After the exposure is made, it returns to wide open. These lenses are known as AUTO lenses.

PRESET LENSES

Some lenses are not coupled to the shutter release. The aperture must be stopped down manually before exposure. These lenses are called PRESET lenses, Fig. 3-26.

A preset lens has two f-stop scales. One is for manually adjusting the aperture. The other is for a mechanical stop so the lens can be opened or closed quickly to a preselected f-stop.

MOUNTING LENSES ON A CAMERA

The lens MOUNT attaches the lens to the camera body. This feature permits the photographer to change lenses rapidly. There are four main types of mounts.
1. Screw mount.
2. Bayonet mount.
3. Breech mount.
4. Clamp mount.

SCREW mount lenses thread into the camera body, Fig. 3-27. Several revolutions are needed to seat the lens in the camera body. *Caution: Do not force a screw mounted lens if it does not turn easily in the camera body. Forcing may damage both the lens and camera body and result in costly repairs.*

The BAYONET lens mount fits into a mounting flange on the camera body. A twist of 90 degrees or less locks the lens into place. All major manufacturers of SLR cameras use this mount. See Fig. 3-28.

A BREECH lens mount, Fig. 3-29, is also attached by a flange. The lens is fitted to the camera body. A ring on the rear of the lens is twisted to locking position.

Fig. 3-25. The lens on the left is set at f/4. The other lens is set at f/2.8. The lens set at f/4 reduces the amount of light passing through the lens to the film by one-half.

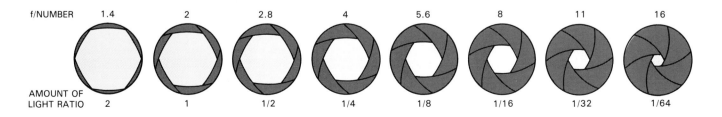

Fig. 3-24. Large f-number indicates small aperture. Small f-number indicates a large aperture.

Fig. 3-26. A preset lens aperture is not connected to camera operation. Aperture must be stopped down manually before making exposure.

Fig. 3-27. Screw type lens mounts were once very popular.

Fig. 3-29. Breech type lens mount can be found on older popular cameras.

Fig. 3-28. Bayonet type lens mount. Modern SLR cameras use this type.

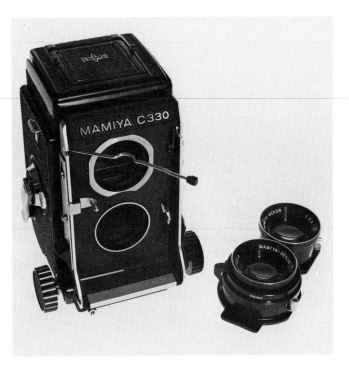

Fig. 3-30. Clamp type lens mount uses spring-loaded wire to hold lens barrel.

A CLAMP lens mount is attached to the camera body with a spring-loaded wire clamp, Fig. 3-30. This type of mount is often used in view cameras and twin lens reflex cameras.

Lenses with screw mounts will usually fit several makes of cameras. Breech and bayonet mount lenses are designed to fit only one make of camera.

LENS SCALES

Adjustable lenses usually have three scales printed on them:

1. Distance scale. This tells the operator how far away the subject is.
2. Depth of field scale. It indicates the nearest and farthest distances the subjects in the picture are in sharp focus.
3. Aperture scale. This indicates the f-stop at which the aperture is set.

Proper use of the scales are explained in greater detail in Chapter 6. A typical lens scale system is displayed on the lens barrel shown in Fig. 3-31.

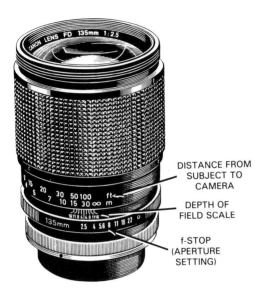

DISTANCE FROM SUBJECT TO CAMERA

DEPTH OF FIELD SCALE

f-STOP (APERTURE SETTING)

Fig. 3-31. Several scales are printed on the barrels of adjustable lenses. They help the camera operator in judging distance, finding the right aperture, and judging how much light is reaching the subject in cases where a flash unit must be used.

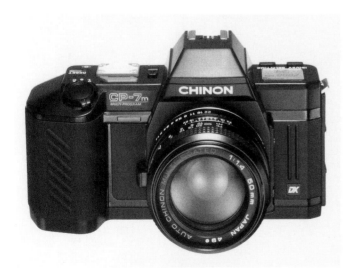

Fig. 3-32. A standard or normal lens usually comes with the camera. It gives about the same perspective as the human eye. (Chinon America)

LENS SELECTION

A 50 mm lens is standard or "normal" for most 35 mm cameras, Fig. 3-32. This lens usually has a large aperture for low light conditions or fast shutter speed. It is an all-purpose lens when only one lens is available. It pictures the subject just about the way it is seen by the human eye.

WIDE ANGLE LENS

A wide angle lens, Fig. 3-33, has a shorter focal length than a normal lens. At any distance it will take in a larger area than the normal lens, Fig. 3-34.

The shorter the focal length, the greater the angle of view. Depth of field also increases with a shorter focal length. Wide angle lenses are used to photograph landscapes, buildings, and groups of people.

Fig. 3-33. A wide angle lens has a short focal length.

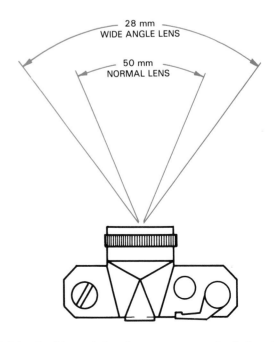

Fig. 3-34. A wide angle lens has a greater angle of view than a normal lens. A larger area can be photographed from the same distance.

TELEPHOTO LENS

A telephoto lens, Fig. 3-35, acts like a telescope. Distant objects appear closer. The greater the focal length, the greater the magnification. (Magnification is making things appear bigger than they really are as seen by the eye.) Telephoto lenses are useful for nature photography, sports photography, and for taking candid photographs. Fig. 3-36 compares normal, wide angle, and telephoto lenses.

ZOOM LENS

A zoom lens, Fig. 3-37, is like many different lenses in one. Such lenses are found in most focal length ranges. Most are made for 35 mm cameras.

CARE OF LENSES

Never clean a lens with facial or toilet tissue, silicon eye glass cleaning tissues, handkerchiefs, fingers, or with water.

For best results, clean lenses with the items shown in Fig. 3-38. They have been especially designed to clean lenses.

Use a soft brush to remove dust. Invert the lens so the dust falls away from the lens, Fig. 3-39. Pressurized air made for cleaning lenses may also be used.

Lens cleaning fluid and special tissue will remove fingerprints and smears without damaging the lens coating. Apply fluid to a folded lens tissue and gently wipe in a circular motion working towards the lens' edge.

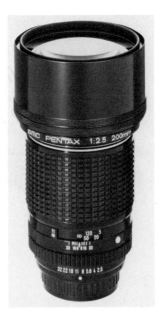

Fig. 3-35. A telephoto lens does for the camera what a telescope does for the eye. (Pentax Corp.)

A

B

C

D

Fig. 3-36. This set of photos compares wide angle, normal, and telephoto lenses. A—35 mm wide angle lens. B—50 mm normal lens. C—100 mm telephoto lens. D—200 mm telephoto lens.

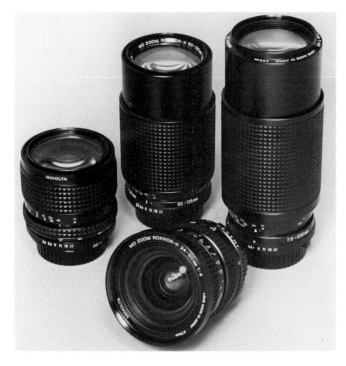

Fig. 3-37. A zoom lens is many lenses in one. It adjusts from normal to several telephoto settings. (Minolta Corp.)

Fig. 3-39. Invert the lens when you clean it. Dust and dirt will fall away from the lens.

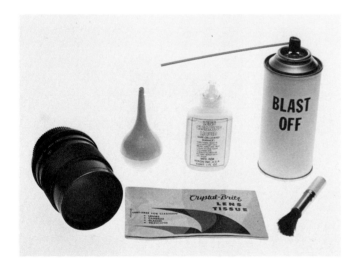

Fig. 3-38. Special tools have been designed to clean lenses without fear of damage to the lens surfaces.

Protect camera and lens from temperature extremes. Avoid salt spray and moisture at the beach.

If a lens and camera has been accidentally dropped in water do not try to disassemble the camera and lens to dry them out. Take them immediately to an approved camera and lens repair shop. The shop should be able to dry them out with a minimum of damage. The camera repair person will also be able to check camera and lens operation to assure that they operate as designed.

When not in use, both ends of the lens should be protected with lens caps, Fig. 3-40. Lens should be stored in lens cases.

WORDS TO KNOW

Aberration, angle of view, aperture, bayonet mount, breech mount, coated lens, compound lens, convergent lens, diaphragm, divergent lens, element, focal length, image point, incident light, lens, lens mount, optics, refraction, simple lens, stopped down, transmitted light.

TEST YOUR KNOWLEDGE — CHAPTER 3

1. List two basic principles of light related to how a lens works.
2. A _____ camera does not need a lens to make a photo.
3. A lens composed of two or more simple lenses is known as a _____ lens. Each of these simple lenses is called an _____.
4. The angle of view of a lens is determined by the _____.
5. A dimly lit subject would be photographed with a fast lens. True or False?
6. Check the f-stop best suited to take the picture in No. 5. ____ f/2 or ____f/16
7. Depth of field is controlled by: (Check the correct answer or answers.)
 a._____Focal length of lens.
 b._____f-stop of lens.
 c._____Type of lens mount used.
 d._____All of the above.
 e._____None of the above.
8. List three uses for a wide angle lens.
9. When should a telephoto lens be used?
10. How does a zoom lens differ from other types of lenses?

Fig. 3-40. When not in use, both ends of the lens should be protected with lens caps.

11. Which of the following items are recommended to safely clean a lens? (Check the correct answer or answers.)
 a._____Soft brush.
 b._____Silicon eye glass tissue.
 c._____A clean handerchief.
 d._____All of the above.
 e._____None of the above.

MATCHING TEST: On a separate sheet of paper, match the appropriate definition in the right hand column with the name or term in the left hand column. Place the correct letter in the blank opposite the number.

12. ____Lens.

13. ____Pinhole camera.

14. ____Transmitted light.

15. ____Refracted light.

16. ____Simple lens.

17. ____Convergent lens.

18. ____Divergent lens.

19. ____Aberrations.

20. ____Stopping down.

21. ____Image size.

a. Does not need a lens to take a picture.
b. Made of a single piece of glass or plastic.
c. Made from transparent material with at least one curved surface.
d. Light rays that are bent.
e. Light that passes through transparent material.
f. Size of subject produced on the negative.
g. Flaws or defects in lens.
h. Lens that bends light rays inward.
i. Lens that bends light rays outward.
j. Reducing size of lens aperture.

THINGS TO DO

1. Make a pinhole camera with the back removed. Cover the back with thin tissue. In a darkened room, point the camera towards a lighted bulb or candle. Observe the image formed on the tissue.

2. Make a series of photographs using the pinhole camera. Prepare a report on the results of your experiment.

3. Collect 10 photographs from magazines. *(Do not remove them from library magazines.)* Pass them around during a group discussion. Discuss the possible aperture setting and lens focal length used for each photo.

4. Collect lens advertisements. (They can be secured from local camera dealers, lens manufacturers, and from discarded photo magazines.) Secure a cutaway illustration of a lens. Count the elements. List the number of convergent and divergent lens elements in the cutaway lens.

5. Study the information collected. Note the differences between the various types of lenses.

6. Most photo magazines evaluate lenses. Study several of these evaluations and explain to the class how the lenses are tested.

7. Secure a camera with an adjustable lens. Take a series of photos at different aperture settings. Note how the depth of field changes. Prepare a table showing the depth of field at different aperture settings.

8. Secure a simple camera with a fixed aperture but adjustable focus. Photograph a subject at various distances while changing the focus. Note how the depth of field changes. How do pictures made with this camera and lens compare with photos made with the camera in Activity No. 7?

4 THE CAMERA

After studying this chapter you will be able to:
☐ List the basic, essential parts of a camera and explain their function in exposing film.
☐ Describe the modes or methods of operation of the modern camera.
☐ Name the types of cameras and explain the main differences between them.
☐ Demonstrate the operation of several different types of cameras.

Any well made camera, if used properly, can produce a sharp, clear picture. As you become more interested in photography, you will want the best camera you can afford. However, you must decide the type of camera best suited for your needs. Before you make such a decision you need to understand the types of cameras and their basic parts.

BASIC PARTS OF A CAMERA

A camera is a light-tight box made to expose light-sensitive material (film), Fig. 4-1. It has:

1. A shutter which controls length of exposure.
2. A diaphragm which controls amount of light admitted into the camera.
3. A lens which controls the direction of the light coming into the camera. Chapter 3 discusses lens principles and types.

SHUTTER

The shutter is a device something like a window blind. When the shutter is opened, light passes through the lens and focuses on the film. The light is reflected from the subject being photographed. All cameras use a shutter and a diaphragm together to control the amount of light that reaches the film.

Except in very simple cameras, the shutter is adjustable. It is timed to seconds and fractions of seconds.

DIAPHRAGM

The diaphragm, also called an APERTURE (opening) CONTROL, is usually found between the lens

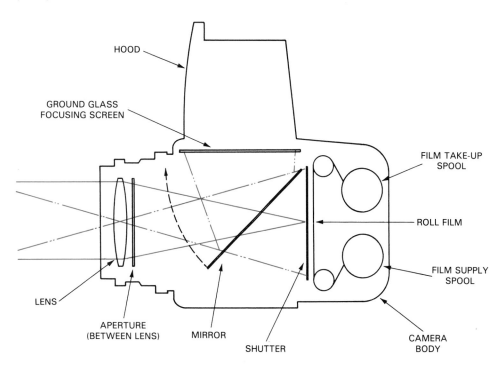

HOOD

GROUND GLASS
FOCUSING SCREEN

FILM TAKE-UP
SPOOL

ROLL FILM

FILM SUPPLY
SPOOL

LENS

APERTURE
(BETWEEN LENS)

MIRROR

SHUTTER

CAMERA
BODY

Fig. 4-1. Cross-sectional drawing of camera shows all its basic parts.

elements, Fig. 4-2. It is a disc with an opening in its center whose size is adjustable. The size of the opening controls the amount of light that can pass through the lens and fall on the lens, Fig. 4-3.

Simple cameras have a fixed aperture. It cannot be made bigger or smaller.

Caution: The aperture and shutter are delicate mechanisms. Keep them protected at all times.

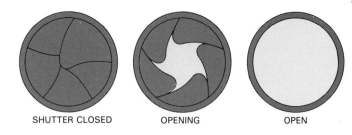

Fig. 4-4. The leaf shutter is a set of thin metal plates. They overlap when closed and keep light from entering the camera.

A focal plane shutter is a curtain of fabric or metal foil. It is located just in front of the film at the back of the camera.

Some cameras use a single curtain; others use a double curtain. In either case, the curtains are wrapped around sets of spools. These spools are put under spring tension when the shutter is cocked (wound up).

The single curtain shutter has slots of various sizes cut into it. Exposure varies according to the size of the slot.

When a double curtain is used, the two curtains move across the film, Fig. 4-5. At fast shutter speeds, the second curtain follows the first curtain closely. At slower speeds it does not follow as close. At fast speeds the opening between the curtains is very narrow. At slow speeds the opening is quite large.

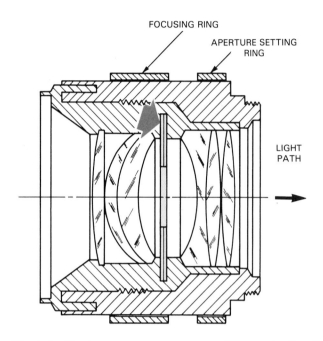

Fig. 4-2. Diaphragm or aperture control is usually found in the lens. It is a metal disc with a circular opening.

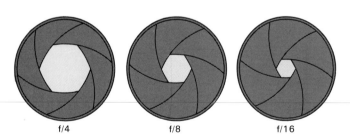

Fig. 4-3. The aperture is the opening in the diaphragm. It can be enlarged or reduced in size. For each increase in f-stop value, the opening grows smaller and reduces the amount of light striking the film by one-half.

TYPES OF SHUTTERS

Two basic types of shutters are currently used on cameras:
1. The LEAF or IRIS type.
2. The FOCAL PLANE type.

Leaf shutters are a set of very thin metal plates. They are set in a circular pattern as shown in Fig. 4-4. The plates move in and out to open and close. They work like the iris (center) of your eye. The leaves overlap at the center when closed and prevent light from entering the camera.

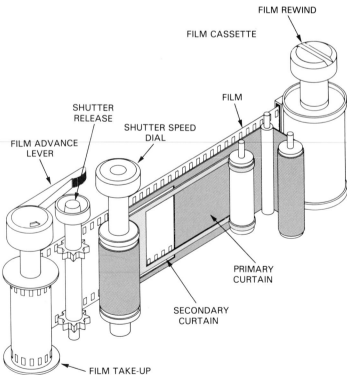

Fig. 4-5. Arrangement of a focal plane shutter. Two curtains travel across the film. The secondary curtain starts to move a split second after the primary curtain has pulled a "window" in front of the film. A slit of light travels across the film.

SHUTTER CONTROLS

Most cameras have a dial or ring for setting the shutter speeds, Fig. 4-6. Shutter speeds are marked on the control. The numbers represent fractions of a second the shutter remains open. For example, the number "1" represents a shutter speed of 1/1 or one second. The number 1/15 means one-fifteenth of a second. Fast shutter speeds—1/125 second and up—can stop the action of a moving object. Shutter speeds of 1/30 second, or faster, are needed when the camera is hand held.

VIEWFINDER

The viewfinder, Fig. 4-7, is located on the top or back of the camera. The photographer uses it to aim and compose the picture. (Composing is making sure all of the subject will appear on the film. It can also mean to arrange the subjects according to good design.)

Some viewfinders are used at eye level. Others are used at waist level, Fig. 4-8. The viewfinder may be a

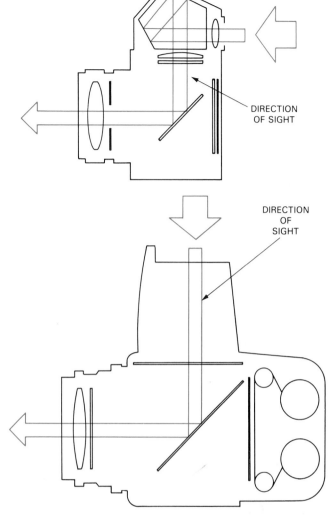

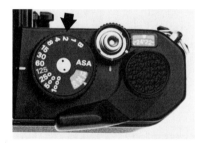

Fig. 4-6. Shutter speed dial. Numbers represents fractions of a second the shutter remains open. The number 125 on the dial stands for a shutter speed of 1/125 second.

Fig. 4-8. Top shows eye level viewfinder; bottom, waist level viewer.

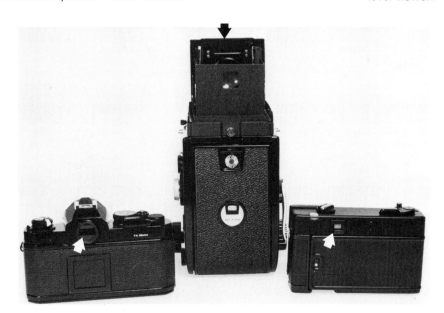

Fig. 4-7. Camera viewfinder is located on the top or back. It is an aid to aiming the camera and composing the picture. Some viewfinders are also used for focusing.

simple wire frame or a system of mirrors and prisms, Fig. 4-9.

The SHUTTER RELEASE opens the shutter and exposes the film. See Fig. 4-10.

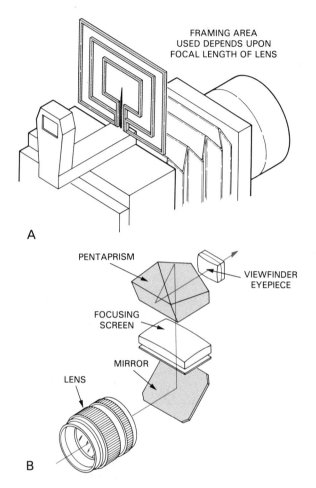

Fig. 4-9. Some viewfinders are simple while others have complex parts. A—Wire frame viewer. B—Mirror and prism viewer.

Fig. 4-10. Typical shutter release locations. Release at left is designed to be operated with the thumb.

FILM ADVANCE

A LEVER, CRANK, or KNOB, Fig. 4-11, is used on most roll film cameras to move unused film to the right position to receive an exposure. Some new cameras now have an automatic film advance that moves the film after every exposure.

On some cameras, exposed film is removed (properly protected from light) while still on the take-up spool. Other cameras require that exposed film be rewound onto the supply spool before it is removed.

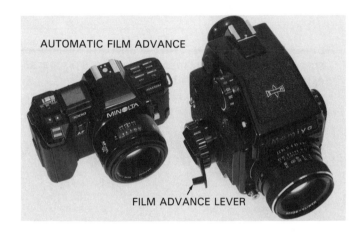

Fig. 4-11. Film advance systems on two types of roll film cameras. The systems are geared to the take-up spool and often recock the shutter too.

A LOCK, Fig. 4-12, on the take-up spool keeps the film from being accidentally rewound. The lock must be released by the photographer. The FRAME COUNTER, Fig. 4-13, indicates how many exposures have been made.

MODES OF OPERATION

Cameras are available with several levels of automation:
1. Manual exposure. Lens aperture and shutter speed

Fig. 4-12. Rewind lock. Film cannot be rewound until the lock is released.

Fig. 4-13. Frame counter helps photographer keep track of unexposed frames remaining on film. (Olympus)

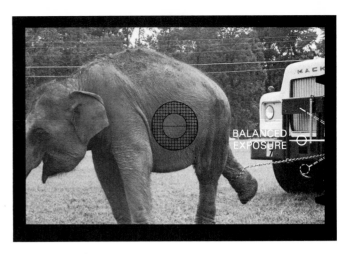

Fig. 4-15. Balanced needle metering system found in some cameras. One needle indicates light intensity, the other moves as exposure settings are adjusted. When the two needles are centered (balanced), aperture and shutter speed combination is right for a properly exposed picture.

must be set by hand. Correct aperture or shutter speed is determined by information from a separate exposure meter, Fig. 4-14.

Many manually operated cameras have built-in exposure metering systems. The metering system is linked to both the shutter speed control and lens aperture control. The correct exposure setting for the available light is found by adjusting the lens aperture ring and/or shutter speed. When a needle or light on one side of the focusing screen centers, the exposure setting is right. See Fig. 4-15.

2. Automatic exposure, Fig. 4-16. This mode of operation is fully automated. Exposure control can be SHUTTER PRIORITY, APERTURE PRIORITY, or PROGRAMMED.

In shutter priority you select the shutter speed. The camera selects the proper lens aperture.

Aperture priority means you select the lens opening. The camera selects the shutter speed.

Fig. 4-16. Automatic 35 mm single lens reflex camera will make proper exposure by controlling either the shutter speed or the aperture. (Chinon America)

In programmed systems the camera selects both shutter speed and aperture. Often the program can be chosen by you for a specific type of picture. For example, a sports program might favor a fast shutter speed to freeze action, Fig. 4-17.

3. A power winder, Fig. 4-18, is a motorized device that advances film automatically after a photo has been made. Many cameras can be fitted with them.

4. Automatic focusing, Fig. 4-19. The camera automatically sets the focus, determines the correct exposure, and turns on the flash, if needed. These settings are made almost instantaneously as the shutter release is pressed.

5. Automated film speed setting. Many modern cameras can automatically set their light meters for the speed of the film loaded. These cameras read the "DX" coding on the leader of most modern roll films.

Three types of automatic focusing systems are used:

1. Electronic-mechanical-optical system. Mirrors on either end of the camera reflect an image of the

Fig. 4-14. Exposure meters are helpful in finding the correct aperture and shutter speed combinations for making a properly exposed picture. (The Saunders Group)

Fig. 4-17. Cameras with programmed automatic exposure control usually let you select a program matched to the type of picture you are taking. (Minolta Corp.)

Fig. 4-18. The power winder is a motorized device that advances the film automatically to the next unexposed frame. Some cameras, such as this do not have a manual film advance. (Minolta Corp.)

Fig. 4-19. Automatic focusing camera. The photographer programs the film speed into the camera and centers the subject in the viewfinder. When the shutter is released, the lens focuses automatically.

Fig. 4-20. A simple camera has no control for focus, setting of aperture, or shutter speed.

subject into electronic sensors. The sensors send electrical impulses to a relay which moves the lens forward or backward until the subject is in focus.
2. Ultrasonic system. A small transmitter on the camera sends out ultrasonic sound waves (cannot be heard by human ear). A receiver on the camera measures the length of time required for the sound waves to bounce off the subject and return. This time measurement controls a very small electric motor that moves the lens into focus.
3. Infrared light system. This system works much like the ultrasonic system. Instead of sound, this system sends out invisible (cannot be seen) infrared light that reflects off the subject and returns to a sensor in the camera. A computer in the camera uses the geometry of the system to calculate the distance to the subject. The computer sets the lens focus appropriately.

TYPES OF CAMERAS

There are many kinds of cameras. Almost all of them are variations of five basic types.
1. Simple camera.
2. Rangefinder camera.
3. Single lens reflex (SLR) camera.
4. Twin lens reflex (TLR) camera.
5. View camera.

SIMPLE CAMERA

Of all cameras, the simple camera, Fig. 4-20, is easiest to understand. To use it, aim and shoot.

There is no need to focus, because the camera is fitted with a FIXED FOCUS lens. This means everything from about 6 ft. (2 m) away and beyond will be in focus. You will get a clear picture of almost everything seen in the viewfinder. An AUXILIARY LENS can be fitted over the regular lens to take close-ups.

Shutter speed and aperture opening are also fixed. This means they cannot be changed. No adjustments can be made for different lighting conditions. For best results, pictures must be taken outdoor in sunlight. Most simple cameras can be fitted with a flash attachment, Fig. 4-21.

Flash units on simple cameras can only supply enough light to take pictures a limited distance from the camera. This distance is listed on the flash bulb or flash cube container. Photos taken beyond flash range are underexposed (very dark) and often useless. Film for simple cameras is available in either rolls or cartridges. Black and white and color film (slides

Fig. 4-21. Flash attachment on a simple camera. This unit uses cubes.

Fig. 4-23. Rangefinder type camera often combines rangefinder and viewfinder. (E. Leitz, Inc.)

and prints) can be used in them. A film speed of ISO 100 is usually recommended.

Film in cartridge form is simply dropped into the camera. After all of the film has been exposed, the cartridge is removed for processing.

In cameras using roll type film, the film must be threaded from the supply spool to the take-up spool, Fig. 4-22. After exposure, the take-up spool, which holds the exposed film, is removed from the camera. The empty film supply spool is shifted. It becomes the take-up spool for the next roll of film.

RANGEFINDER CAMERA

The rangefinder camera, Fig. 4-23, uses a viewfinder combined with a focusing device called a rangefinder, Fig. 4-24. Most 35 mm rangefinder cameras use a superimposed-image type rangefinder. (This means one image is over the top of the other.) A double image appears in the center of the viewfinder when the lens is not properly focused on the subject, Fig. 4-25. The lens focusing ring must be rotated until the two images become one. The lens will take a sharp picture when the two images are aligned.

Rangefinder cameras are suitable for serious photographic work. They have features needed by the pro-

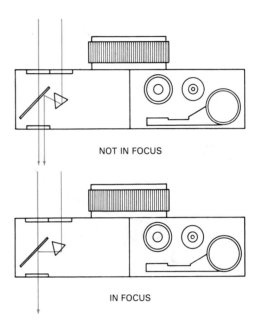

NOT IN FOCUS

IN FOCUS

Fig. 4-24. Lens is in focus when two images in rangefinder become one.

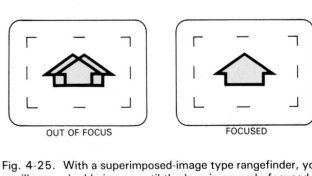

OUT OF FOCUS FOCUSED

Fig. 4-25. With a superimposed-image type rangefinder, you will see a double image until the lens is properly focused.

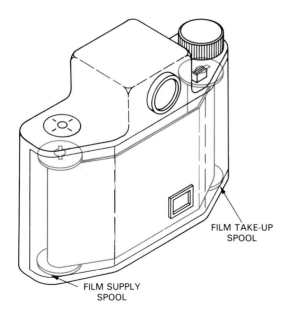

FILM TAKE-UP SPOOL

FILM SUPPLY SPOOL

Fig. 4-22. When loading roll film, be sure the dark side (film side) of the paper leader faces the lens.

fessional photographer. This includes small size and fairly light weight. Multi-element interchangeable lenses (35 mm, 50 mm, 90 mm, and 135 mm) are available. Such cameras also have multiple aperture settings (f-2.8 to f-16) and a full range of shutter speeds. They are available in manual and automatic modes of operation.

While the rangefinder camera has many advantages, it does have a few drawbacks. PARALLAX error occurs when the subject being photographed is closer than 6 ft. (1.5 to 2 m). The error increases the closer the subject is, Fig. 4-26. The viewfinder sees the subject from a slightly different position than the lens. This is often the cause of pictures in which the subject is too far off to one side, Fig. 4-27.

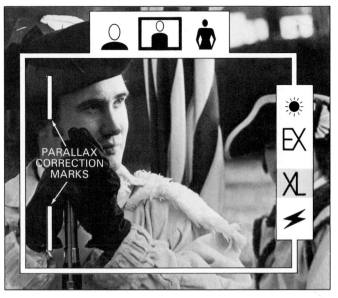

Fig. 4-28. Some viewfinders are fitted with parallax compensation frame marks for close-up work. The area outside the frame will not appear in the picture.

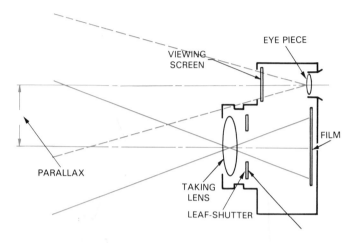

Fig. 4-26. Parallax error occurs when the subject is too close to the camera.

Parallax can be demonstrated by looking at a close-up object with one eye closed. Then, while in the same position, look at the subject with the other eye. The image each eye sees is slightly different.

Some viewfinders are fitted with parallax compensation frame marks, Fig. 4-28, for close-up work. The area outside the frame will not appear in the picture even though it can be seen in the viewfinder.

Changing to a lens with a different focal length can also cause problems. The lens' field of view changes

but the viewfinder field of view remains the same as it was for the normal lens. To compensate for the difference, frame lines for the different lenses are scribed or projected on the viewing screen, Fig. 4-29. However, the photographer must remember to use the proper frame lines (for the lens on the camera) when composing the picture.

Adding filters to a rangefinder camera with a built-in exposure meter can also cause problems. A filter absorbs a portion of the light that would normally pass through the lens. Unless a similar filter is placed over the meter's sensing unit, the photo will be underexposed. If a second filter is not available, the amount of additional exposure required is given as a number

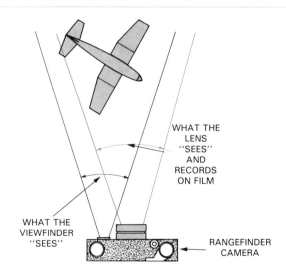

Fig. 4-27. Problem caused by parallax error. Left. Rangefinder sees the subject slightly different than the lens photographs it. Right. Part of subject is "chopped" off because lens position is different from viewfinder position.

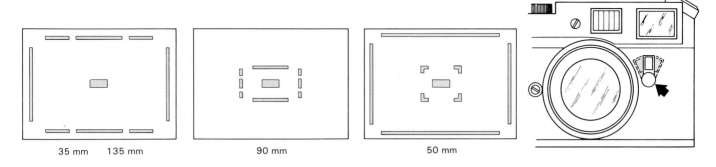

35 mm 135 mm 90 mm 50 mm

Fig. 4-29. Framing lines in the viewfinder must be used when the normal lens is replaced with a lens of different focal length. A lever on some rangefinder cameras is used to slide screens with different framing lines into the viewfinder.

called a FILTER FACTOR. A filter factor table is furnished with the filter and with some film.

TWIN LENS REFLEX CAMERA

The twin lens reflex camera, Fig. 4-30, (also known as a TLR) has a two-section body. It is fitted with a pair of matched lenses. One lens is mounted over the other. Composing and focusing are done with the top lens. The bottom lens takes the picture.

The lenses are always the same focal length. If the camera is designed to take interchangeable lenses, both lenses are mounted on the same lensboard. They are changed as a unit, Fig. 4-31. The camera lens has a full range of shutter speeds and aperture settings.

For focusing, light reflected from the subject enters through the upper lens. The image is reflected upwards from a fixed mirror to a ground glass focusing screen, Fig. 4-32. The twin lenses are focused in unison. When the viewing image is in sharp focus, the image that falls on the film will also be in focus.

Fig. 4-31. Both lenses are mounted on a single lensboard. They are changed as a unit.

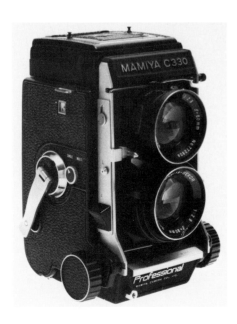

Fig. 4-30. Twin lens reflex (TLR) camera uses top lens for viewing but bottom lens exposes the film.

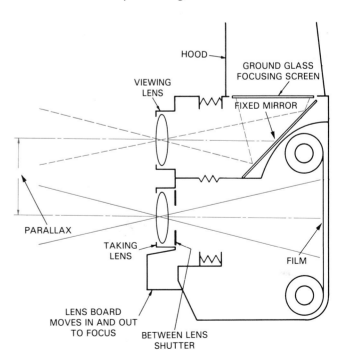

HOOD

VIEWING LENS

GROUND GLASS FOCUSING SCREEN

FIXED MIRROR

PARALLAX

TAKING LENS

FILM

LENS BOARD MOVES IN AND OUT TO FOCUS

BETWEEN LENS SHUTTER

Fig. 4-32. How a TLR camera works. One lens reflects image to ground glass. Second lens takes picture.

The focusing screen is in the top of the camera, Fig. 4-33. It is designed for viewing the image from above. When composing and focusing, the image seen in the viewfinder is upright but is reversed from right to left. The TLR is usually held at waist level.

A collapsible hood shields the viewing screen, Fig. 4-34. This makes the image appear brighter on the viewing screen. A flip-up magnifier on the hood aids in focusing.

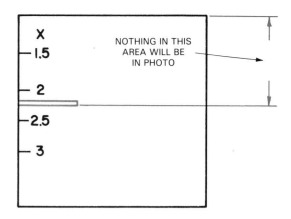

Fig. 4-35. Parallax correction indicator on a TLR camera. Area above needle will not be in the negative.

Fig. 4-33. The focusing screen is on the top of TLR cameras.

Fig. 4-34. A collapsible hood makes image appear brighter on viewing screen.

The TLR camera, like the rangefinder camera, has the problem of parallax. A moving parallax correction indicator is fitted below the viewing screen on better TLR cameras, Fig. 4-35.

Filters can cause exposure problems when using a built-in light meter if the same type filter is not fitted over the meter. Exposure meters can be built in or added onto the camera, Fig. 4-36. A hand-held meter may also be used.

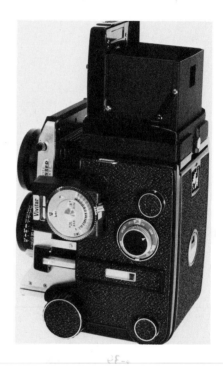

Fig. 4-36. Add-on exposure meter is attached to side of camera body.

Modern TLR cameras use 120 and 220 size roll film. The 2 1/4 in. by 2 1/4 in. negatives make it easier to produce high quality enlargements.

Film is advanced with a film advance crank, Fig. 4-37. The crank also activates the SHUTTER COCKING LEVER when the film is advanced.

With practice, a TLR camera is easy to use. To make the camera more versatile when used for action and sporting events, the regular viewfinder can be replaced with a prism finder, Fig. 4-38. This finder permits eye-level viewing.

SINGLE LENS REFLEX CAMERA

The single lens reflex camera, also known as the SLR, uses the same lens for viewing, focusing, and

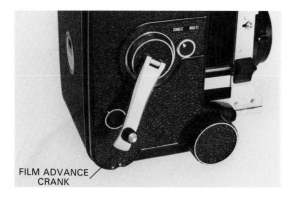

Fig. 4-37. The film advance crank cocks the shutter mechanism while advancing the film for the next exposure.

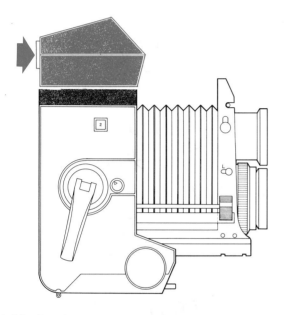

Fig. 4-38. Regular waist level viewfinder has been replaced with a prism finder to permit eye level viewing.

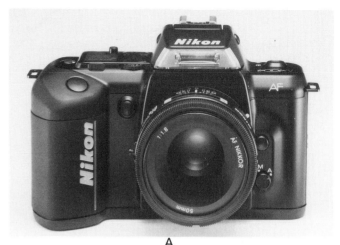

A

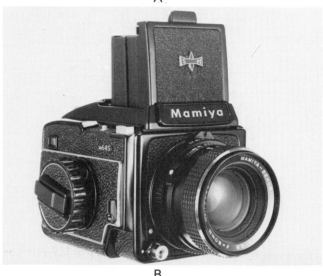

B

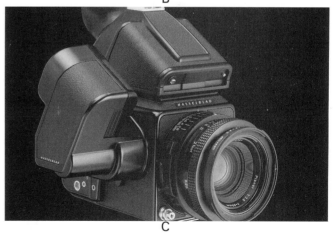

C

Fig. 4-39. Single lens reflex cameras. A—35 mm format. B—Medium format SLR with waist level viewfinder. C—Medium format (120/220) SLR with eye level viewfinder. (Nikon Inc., Bell & Howell—Victor Hasselblad Inc.)

taking the picture, Fig. 4-39. For viewing and focusing, a mirror reflects light from the subject upwards through a focusing screen into a PENTAPRISM, Fig. 4-40. (Although a few SLR cameras are designed for waist level viewing, most are fitted with the pentaprism. The pentaprism permits eye-level viewing.) The pentaprism is a mirrored five-sided prism. The image seen in the eyepiece is upright and correct from left to right. The photographer sees what the lens sees.

So that it does not interrupt (cut off) the image being photographed, the mirror must flip up instantly when the picture is taken. See Fig. 4-41. The mirror drops back immediately after the picture is taken. The viewing screen is blacked out for an instant.

Caution: Avoid touching the mirror when the lens is removed or being changed, Fig. 4-42.

Many SLR cameras have built-in exposure meters. The meter is usually located behind the lens and reads the intensity of the light coming through the lens, Fig. 4-43. Since it is located behind the lens, the meter

automatically compensates when a filter is added or when different lenses are used on the camera.

The aperture is located in the lens body on SLR cameras. Focusing is best done with the aperture wide open. This provides the brightest image on the viewing screen. To do this, a lens is fitted with a

45

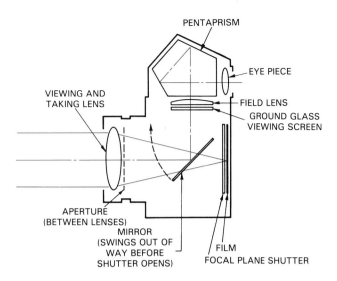

Fig. 4-40. How the SLR camera works.

Fig. 4-42. Never touch the mirror when the lens is removed from the SLR camera.

MANUAL or AUTOMATIC aperture control.

With manual aperture control, the aperture must be opened wide for focusing. Then it must be closed or stopped down by hand for metering.

This method for determining the aperture setting for the correct exposure is called STOP DOWN METERING. The aperture is stopped down until a meter needle or light display in the viewfinder indicates the aperture setting is correct.

Automatic aperture control permits focusing and metering to be done with the lens wide open. It remains wide open until the picture is taken. When the shutter is tripped, the aperture stops down instantly to the correct setting.

A depth of field preview button, Fig. 4-44, enables the photographer to stop down the aperture. This permits him or her to see what will and will not be in focus when the picture is taken. It is fitted to most modern SLR cameras.

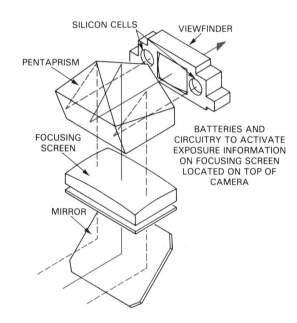

Fig. 4-43. Many SLR cameras have built-in exposure meters. Shown is a typical installation of the light-reading sensors.

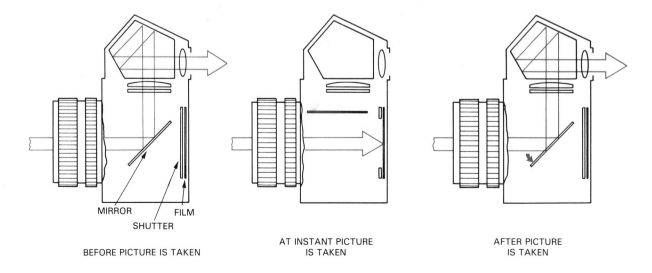

BEFORE PICTURE IS TAKEN

AT INSTANT PICTURE IS TAKEN

AFTER PICTURE IS TAKEN

Fig. 4-41. When an SLR camera takes a picture, the mirror flips up instantly. It drops back in place after the exposure is made.

Fig. 4-44. The depth of field preview button permits the photographer to see what will and will not be in focus with a specific aperture setting. Arrow points to the control button. (Nikon Inc.)

Fig. 4-45. Small format (110) SLR camera uses drop-in film cartridges.

FORMATS

Single lens reflex cameras are made in several formats (sizes and shapes). The smallest is the 110, Fig. 4-45.

The most popular format is the 35 mm. A camera of this format is shown in Fig. 4-44. The width of the film is actually 35 millimeters.

A third and larger format used with SLR cameras is adaptable to 120, 220, or 70 mm. Polaroid film can also be used by changing the camera back, Fig. 4-46.

The SLR camera is usually a "system" camera. Most manufacturers offer a wide assortment of lenses and other accessories designed especially for the camera, Fig. 4-47. The camera is adaptable for almost every photographic situation.

Fig. 4-46. Medium format SLR camera uses roll film in 120, 220, and 70 mm sizes. (Mamiya Co.)

Fig. 4-47. A "system" camera. A wide range of lenses and accessories are designed especially for the camera. (Bronica, Unitron Instruments, Inc.)

When purchasing accessories, be sure they will be compatible with your camera. Manufacturers sometimes make design changes in a camera. Lenses and accessories for an earlier model camera may not fit the latest model even though they appear to be the same.

VIEW CAMERA

The view camera, Fig. 4-48, is used with medium and large format film. Viewing and focusing are done on a ground glass. The camera is first set to give the approximate image size desired. Slight changes can be made by racking the camera and rail in or out on the tripod block.

The advantage of the view camera is its ability to correct perspective distortion. (Distortions are images twisted out of shape by camera angles.) Frames at the front and back carriages can be pivoted (turned) in several directions to make the corrections. Refer to Fig. 4-49 to see how camera adjustments are used to control image distortion and/or give the photographer complete control over picture composition.

View camera lenses are mounted on a LENS-BOARD, Fig. 4-50. Lenses may be changed to suit the job. Aperture and shutter are contained in the lens body.

View cameras use film in sheet form. The most common sizes are 4 in. by 5 in. and 8 in. by 10 in. Polaroid backs have been designed for use with view cameras, Fig. 4-51.

View cameras are used when large format negatives are needed. The large negative size produces enlargements that are unequaled in sharpness and detail.

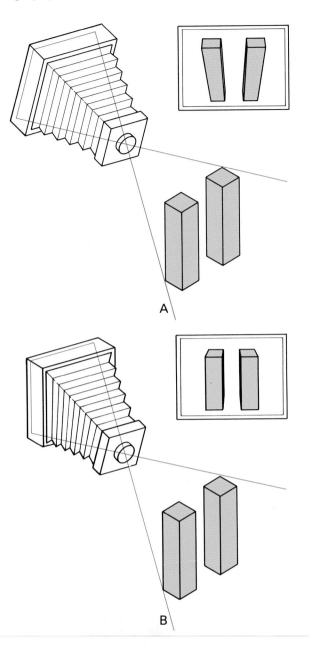

Fig. 4-49. The front and back carriages of a view camera can be pivoted in several directions to control image distortion. A—Distorted view. B—Distortion corrected.

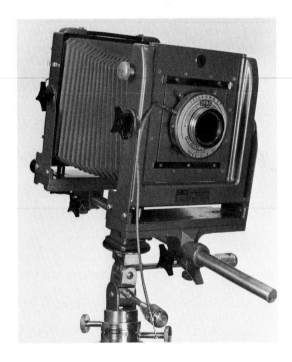

Fig. 4-48. A view camera. Because of its size, it must always be mounted on a tripod.

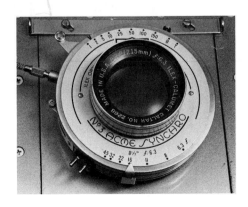

Fig. 4-50. Aperture and shutter are contained within the lens body.

48

Fig. 4-51. A Polaroid back is available for view cameras. It permits the camera to make "instant" pictures.

OTHER TYPES OF CAMERAS

There are several other types of cameras that are variations of the five camera types already mentioned. However, they are unique for one reason or another.

PRESS CAMERA

A press camera, Fig. 4-52, is a combination of the rangefinder and view cameras. It uses medium to large format film in roll or sheet form. Sheet film up to 4 in. by 5 in. can be used. A Polaroid back can be fitted to provide an "instant" picture and/or negative.

The press camera uses a rangefinder focusing system. Lenses are interchangeable and a number of

different lenses are available.

The press camera's main advantage is its ability to take medium and large format pictures in fast-moving situations. However, the 35 mm SLR camera has taken over many of the press camera's jobs.

INSTANT PICTURE CAMERA

Instant picture cameras, Fig. 4-53, are variations of the simple rangefinder or SLR type cameras. Many types of film are available in both black and white and color. Some "instant" film is designed to produce both a picture and a negative in a minute or less. Some of the color prints can be seen as they develop.

UNDERWATER CAMERA

The underwater camera, Fig. 4-54, is designed for use in wet environments (places). It is waterproof and

Fig. 4-53. Instant picture camera. Some produce both a photograph and a negative. (Polaroid Corp.)

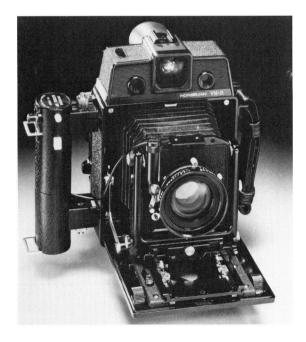

Fig. 4-52. A press camera is a combination of the rangefinder and view cameras. (Calumet Photographic Inc.)

Fig. 4-54. An underwater camera is designed for use in wet environments. (Chinon America, Inc.)

sealed to protect film during exposure. However, it should not be used at water depths greater than that specified by the manufacturer.

Waterproof cases are made for many conventional cameras. Care must be taken when they are used because water leakage can seriously damage or ruin a camera.

SLR STILL VIDEO CAMERA

Still video cameras are similar to other cameras, but record images on an electronic medium (material), Fig. 4-55. Still video cameras have many of the same parts and controls as other cameras. Instead of using film, however, a still video camera can record as many as 50 photographs on a rotating metallic disk housed in a flat plastic container. This "floppy" disk is similar to the disks used to store information in computers. Unlike film which is a permanent record, disk-stored pictures can be "erased" and the disk reused.

Other accessory units will permit:
1. Addition of sound to the disc.
2. Duplication of discs.
3. Production of hard copies (slides and/or prints).
4. Long distance image transmission over the telephone. See Fig. 4-56.

HOW IT WORKS

A tiny imaging screen with many light-sensitive photo conductors is the heart of these types of cameras. Most have a light sensitivity that compares to a film speed of ISO 80 to 100.

These cameras handle like any SLR camera. Floppy disks are loaded through doors in the camera bodies.

To take a picture, the release is partially depressed to start the disc rotating. A diode (light) in the viewfinder indicates the camera is on "standby." Another diode indicates when the disc is up to speed. A picture is taken by fully depressing the release.

A magnetic recording head registers the image on the rotating disc. Each picture requires a circle on the disc. The recording head advances across the disc for

Fig. 4-55. Photograph of Sony still video. Lens focuses on a solid-state video screen instead of on film.
(Sony Corp. of America)

Fig. 4-56. Still video "photo" can be reproduced and viewed several different ways. It can be transmitted long distances by telephone.

the next picture. Since the pictures are not recorded on a spiral, access to individual shots is easy and rapid.

DISC CAMERA

The disc camera is named for its unusual film cartridge. The film, consisting of fifteen 8 by 10 mm exposures arranged around the outer rim of a disc base, is housed in a light-tight cartridge that drops into the camera, Fig. 4-57.

The film is advanced automatically by a small motor. Electronic circuitry meters light intensity, sets the exposure, and triggers an electronic flash when needed. Power is provided by two 3 volt lithium carbon monofluoride dry cell batteries.

The four-element f-2.8 lens is nonfocusing. A short focal length provides depth of field from 4 ft. to infinity. Fig. 4-58 shows an exploded view of the loaded film cartridge.

Fig. 4-57. Disc film is housed in flat cartridge which drops into camera over a motor drive. (Kodak)

WORDS TO KNOW

Aperture priority, auxiliary lens, crank, curtain, depth of field, depth of field preview, film advance, filter, filter factor, focal plane shutter, frame counter, iris type shutter, leaf shutter, lensboard, manual, parallax, pentaprism, power winder, press camera, rangefinder camera, shutter, shutter cocking lever, shutter priority, shutter release, SLR, superimposed image, supply spool, take-up spool, TLR, view camera, viewfinder.

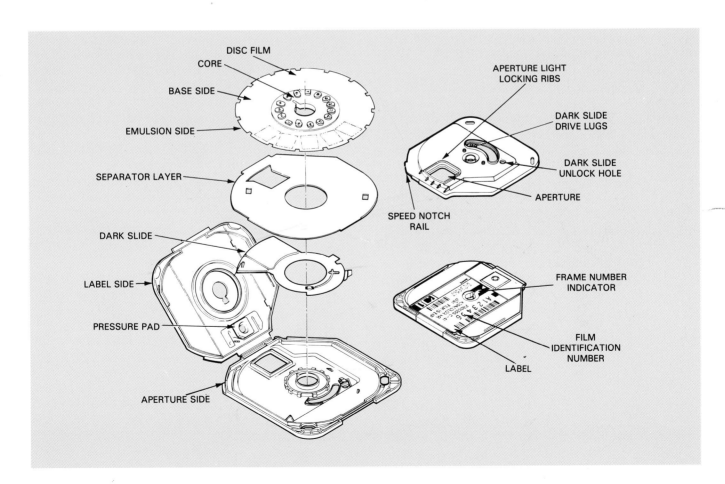

Fig. 4-58. Exploded view shows elements of disc film cartridge.

TEST YOUR KNOWLEDGE — CHAPTER 4

1. What is a camera?
2. How does a camera take a photograph?
3. The camera aperture is: (Check the correct answer or answers.)
 a. A device that catches the light reflected from the subject.
 b. A device that regulates the length of time light is permitted to strike the film.
 c. An opening that can be enlarged or reduced in size to restrict the amount of light that can pass through the lens.
 d. All of the above.
 e. None of the above.
4. The shutter on a camera is: (Check the correct answer or answers.)
 a. A device that catches the light reflected from the subject.
 b. A device that regulates the length of time light is permitted to strike the film.
 c. An opening that can be enlarged or reduced in size to restrict the amount of light that can pass through the lens.
 d. All of the above.
 e. None of the above.
5. There are two basic types of shutters. Briefly describe each type.
6. Shutter speed is the _____.
7. What do the numbers 60, 125, 250, and 500 signify on the shutter speed dial?
8. Shutter speeds of _____ second, or faster, are needed when you hand hold a camera.

MATCHING TEST: On a separate sheet of paper, match the appropriate definition in the right hand column with the name or term in the left hand column. Place the correct letter in the blank opposite the number.

9. ____ Shutter speed dial.
10. ____ Viewfinder.
11. ____ Shutter release.
12. ____ Film advance lever.
13. ____ SLR camera.
14. ____ TLR camera.
15. ____ View camera.
16. ____ Press camera.

a. One lens is used to compose and focus while a second lens is used to take the picture.
b. A combination of a rangefinder camera and a view camera.
c. Used to advance film to the next exposure.
d. Uses the same lens for viewing, focusing, and taking the picture.
e. Used to aim and focus the camera.
f. Trips the shutter.
g. Sets shutter speed.
h. Large format camera.

17. An automatic camera which requires the photographer to set the lens aperture is known as a _____ camera.
 a. shutter priority
 b. aperture priority
 c. instant picture
18. On an automatic camera, using the mode of operation described in Question 17 permits you to control the _____ in a picture.
19. Prepare a sketch showing how a rangefinder camera works.
20. Prepare a sketch showing how a SLR camera works.
21. Prepare a sketch showing how a TLR camera works.
22. With which type of camera is parallax a problem when making close-up photographs?
23. Describe the parallax problem of the above camera. Use a sketch if necessary.
24. The following cameras may use film in sheet form: (Check the correct answer or answers.)
 a. Press camera.
 b. Single lens reflex, 35 mm.
 c. Twin lens reflex, 2 1/4 by 2 1/4 format.
 d. View camera.

THINGS TO DO

1. Carefully read the instruction book that came with your camera. If you do not have one, contact the manufacturer for a copy. (Be sure the manual is for your model of camera.) Learn the location, purpose, and names of the various camera parts.
2. Make a large-scale drawing of your camera and label the various parts by their correct names and what they do.
3. Practice preparing your camera for taking pictures. Learn how to program the film speed (ASA/ISO rating) into your camera. Know how to load your camera and how to remove the film after exposure.
4. Practice composing and focusing your camera. Learn how the light meter works and how to use it to take properly exposed pictures.
5. Make large-scale drawings of how an SLR camera works.
6. Make a large-scale drawing of how a TLR camera works.
7. Make a large-scale drawing showing how a view camera works.
8. Invite a camera repair technician to the class. Have her or him explain how to take care of a camera.
9. Invite the owner of a camera store to the class. Have the person explain how to select and purchase a camera.

5 BLACK AND WHITE FILM

After studying this chapter you will be able to:
☐ List the different forms in which black and white film is manufactured.
☐ Describe terms such as color sensitivity, grain, speed, contrast, density, and resolution as they relate to black and white film.
☐ Describe the makeup of film.
☐ Explain how film records images produced by reflected light.
☐ List different film speeds and relate this information to exposure control.
☐ Describe proper procedures for care and handling of film.

Photographic film is a thin sheet or strip of flexible plastic coated with a light-sensitive material called an emulsion. Film is exposed in a camera to make photographic negatives and transparencies. (A transparency positive is an image made on film.)

There are many kinds of film, Fig. 5-1. Film differs in many ways: size, mode, color sensitivity, graininess, speed, and resolution. These differences will be explained.

FILM SIZE

Film is made in many sizes, Fig. 5-2, to fit the different camera formats. Film size refers to the dimen-

Fig. 5-1. Many kinds and sizes of film are made. This is but a small portion of the stock carried by a modern photo shop.

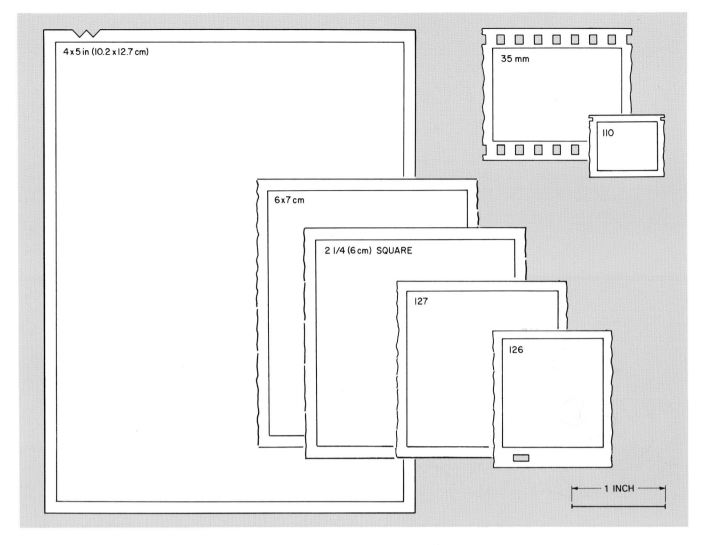

Fig. 5-2. Common film is shown in actual sizes of a single negative.

sions to which it has been cut or to the size of negative. For example, 6 × 7 cm film fits a camera which produces a negative 6 × 7 cm.

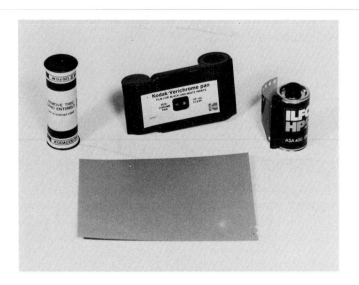

Fig. 5-3. Film is packaged as rolls (spool and canister), cartridges, and sheets.

FILM MODE

Films are packaged in three basic modes, Fig. 5-3: 1. Rolls. 2. Cartridges. 3. Sheets.

ROLL FILM

Roll film is the most common. It is contained in a light-tight canister (also known as a magazine) or on a spool with a paper backing, Fig. 5-4.

Roll and cartridge film can be bought in different lengths. Length is sometimes given as the number of exposures per roll. Film can also be purchased in BULK. These are rolls of 50 ft., 100 ft., or longer. In this form a BULK LOADER, Fig. 5-5, is necessary. This is a device that holds the bulk film roll and dispenses it into reusable canisters. More than 36 exposures of 35 mm film can be rolled into a canister.

Film is less expensive when purchased in bulk. However, bulk film should only be purchased if it is to be used within a year.

CARTRIDGE FILM

The cartridge is a light-tight plastic container. A small opening in the back of the cartridge shows how

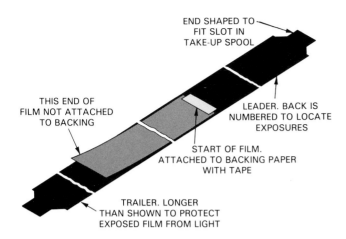

END SHAPED TO FIT SLOT IN TAKE-UP SPOOL

THIS END OF FILM NOT ATTACHED TO BACKING

LEADER. BACK IS NUMBERED TO LOCATE EXPOSURES

START OF FILM. ATTACHED TO BACKING PAPER WITH TAPE

TRAILER. LONGER THAN SHOWN TO PROTECT EXPOSED FILM FROM LIGHT

Fig. 5-4. Spooled film has a paper backing that protects the film from light.

Fig. 5-5. Bulk film loader. This device holds bulk film and dispenses it into reusable canisters. Film is less expensive if purchased this way.

many exposures have been made on the film, Fig. 5-6. A paper backing provides additional protection from light.

The film moves from one storage section of the cartridge to the other as exposures are made. The exposure is made through an opening midpoint on the

Fig. 5-6. Cartridge film camera. Number of exposures made on the film is shown through window in both cartridge and camera.

front of the cartridge, Fig. 5-7.

Cartridge type cameras are easy to load. The film cartridge drops into the camera, Fig. 5-8. No film threading is required.

SHEET FILM

Sheet film, often referred to as CUT FILM, is used primarily in large format cameras. It comes in cartons, Fig. 5-9. It must be loaded into FILM HOLDERS, Fig. 5-10, in complete darkness before it can be used.

Most sheet film has REFERENCE NOTCHES along one edge near the corner, Fig. 5-11. These

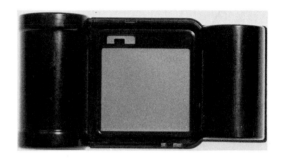

Fig. 5-7. Exposure is made through the opening in the front of the cartridge.

Fig. 5-8. Cartridge type cameras are easy to load.

Fig. 5-9. Sheet film is used primarily in large format cameras.

Fig. 5-10. Sheet film must be loaded into film holders before it can be used in a camera.

Fig. 5-11. In the darkroom, it is easy to identify the emulsion side and the type of cut film by feeling the notches.

Fig. 5-12. Graininess is the mottled or sandlike effect that can be seen when a negative is enlarged.

notches help the photographer identify type of film and the emulsion side while working in the darkroom.

COLOR SENSITIVITY

Color sensitivity is the way film responds to light of various wavelengths (color). It determines, to a large extent, the gray tones in which colored objects will be reproduced on a print. Film that is not sensitive to certain colors (red and green, for example) will reproduce these colors as tones of gray that are too dark.

Most films used in general photography are PAN-CHROMATIC. They are sensitive to all colors of visible light. Thus, panchromatic film will reproduce colors on a print as gray tones having the same degree of brightness as they appear to the human eye.

GRAININESS

Graininess is the mottled or sandlike effect that appears when a negative is enlarged, Fig. 5-12. It results from the clumping of silver grains in the emulsion.

All film has some grain but the degree of graininess depends upon the type of film used and way it is developed. Graininess increases when film is overex-

posed or underdeveloped. It also tends to increase with film speed. *As a general rule, image sharpness improves as graininess decreases.*

FILM SPEED

Film speed is a measure of a film's sensitivity to light. It affects the exposure time needed to produce a good image on a negative. FAST film is very light-sensitive. It is usually chosen to photograph dimly lit subjects and rapidly moving objects (sports photography). It is also the best choice when good depth of field is desired, Fig. 5-13.

SLOW FILM needs much more light to produce a good image than does fast film. Bright scenes or long exposures are required to produce satisfactory negatives.

ISO VALUES

Film speed (sensitivity to light) is measured in a special scale, the ISO rating. ISO stands for International Standards Organization. The ISO number is provided with almost every type of film and is very important. It must be known to calibrate your hand-held meter or the meter in your camera, Fig. 5-14. Older books, manuals, and cameras may refer to the ASA or DIN scales. ASA is identical to the ISO scale and the DIN scale was used in Europe. These scales are outdated and no longer used.

The higher the ISO number the "faster" (more light-sensitive) the film. Film rates at 400 is twice as fast as film and an ISO of 200. That is, 400 film will require only half as much exposure to produce the same negative density.

The ISO scale is designed so that doubling the

Fig. 5-13. Fast film is usually used to photograph dimly lit scenes, rapid motion, or scenes where great depth of field is needed.

Fig. 5-14. Film speed is shown on most film containers. You need the ISO rating of the film before you can calibrate your light meter. This film has an ISO rating of 400 at 27 °C.

Slow film usually has very fine grain and high resolution. It is used where extreme enlargements or fine detail are required, Fig. 5-15.

Medium speed film also has fine grain and high resolution. However, these characteristics are not quite as good as on slow film. Medium speed film is good for general photography, Fig. 5-16.

Fast film has moderate grain and lower resolution than either slow or medium speed film. Grain is still

Fig. 5-15. Slow film is characterized by its fine grain and high resolution. This type of film should be used when extreme enlargements are to be made.

number is the same as halving (cutting in half) the shutter speed or opening the aperture one stop. For example; "64 ISO = f/5.6 at 1/60 second" is the same exposure as "125 ISO = f/5.6 at 1/125 second" or "f/8 at 1/60 second."

The ISO numerical rating is determined by the manufacturer. However, the film's speed rating is only a recommendation.

FILM SPEED RANGES

There are four basic film speed ranges. Slow film has an ISO range of less than 50. The range of medium speed film is 50-125. Fast film ranges from 160-400 while ultra-fast film is any speed above 400.

adequate for 8 x 10 or 11 x 14 enlargements. Use fast film in low light or situations requiring high shutter speeds, Fig. 5-17. Its high speed also permits very small aperture settings which will provide good depth of field.

Ultra-fast film has poor grain qualities and low resolution. Some fast film can be pushed into the ultra-fast range. Ultra-fast films are used mostly for very dim lighting situations and in industrial applications where high speed is important.

No one film is ideal for all situations. Film must be chosen carefully for each job. You must experiment with different films until you get the results you desire.

Fig. 5-16. Medium speed film is suitable for general photographic work.

Fig. 5-17. Low-light action shots can usually be made with fast film.

RESOLUTION

Resolution is the ability of a film to record fine details, Fig. 5-18. Slow film can usually reproduce smaller and finer details than fast film. However, other factors can also greatly reduce the resolving power of film.
1. Quality of the lens used.
2. Overexposing the film.
3. Underexposing the film.

The DATA SHEET furnished with most film will indicate its resolving power. See Fig. 5-19.

HOW BLACK AND WHITE FILM IS MADE

Film properly exposed and developed produces a negative on which the light values of the subject

Fig. 5-18. Resolution is the ability of a film to record fine details.

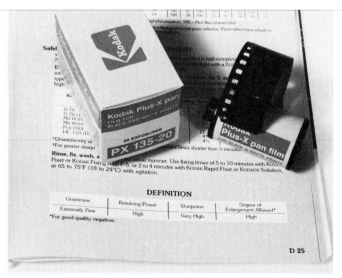

Fig. 5-19. The data sheet furnished with the film or a film data handbook will show the film's resolving power.

photographed are reversed. That is, light areas on the subject appear dark on the negative while dark areas of the subject will appear light or clear.

To produce a good negative, film must be sensitive to the light that strikes it during exposure. Silver halides are the most commonly used light-sensitive material.

Film, while simple in appearance, is a complex product, Fig. 5-20. It is composed of five layers:
1. The supercoat.
2. The emulsion.
3. Acetate base.
4. Antihalation layer.
5. Anticurl layer.

EMULSION

The emulsion is made up of silver halides such as silver bromide, silver iodide, and silver chloride. They are suspended in a gelatin solution. The emulsion is spread onto a transparent plastic base. While holding the silver halides evenly suspended, the gelatin increases the light sensitivity of the emulsion.

Gelatin is used because it is porous. It allows the processing liquids to enter and develop the exposed emulsion.

A thin supercoat is added. It protects the emulsion.

BASE AND ANTIHALATION LAYERS

The base is the plastic sheet or strip on which the emulsion is spread. It gives the film strength and shape.

The antihalation layer stops light from being reflected back into the emulsion from the rear surface on the base, Fig. 5-21. Light reflection would cause a halo around the image of a bright subject.

This layer gives unexposed film its gray appearance. It is washed away during processing.

ANTICURL LAYER

The emulsion expands slightly during processing. It shrinks as it dries and tends to curl the film badly.

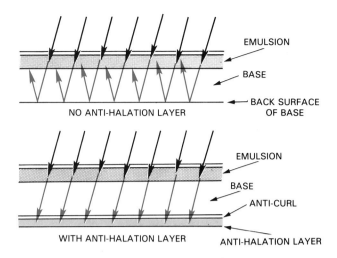

Fig. 5-21. The antihalation layer prevents light from being reflected back to the emulsion from the rear surface of the film base.

The anticurl layer works against this action. Without this layer, the developed film would not lie flat for printing.

HOW FILM WORKS

Film reacts when light strikes some of the tiny silver halide crystals during exposure. (There are many

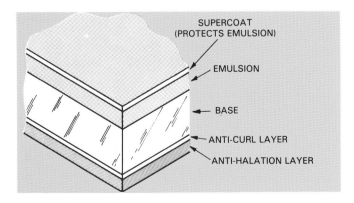

Fig. 5-20. Film is a complex product as can be seen from this cross-section of a typical film.

Fig. 5-22. A high contrast negative produces a print that does not have a good range of intermediate (gray) tones.

Fig. 5-23. This print was made from a low contrast negative.

Fig. 5-24. Contrast can be used for effect. This picture uses low contrast to get the required effect of a hazy day on the beach.

Fig. 5-25. High contrast in this print causes the bare, dead tree to stand out against the background.

Fig. 5-26. The film used to photograph this scene accurately recorded the wide range of subject brightness.

Fig. 5-27. Exposure latitude of a film is the amount you can overexpose or underexpose and still have a usable negative. How many negatives in the proof shown above do you think are capable of producing an acceptable print?

millions of crystals in each square centimeter of film.) When exposed to light, an important change is brought about within the chemical structure of the silver halide crystal.

However, there is no visible change. The LATENT (unseen) image must be brought out by developing agents. The developer converts the "changed" silver halide crystals into black metallic silver which can be seen. The more light that reaches the emulsion, the more crystals are affected.

This is the reason a negative is the reverse of the subject. Light areas of the subject reflect more light back to the film. Many silver halide crystals are affected. These produce the dark areas on the negative.

Dark areas on the subject absorb most of the light and reflect little or no light back to the film. Few, if any, silver crystals are changed. These areas remain relatively clear on the negative.

Negatives are not composed of strictly black and clear areas. A negative has many different tones. They range from almost clear areas to completely dark areas. The resulting print will be the exact reverse of the negative.

DENSITY AND CONTRAST

A negative has density and contrast. The amount of metallic silver deposited on the negative determines the density. Density describes the light-transmitting qualities of a negative. Film with many dark areas is considered a dense negative.

Contrast is the difference in densities of various areas of a negative. A high contrast negative does not have a good range of intermediate tones, Fig. 5-22. It has only areas of high and low densities. A lot contrast negative has only a small range of densities. See Fig. 5-23.

Density depends upon the kind of film used and the amount of light striking the film. Contrast is determined by the kind of film used and the contrast in the subject. Density and contrast can be altered in the developing process.

Moderate density is preferred in a negative. A high-density negative loses detail and is grainy. A low-

density negative has less detail and is difficult to print because of a lack of contrast.

Contrast can be used for effect. Some "mood" pictures use low contrast to get the required results, Fig. 5-24. High contrast can provide a stark (bare) impression, Fig. 5-25 or produce a scene in silhouette. However, moderate contrast is best for most photography.

LATITUDE

Latitude is the ability of the film to record a broad range of differences in subject brightness. A film which can reproduce a broad range of subject brightness, Fig. 5-26, is said to have "wide" latitude.

EXPOSURE latitude is the amount of overexposure or underexposure a film can stand and still produce an acceptable image. See Fig. 5-27.

EXPOSURE CONTROL

In photographic terms, exposure is the amount of light allowed to fall on the film. The intensity of the light entering the camera is determined by the aperture setting. Shutter speed controls the length of time the light is allowed to enter the camera.

In other words, a light of high intensity acting for a short period of time will produce the same photographic effect on film as a light of lesser intensity acting for a longer time.

This exposure relationship is known as the LAW OF RECIPROCITY. The following exposures will allow the same amount of light to reach the film and produce negatives of the same intensity:
1. 1/500 second at f/5.6.
2. 1/250 second at f/8.
3. 1/125 second at f/11.
4. 1/60 second at f/16.
5. 1/30 second at f/22.

These exposure settings are also said to have the same EXPOSURE VALUES (EV).

An understanding of this exposure relationship gives the photographer better control over picture-taking situations. For example, under identical

lighting conditions, the camera settings just listed provide a photo-taking range from stopping action to a greatly increased depth of field. In other words, to "shoot" an athlete "making a basket" you would probably set your shutter at 1/500 sec. and the aperture at f/5.6. To photograph a scene that extends all the way from 10 ft. to 30 ft. beyond the camera, you would need to use a much slower shutter speed and a much smaller aperture setting.

RECIPROCITY FAILURE

Unfortunately, film does not follow the Law of Reciprocity for extremely long and short exposures. This problem is called RECIPROCITY FAILURE. It occurs because the emulsion is at its greatest efficiency in the normal exposure range. Efficiency of all film decreases during either long or short exposures. The FILM DATA SHEET, Fig. 5-28, will give information on how to compensate for the problem.

KODAK PLUS-X PAN FILM

35 mm and Wider in Long Rolls

● Medium-speed panchromatic film with extremely fine grain and high resolving power ● Medium contrast, wide exposure latitude ● Excellent sharpness in enlargements.

Safelight: Handle and process the film in total darkness. After development is half completed, you can use a KODAK Safelight Filter No. 3 (dark green), or equivalent, in a suitable safelight lamp with a 15-watt bulb for a <u>few seconds only</u>. Keep the safelight at least 4 feet from the film.

Reciprocity Effect Adjustments:

If Indicated Exposure Time Is (seconds)	Use Either		And, in Either Case, Use This Development Adjustment
	This Lens Aperture Adjustment	Or — This Adjusted Exposure Time (seconds)	
1/1000	none	no adjustment	10% more
1/100	none	no adjustment	none
1/10	none	no adjustment	none
1	1 stop more	2	10% less
10	2 stops more	50	20% less
100	3 stops more	1200	30% less

Fig. 5-28. When in doubt about reciprocity failure refer to the data sheet for the film being used. (Eastman Kodak Co.)

CHROMOGENIC FILM

Several manufacturers are producing a film called "chromogenic" black and white. It uses color technology to produce a dye image negative. After processing, little silver remains in the emulsion.

The film has two light-sensitive emulsion layers. One is slow, the other fast. This gives the film a very broad exposure latitude. (This means photos can be taken under greatly different lighting conditions.) High quality negatives with almost grain-free images

can be made even where high speed, low-light conditions are found.

Chromogenic film can be rated upward to ISO 1600 for available light photography, Fig. 5-29. It can also be overexposed at ISO 200 for even finer grain development, Fig. 5-30. These exposures can be made on the same roll of film.

Fig. 5-29. Print from chromogenic negative shot at 800 ISO. Greatly enlarged print did not show the film's grain structure as it would have if conventional film has been used.

Fig. 5-30. View of the Inner Harbor, Baltimore, Maryland. This photo was taken on the same roll of film as Fig. 5-29. This negative was exposed at ISO 200.

INSTANT FILM

Instant films can produce prints or transparencies within seconds of taking the photograph, Fig. 5-31. These types of film come in packets, sheets, and rolls.

Sheet film must be loaded into a special holder fitted to a conventional camera, Fig. 5-32. However, instant film cannot be used with most regular cameras.

The film is made up of a positive receiving paper and a negative sheet. The two materials are kept separated until after exposure to light, Fig. 5-33. Developer is stored in a pod between the negative emulsion and the positive receiving paper.

After exposure, the two sheets are pulled through the rollers which release the developer and spread it evenly between the emulsion and paper, Fig. 5-34. The negative is developed. An emulsion solvent causes the transfer of silver from unexposed areas of the negative to the positive receiving paper. A positive image forms on the sheet.

One type of instant film produces both a print and a usable negative. The negative must be washed in sodium sulfate to clear the chemical residue. This film has a fine grain and can produce high quality enlargements.

For best results, especially in very cold weather, follow the instructions on the film's data sheet.

SPECIAL FILMS

Most black and white film used today is negative panchromatic film. There are other types of film that

Fig. 5-31. Instant film yields a print within seconds of taking the picture. (Polaroid Co.)

Fig. 5-32. Instant film must be loaded into a special holder for use in a conventional camera.

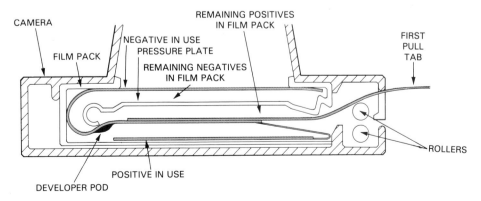

Fig. 5-33. Instant film consists of both a positive receiving paper and a negative sheet. The two materials remain separated until after exposure. Developer is stored in a pod between the negative emulsion and positive receiving paper.

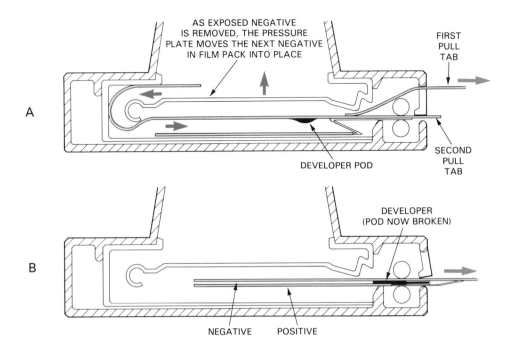

Fig. 5-34. After exposure, the two sheets are pulled through rollers which spread the developer between the emulsion and paper. Some black and white instant film must be coated with the film. This makes the image permanent. A—Before sheets are pulled through the developing rollers. B—Sheets being pulled through rollers.

can be used for special applications. They are:

1. Reversal film which makes a positive black and white transparency. The positive is like a negative except that the blacks and white are reversed. It must be viewed in a projector to get the black and white effect.

2. Copy film. It is used to photograph line drawings and printed material. It produces negatives with dense blacks and clear areas.

3. Infrared film which is sensitive to part of the infrared light spectrum plus some of the visible light spectrum. It can be used to photograph objects in darkness (animals and security purposes) when used with an infrared light source.

CARE AND HANDLING OF FILM

Unprocessed film can be damaged by high temperatures, high humidity, and light. It can also be fogged by the x-ray machines airports use to check luggage. To assure permanence, processed film must be handled and stored properly.

UNPROCESSED FILM

Light, of course, will fog unprocessed film. Avoid loading and unloading a camera in bright sunlight. The same precaution applies when changing lenses.

Heat destroys film. Never leave it in a camera in the glove compartment of a car or in bright sunlight. Store film in a cool, dry place. Transport it in an insulated container.

Film is dated for greatest effectiveness. The expira-

tion date is printed on the film container, Fig. 5-35. Time changes film speed and overall image quality.

Protect film from humidity. Do not remove the film from its foil pouch or sealed container until it is ready to be used. After exposure, seal it in a plastic bag with all of the air squeezed out. Have film processed as soon after exposure as possible. Do not leave film in the camera for extended periods of time.

If refrigerated at 55°F (13°C) or lower, film can be stored for long periods. Film kept in this way should remain in the original foil pouch or container. This will protect it from condensation after it is removed

Fig. 5-35. Film is dated to assure negative quality.

from cold storage. Allow film to reach room temperature (about 1 1/2 hours) before opening package.

PROCESSED FILM

Keep processed negatives clean and free from dust. Handle film only by the edges, Fig. 5-36. Never store negatives in paper envelopes. Chemicals used in papermaking can damage the film's emulsion.

Store negatives in a cool, dry place. Number the negative envelopes and record the image on them so you can find them easily when prints are to be made.

WORDS TO KNOW

Antihalation layer, chromogenic film, color sensitivity, contrast, data sheet, density, emulsion, fast film, film speed, graininess, halides, infrared film, latent, latitude, panchromatic, resolution, reversal film, slow film, transparency, ultra-fast film.

TEST YOUR KNOWLEDGE — CHAPTER 5

1. What is photographic film?
2. Film is available in three basic modes. List them.
3. The color sensitivity of a black and white film refers to the way the film: (Check the correct answer or answers.)
 a. Will reproduce colors as gray tones on a print.
 b. Responds to light of various wavelengths (colors).
 c. Reproduces gray tones on a print that are too dark.
 d. All of the above.
 e. None of the above.
4. Panchromatic films are _____.
5. Film graininess refers to the: (Check the correct answer or answers.)
 a. Dust spots on the film.
 b. Sandlike effect that often appears when a negative is enlarged.
 c. Clumping of silver grains on a processed negative.
 d. All of the above.
 e. None of the above.
6. Graininess tends to increase with _____.
7. Film speed is a measure of _____.
8. Resolution is the ability of a film to_____ _____.
9. To produce a negative, film must be _____.
10. Make a sketch showing a cross section of film. Label the various parts.
11. Why is an antihalation layer used on film?

Fig. 5-36. Handle film only by the edges. Store negatives in plastic or glassine envelopes made especially for this purpose.

12. Describe the following characteristics of a negative.
 a. Density.
 b. Contrast.
 c. Exposure latitude.
13. Explain how black and white film works.
14. List two shutter speed/aperture combinations with the same exposure value as 1/125 second at f-5.6.
15. How is the ISO RATING of a film useful?
16. Unprocessed film can be damaged by: (Check the correct answer or answers.)
 a. Heat.
 b. Humidity.
 c. X-rays.
 d. All of the above.
 e. None of the above.

THINGS TO DO

1. Secure information on the various types of black and white films. Prepare a brief summary on the characteristics of each film. Duplicate your summary for your fellow students.
2. Demonstrate how to load reusable canisters with bulk film.
3. Shoot several rolls of film with 32, 125, and 400 ISO ratings. Develop each roll as recommended on the data sheet. Make enlargements and make a comparison of graininess. Prepare a report on what you find.
4. Make a black and white positive transparency.
5. Expose a roll of infrared film with and without the recommended filter. Describe the results.

Most modern cameras are designed for simple operation with few controls. For consistent results, however, the beginning photographer must master some basic skills such as proper techniques for holding the camera, framing the subject and releasing the shutter. Top. Disc camera requires the user to make no settings. Bottom. A modern 35 mm. It may require many or few decisions of the photographer, depending on the mode of operation chosen.
(Eastman Kodak Co., Olympus Corp.)

6 HOW TO USE A CAMERA

After studying this chapter you will be able to:
- ☐ Load and remove film from the camera.
- ☐ Hold the camera and operate the shutter without movement.
- ☐ Focus the camera using rangefinder and through-the-lens focusing systems accurately.
- ☐ Use the metering system accurately.
- ☐ Compose and frame the scene or subject being photographed.

A good photographer must be part technician and part artist. To produce striking pictures, he or she needs to:
1. Understand how the equipment works so it can be used to best advantage, Fig. 6-1.
2. Be able to spot, compose, and record events that make interesting pictures, Fig. 6-2.

LOADING AND REMOVING FILM

Film is loaded and removed in different ways depending upon the type of camera. Emulsion side (dull surface) of film is always toward the shutter.

Fig. 6-2. A good photographer must be able to spot, compose, and record events that make interesting pictures.

Fig. 6-1. To consistently produce striking pictures you must know how to use your equipment to best advantage. (Bell & Howell - Mamiya Co.)

67

Never load a camera in bright sunlight. There is danger of light leaking onto film.

LOADING CARTRIDGE FILM

Cameras using cartridge film are easiest to load, Fig. 6-3. Insert the cartridge into the opened camera and close the back. Advance the film until the number "1" appears in the film counter window, Fig. 6-4. The camera is ready for taking pictures.

CAMERAS USING ROLL FILM

Twin lens reflex (TLR) cameras, some SLR (single lens reflex) and some simple cameras use paper-backed roll film. The film unwinds from its spool to a take-up spool, Fig. 6-5. It will be removed from the camera on the take-up spool.

To load, move the spool left in the camera to the take-up position. (This is the empty supply spool from the last roll of film used.) Place a new film roll in the film chamber, Fig. 6-6. Lock the spool ends in place. The spool should rotate freely.

Unwind the paper leader (the first part of the backing paper). Insert the tapered end into the take-up spool, Fig. 6-7. Better cameras are fitted with polished guide rails and a back pressure plate. They keep the film flat during exposure.

Advance the film enough to be sure the film transport system operates properly. At this point, what is done next depends on the camera being used. On many cameras, the back must be closed and the film advanced until a number "one" appears on the film counter window or on the counter.

Several other cameras load differently. The film is advanced until arrows on the paper backing align

Fig. 6-3. A quick loading camera. Cartridge is simply dropped into place and the camera back closed. No film threading is necessary.

Fig. 6-4. Advance the film until the first number appears in the film counter window.

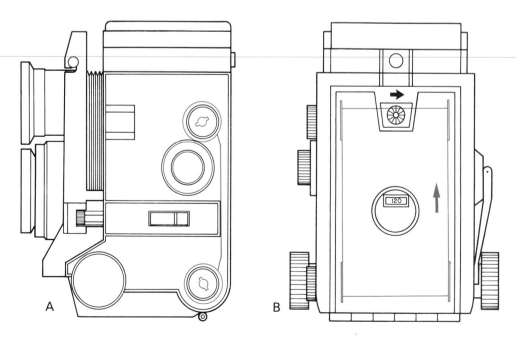

Fig. 6-5. Roll film is used in TLR, some SLR, and simple cameras. A—Side view of film properly attached in TLR camera. B—Back view of paper backing attached to take-up spool.

68

with start marks on the camera body. See Fig. 6-8. Then the back is closed and the film advance lever is rotated until it stops. The film counter should show that the film is in position for the first exposure.

After the last exposure, the film is advanced until all of the paper backing is on the take-up spool. It can now be removed from the camera. The paper backing still protects the film from light, Fig. 6-9.

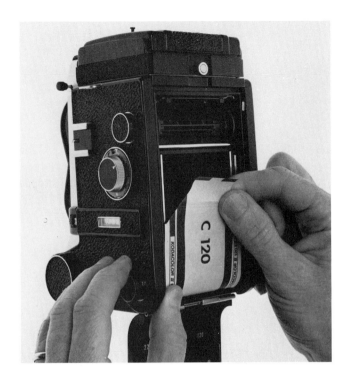

Fig. 6-6. Set the film spool in the film chamber. Be sure the emulsion side of the film will face the lens. Unwind enough paper leader to reach the empty take-up spool.

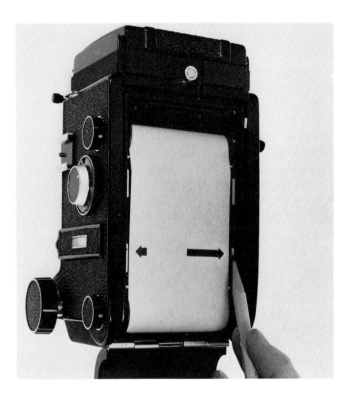

Fig. 6-8. Advance the film until arrows on the paper backing align with start marks on the camera.

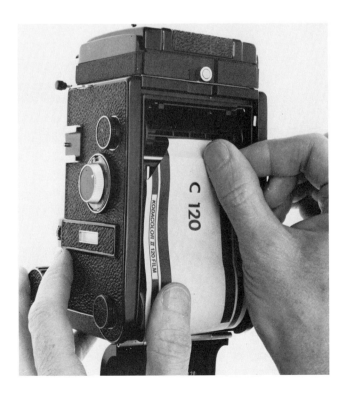

Fig. 6-7. Insert the tail of the paper leader into the slot of the take-up spool.

Fig. 6-9. Film has been advanced until all of the paper backing is wound onto the take-up spool. It is ready to be removed.

CAMERAS USING FILM MAGAZINES/CANISTERS

All 35 mm single lens reflex (SLR) and rangefinder cameras use film held in magazines/canisters, Fig. 6-10. The take-up spools of these cameras are built in. They cannot be removed. The exposed film must be rewound into the canister. Place the canister in the film chamber. Lock it into place by depressing the rewind crank.

Extend the film leader along the guide rails and insert the end into a slot in the take-up spool, Fig. 6-11. Film perforations must engage the film sprocket roller, Fig. 6-12. Advance the film and check for binding. Rotate the rewind crank until all slack is removed from the film. Close the camera back. Advance the film until the film counter indicates that the film is ready for the first exposure.

REMOVING FILM

To remove exposed film, first depress the rewind clutch button, Fig. 6-13. The button keeps the film from moving in the wrong direction. Turn the rewind

Fig. 6-12. Film perforations must engage the film sprocket roller (shown by arrows).

— INFORMATION PANEL

Fig. 6-10. SLR and rangefinder cameras use film contained in a magazine/canister. (Eastman Kodak Co.)

Fig. 6-13. Exposed film must be rewound into the canister before it can be removed from the camera. Rewind clutch button (arrow) must be depressed before rewinding.

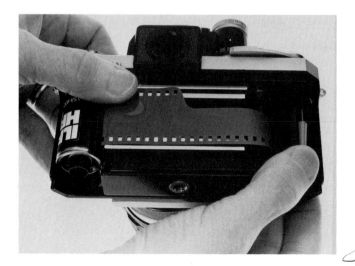

Fig. 6-11. Extend the film leader along the guide rails and insert it in the slot of the take-up spool.

crank until all of the film is rewound into the canister. This is indicated when the crank turns easier. Open the camera back. Pull up the rewind knob to free the canister. Remove the film.

CAMERAS USING SHEET FILM

View cameras and some press cameras use sheet film. The film is loaded into special film holders in complete darkness. The film holders fit into a slot in the camera back.

A metal or plastic slide protects the film from light.

A flange on the slide has one bright side and one dark side, Fig. 6-14. When the bright side faces outward it indicates the film is ready for exposure. After exposure of the film the bright side should face inward. This reduces chance of making a double exposure.

To make the exposure, focus the camera and cock the shutter. Remove the slide from the holder, Fig. 6-15. Make the exposure. Replace the slide with dark side of the flange facing the lens. Only then may you remove the holder from the camera. *The film must be removed from the holder in complete darkness.*

HOLDING THE CAMERA

Hold the camera so that it is well supported. Blurred or "fuzzy" pictures will result from camera movement or vibration. Fig. 6-16 shows the result of camera movement. It becomes more apparent as the

Fig. 6-16. A "fuzzy" picture will result if the camera moves while the exposure is made.

Fig. 6-14. Holder for sheet film holds two pieces of film. Flange on each of slides has one bright side and one dark side.

Fig. 6-15. Film holder fits into back of view camera. After holder is locked into place, forward slide is removed. After the exposure is made the slide is replaced dark side out.

shutter speed decreases. Telephoto and close-up lenses also emphasize camera movement.

Most people can take sharp pictures with a normal lens down to speeds of 1/30 second. Below this speed, body movement of which you may not be aware will cause blurring. Since telephoto and close-up lenses exaggerate movement, they require a higher shutter speed for hand-held use. A good rule of thumb is to use a shutter speed equal to the inverse (turned upside-down) of the lens' focal length. For example:
1. A 135 mm lens should not be used at less than 1/135 sec. (1/125 sec.).
2. A 500 mm lens should not be used at less than 1/500 sec.

Some photographers are able to hold a camera steadier than others. You should experiment to learn the slowest shutter speed you can use and still get good pictures.

USING A TRIPOD

When there is not enough light to use at least a 1/30 sec. shutter speed, or for close-up photography, a tripod may be required. Be sure it is strong enough for the work to be done.

OTHER CAMERA SUPPORTS

Other camera supports can be used if there is no tripod. Tables, chairs, fences, and even the floor can be used, Fig. 6-17.

HOW TO HAND HOLD A CAMERA

To hand hold a simple camera, wrap both hands around the camera sides. Use the right-hand index finger to press the shutter release button.

71

Fig. 6-17. Any suitable support can be used when lighting conditions are poor and require a slow shutter speed.

SLR and rangefinder cameras are held by wrapping the right hand around the camera body, Fig. 6-18. The index finger rests on the shutter release button. The thumb rests on the film advance lever. Cradle the camera body with the left hand. The thumb and index finger should remain free to rotate the aperture and focusing rings. Holding the camera in this manner permits the use of all primary controls without moving your eye away from the viewfinder.

TLR cameras are usually held at chest level. The focusing screen can then be easily seen from above. A neck strap will give added support. Both hands cradle the bottom and sides of the camera. The right thumb rests on the shutter release. Focusing is done with the left hand. View cameras, because of size and weight, must be mounted on a tripod, Fig. 6-19.

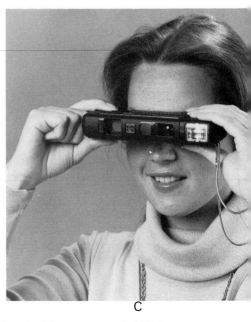

A B C

Fig. 6-18. Hand holding a camera must be done properly to reduce camera motion. A—Proper way to hold 35 mm SLR and rangefinder cameras. B—Recommended way to hold a larger format SLR camera. (Bell & Howell-Mamiya Co.) C—Taking a picture with a 110 camera. (Eastman Kodak Co.)

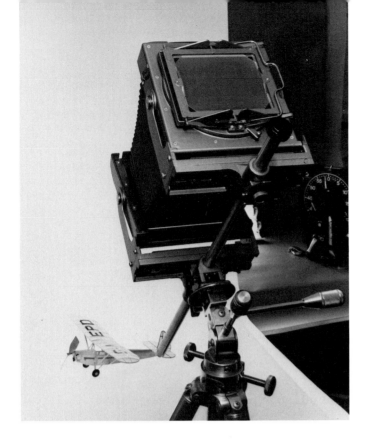

Fig. 6-19. View cameras are too heavy to be hand held. They must be supported on a tripod.

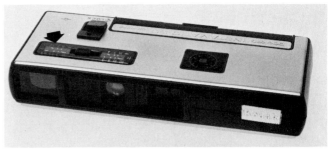

Fig. 6-20. Arrow points to slide focusing system. Distance scale is in feet and metres. (Eastman Kodak Co.)

Fig. 6-21. Ground glass viewing screen is used for focusing view camera.

USING THE SHUTTER RELEASE

Depressing the shutter release correctly is just as important as holding the camera properly. The shutter release should be depressed in a smooth, even manner. A quick "jab" on the release usually results in camera movement and a blurred picture.

FOCUSING THE CAMERA

Proper focusing is required for sharp pictures. Cameras with preset lenses have no adjustment for focusing. They should not be used to photograph an object that is closer than six ft. (2 m). Objects in this distance will be out of focus. A close-up lens is available for some simple cameras. It slips over the regular lens.

Cameras with focus range settings or zones are the simplest of the focusing cameras. There are three or four focusing zones to which the lens can be set. The distance from camera to subject must be estimated or measured. The lens zone for this distance is used.

In cameras having a slide bar focusing system, Fig. 6-20, the subject-to-camera distance must be estimated or measured. The lens is focused by moving the bar on the camera-to-subject distance.

Cameras with complex focusing systems use several methods for accurate focusing. Rangefinder cameras use a superimposed image (one on top of the other) focusing system. SLR and TLR cameras have focusing screens with various aids. View cameras have a ground glass viewing screen, Fig. 6-21.

SUPERIMPOSED IMAGE FOCUSING

The superimposed image focusing system shows two images of the subject in the camera viewfinder. The lens focusing ring is turned until the two images become one image, Fig. 6-22. The subject is then in focus.

FOCUSING SCREEN SYSTEM

SLR and TLR cameras are fitted with ground glass focusing screens. A mirror projects the image coming through the lens onto the focusing screen. Focusing is done by rotating the lens focusing ring. To assist in focusing, many focusing screens have built-in aids. These aids are of two basic types:
1. Split-image spot.
2. Microprism.
The two are sometimes combined on the same focusing screen.

A split-image spot breaks the image into two parts that do not match up, Fig. 6-23, when the image is out of focus. The lens focusing ring is rotated until the two images come together to form a single image. See Fig. 6-24.

NOT FOCUSED

FOCUSED

Fig. 6-22. Superimposed image focusing system displays two images of the subject in the viewfinder when the lens is not focused properly. The lens focusing ring is rotated until the two images become one.

A microprism aid appears as a small circle in the center of the screen. The image is dark and blurred when out of focus, Fig. 6-25. To focus, rotate the lens focusing ring until the image suddenly appears in sharp outline, Fig. 6-26.

Split-image spot aids are best for very precise focusing. Microprisms are easiest to use with action photography. Both are suitable for general photography.

Lenses with a maximum aperture of less than f/5.6 may cause a focusing aid to black out and be useless. Too little light is reaching the screen. If this occurs, use the outer ground glass part of the screen to focus.

NOT IN FOCUS

Fig. 6-23. A split-image spot in the center of the viewing screen breaks a portion of the image into two nonmatching parts until the lens is properly focused.

NOT IN FOCUS

Fig. 6-25. A microprism is dark and blurred until the lens is properly focused.

FOCUSED

Fig. 6-24. The subject is in focus when the images in the spot match and form a single image.

FOCUSED

Fig. 6-26. To focus using a microprism aid, rotate the lens focusing ring until the image is in sharp outline.

FOCUS BY ESTIMATING DISTANCE

You can focus SLR, TLR, and rangefinder cameras by estimating camera-to-subject distance. First, locate the estimated distance on the distance scale engraved on the lens focusing ring, Fig. 6-27. The lens focusing ring is rotated until the distance matches the same distance scale mark engraved on the lens barrel. This focusing technique is employed when the viewfinder cannot be used.

A different method of focusing must be used with infrared film. You must follow these steps:
1. Focus the subject normally.
2. Find subject-to-camera distance on the subject distance scale.
3. Align the distance with the infrared focusing mark engraved on the lens barrel, Fig. 6-28. *This is the only way a lens can be accurately focused for infrared film.*

DEPTH OF FIELD

Depth of field is the distance between the nearest and farthest object in a scene that appears in acceptably sharp focus. Depth of field can be controlled by:
1. Focal length of lens. The shorter the distance from the lens to the film, the greater the depth of field, Fig. 6-29.
2. F-number. Depth of field is increased as lens aperture becomes smaller, Fig. 6-30.
3. Distance of object to the lens. Depth of field increases the farther away the subject is from the camera, Fig. 6-31.

Most lenses have scales for these three factors. You should know how to use these scales to increase or decrease depth of field. See Fig. 6-32 for examples of large and shallow depth of field settings.

The scale to show depth of field is used in the following way:
1. Suppose the camera is focused on a subject 5 ft. (1.5 m) away.

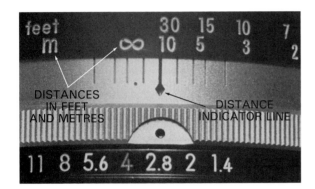

Fig. 6-27. Lenses on many cameras can also be focused by measuring or estimating the distance from subject to camera. The lens focusing ring is then rotated until the required distance to subject is matched on the distance scale engraved on the lens focusing ring.

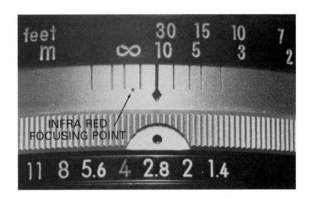

Fig. 6-28. Focusing mark for infrared film. Distance is aligned with this mark.

	5 FT (1.5 m)	10 FT (3.0 m)	15 FT (4.5 m)	20 FT (6.0 m)	25 FT (7.5 m)	30 FT (9.0 m)	35 FT (10.5 m)	40 FT (12.0 m)	INFINITY
28 mm									
50 mm									
135 mm									

Fig. 6-29. The shorter the focal length of a lens, the greater the depth of field.

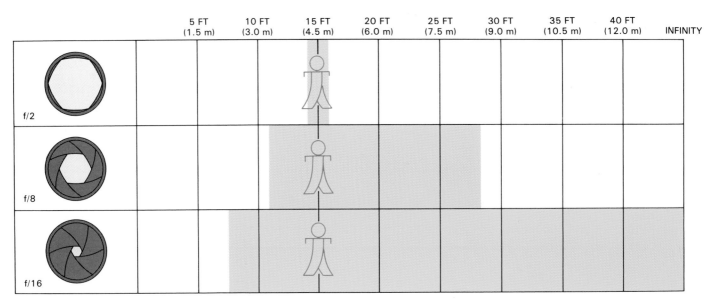

Fig. 6-30. Depth of field becomes greater as lens aperture is stopped down.

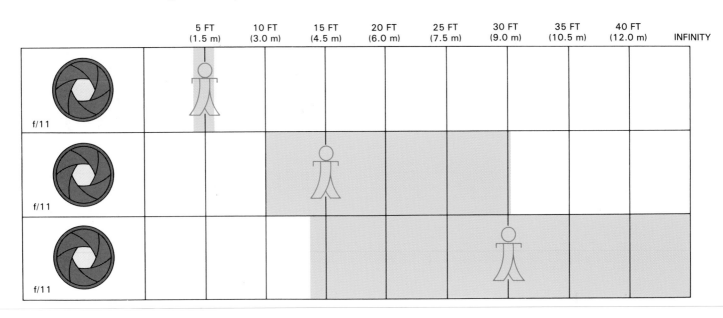

Fig. 6-31. Depth of field increases as the distance between the subject and camera increases.

2. The lens aperture is set for the proper exposure, in this case f/8.
3. The center and upper scale show that the depth of field will be from 4 1/2 ft. (1.4 m) to about 6 ft. (1.8 m), Fig. 6-33. Everything within this distance will be in focus.

Now, suppose that in the picture-taking situation just described, there is an object at 7 ft. which you wish to bring into focus. The quickest way is to choose a smaller f-stop and a slower shutter speed. This will increase the depth of field while giving the film the same exposure.

At times you may want background to be indistinct. Then you will deliberately cause it to be out of focus. See Fig. 6-34.

Many cameras have a depth of field preview con-

trol, Fig. 6-35. This permits the photographer to check the depth of field before taking the picture. Most modern lenses also have a depth of field scale incorporated with the distance scale engraved on the lens barrel.

METERING

It is important that negatives be uniformly exposed to reproduce the full range of tones of the subjects. To expose negatives properly, the amount of light reaching the film must be known. A LIGHT METER, also known as an EXPOSURE METER, Fig. 6-36, is used to measure this light.

If you have no light meter, the film data sheet will suggest aperture/shutter speed combinations for

Fig. 6-32. Depth of field is the nearest and farthest distances that will be in focus on a photograph. Left. Taken at f/22. Note the great depth of field. Right. This photo was taken at f/2.5. The depth of field is quite shallow.

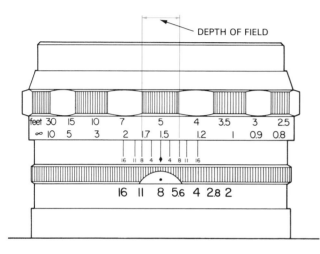

Fig. 6-33. Depth of field scale (center) is read against focusing scale (top). The distance between the nearest point and the farthest point of acceptable focus is indicated by arrows.

Fig. 6-35. Depth of field preview control permits photographer to check depth of field before making exposure.

Fig. 6-36. An exposure meter. It measures the amount of light falling on (or reflected from) the subject.

Fig. 6-34. Depth of field in this picture was reduced to emphasize the main subject.

many lighting conditions, Fig. 6-37. Use this information. Never try to guess the proper exposure settings.

HOW AN EXPOSURE METER WORKS

Exposure meters are either the hand-held type or they are built into the camera, Fig. 6-38. Basically, both work the same way.

An exposure meter has a sensor or cell that measures the light reflected from or falling on the subject. However, just knowing the amount of light is not enough. By itself, this information is incomplete. It must be programmed (set) with the film speed before it can be used to help select the exposure settings.

When light strikes the sensor, an electric current flows through the meter's circuitry. The more intense the light, the greater the current flow. Current moves a needle across a scale on the face of the meter, Fig. 6-39. The stronger the light, the further the needle moves across the scale. Using an exposure calculator that is part of the meter, the current flow (needle movement) can be turned into information that will tell you the aperture/shutter speed combinations that will give you a properly exposed picture.

Some exposure meters use selenium sensors. They are able to change light into an electric current. No

KODAK TRI-X PAN FILM

35 mm and 70 mm Films in Rolls

• Fast, panchromatic film • Ideal for all types of black-and-white photography where sharp images, high speed, and fine grain are required.

Safelight: Handle and process the film in total darkness. After development is half completed, a KODAK Safelight Filter, No. 3 (dark green), or equivalent, in a suitable safelight lamp with a 15-watt bulb can be used for a few seconds only. Keep the safelight at least 4 feet from the film.

EXPOSURE

Speed: ASA—400

This number is for use with meters and cameras marked for ASA speeds, in either daylight or artificial light. It will normally lead to approximately the minimum exposure required to produce negatives of highest quality.

If, with normal development, your negatives are consistently too thin, increase exposure by using a lower number; if too dense, reduce exposure by using a higher number.

Outdoor Exposure Guide for Average Subjects:

Set Shutter at 1/200 or 1/250 Second				
Bright or Hazy Sun on Light Sand or Snow	Bright or Hazy Sun (Distinct Shadows)	Weak, Hazy Sun (Soft Shadows)	Cloudy Bright (No Shadows)	Open Shade† or Heavy Overcast
f/32	f/22*	f/16	f/11	f/8

*f/11 for backlighted close-up subjects.
†Subject shaded from sun but lighted by a large area of sky.

Filter Factors: Multiply normal exposure by filter factor given below:

KODAK WRATTEN Filters	No. 6	No. 8	No. 11	No. 15	No. 25	Polarizing Screen
Daylight	1.5	2*	4	2.5	8	2.5
Tungsten	1.5	1.5	3*	1.5	5	2.5

*For gray-tone rendering of colors approximating their visual brightness.

Fig. 6-37. Film data sheet, packaged with most film, will provide aperture/shutter speed combinations for many lighting conditions. (Eastman Kodak Co.)

Fig. 6-39. When light strikes the sensor(s) of the light meter it causes an electric current to flow. Current flow moves a needle (see arrow) on the meter's face to indicate intensity of light.

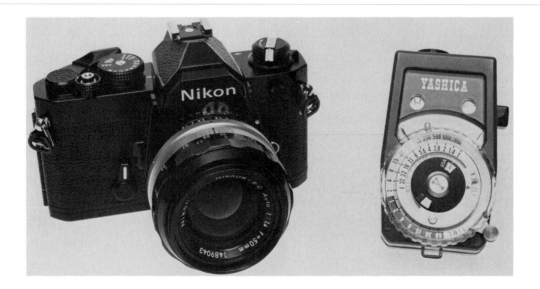

Fig. 6-38. Camera at left has light meter built into it. Hand-held meter, right, can be used to set exposure on any camera.

batteries are needed with this type of sensor. However, selenium is not very sensitive to light.

Most meters use cadmium sulfide (CdS) or silicon (Si) sensors. While being more sensitive to light, they do not generate an electric current. They require a battery.

Light striking these sensors reduces their electrical resistance. This allows more current to flow from the battery through the circuitry. Flow is measured by the meter and is used to supply the information needed to set your camera.

CdS or Si meters will not work if the battery is in poor condition. Therefore, it is important that the battery be checked often. It is also recommended that it be replaced at least once a year, more often if the meter is used a great deal.

HAND-HELD METERS

Hand-held exposure meters are of two types:
1. Reflected light exposure meter.
2. Incident light exposure meter.

Many hand-held meters have attachments that permit the meter to be converted from one type to the other.

Reflected light exposure meters measure the light REFLECTED from the subject to the meter, Fig. 6-40. Incident light exposure meters measure light FALLING ON the subject, Fig. 6-41.

Reflected light exposure meters are pointed at the subject, Fig. 6-42. Incident light exposure meters must be held near the subject and pointed at either the camera or light source, Fig. 6-43.

Reflected light exposure meters work well with most subjects. However, they can give inaccurate readings when used on extremely light or dark subjects. On such subjects, incident light exposure meters are more accurate though some photographers find them more difficult to use.

Fig. 6-41. Incident light meters measure light falling on the subject.

Fig. 6-42. Reflected light meters are pointed at the subject from the same direction as the camera.

Fig. 6-40. Reflected light meters measure the light reflected from the subject.

Fig. 6-43. Incident light meters must be held near the subject. They must be pointed at either the camera or light source.

USING A HAND-HELD METER

To use a hand-held meter, set the film speed rating on the meter as shown in Fig. 6-44. This step is very important for proper exposure of the film. The rating is furnished with the film.

Point the meter at the photographic subject. Turn on the meter. This will cause the exposure indicator needle to move to some spot on the scale. When it stops, move the guide needle to the same position. (See large arrow.) This is done by rotating the exposure index ring, Fig. 6-45.

Fig. 6-44. Programming (dialing) the film speed into the meter.

Fig. 6-45. Turn the reflected light meter on and point it at the subject. The exposure indicator needle will move. Turn the exposure index ring until the guide needle lines up with the indicator needle. Read the dial for proper shutter speed and f-stop settings.

BUILT-IN EXPOSURE METERS

Built-in exposure meters are mounted either in the camera body, Fig. 6-46, or in the pentaprism of SLR cameras, Fig. 6-47. A few cameras have the meter located behind the mirror, Fig. 6-48.

When the meter is in the pentaprism or behind the mirror it is known as through-the-lens or TTL metering. The meter measures the intensity (brightness) of the light coming through the lens. This technique is preferred. It compensates automatically for the effect of lens and filter on light.

TTL meters interact with the aperture, shutter

Fig. 6-46. Exposure meter on one type of rangefinder camera.

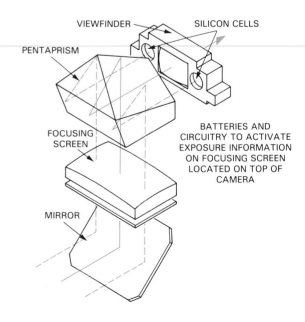

Fig. 6-47. Schematic of exposure meter in SLR camera. Meter measures light coming through lens.

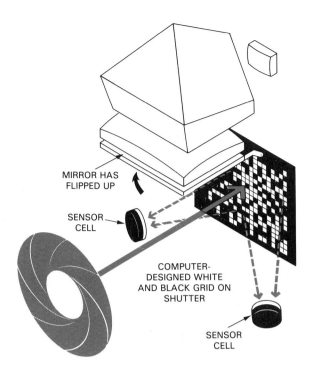

Fig. 6-48. Some SLR cameras have the exposure meter located behind the mirror. It measures the light at the instant of exposure.

speed, and film speed controls to indicate whether the settings will provide:
1. An overexposed negative.
2. An underexposed negative.
3. A properly exposed negative.
No series of aperture/shutter speed combinations are displayed as they are on hand-held exposure meters.

Built-in exposure meters appear in the viewfinder in one of the following displays:
1. Follow pointer.
2. Single needle.
3. Light emitting diodes (LEDs).

FOLLOW POINTER DISPLAY

A follow pointer display has two moving needles, Fig. 6-49. One needle is controlled by light intensity. The other needle is linked to aperture settings or shutter speed. The needles will align or match when the proper exposure conditions are met. If the needles cannot be made to match, there is:
1. Not enough light.
2. Too much light. The exposure cannot be made.

SINGLE NEEDLE DISPLAY

The single needle display has one needle and a static (fixed) mark showing in the viewfinder, Fig. 6-50. When the needle aligns or is centered with the static mark, exposure settings are correct. Underexposure or overexposure is signaled by + and − symbols on either side of the proper exposure mark.

Fig. 6-49. Follow pointer display. Needles align when the proper aperture/shutter speed combination is selected.

LED AND LCD DISPLAY

A light emitting diode (LED) display shows proper exposure, underexposure, and overexposure by a series of tiny LEDs, Fig. 6-51. A lighted center diode, usually green, indicates that the camera is set to take a properly exposed picture. The display is visible when looking through the viewfinder.

The liquid crystal display (LCD) uses liquid crystals that can mimic (look like) follow pointers or single-needle display. LCDs are often used to provide shutter speed and aperture information.

AUTOMATED EXPOSURE CAMERAS

A camera that is automated needs little or no hand operation for exposure. Some systems require the photographer to choose either the aperture setting or the shutter speed. The camera will then take care of the other setting needed for a proper exposure. There

ARROW STATIC MARK

Fig. 6-50. Single needle display metering system. Proper exposure conditions are indicated when the needle is centered with the static mark.

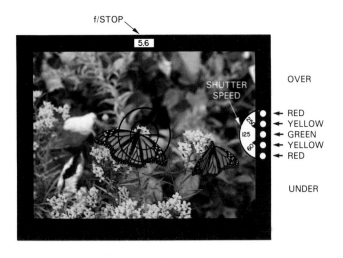

Fig. 6-51. Light emitting diode display (LED). A series of tiny LEDs indicate whether exposure is correct.

are several terms used with automated cameras:
1. APERTURE PRIORITY means you choose the f-stop and the camera will select the right shutter speed.
2. SHUTTER PRIORITY means you choose the shutter speed and the camera automatically sets the aperture.
3. PROGRAMMED MODE means the camera selects both shutter speed and aperture.

The viewfinder will display both the aperture and the shutter speed. See Fig. 6-52.

HOW METERS MEASURE LIGHT

To use metering information properly you need to know how meters work. The main methods are:
1. Averaging system.
2. Spot system.
3. Center-weighted system.

AVERAGING SYSTEM

The averaging system uses two sensor cells that measure the light reflected from the subject. All TTL

systems measure reflected light. The sensors cover most of the image area, Fig. 6-53. This system averages the readings from the two sensors and calculates an average light value exposure.

Averaging meters are easy to use and are recommended for beginners. However, they can give a false reading is one sensor receives bright light (as from the sky) while the other sensor receives little light (deep shadows). Care must be taken to be sure both sensors are receiving light from the subject and not from surrounding areas.

SPOT METERING SYSTEM

A spot metering system measures only the light striking a small circle in the center of the frame, Fig. 6-54. The subject must be metered with the circle area to work properly. It must be used carefully for true readings.

CENTER-WEIGHTED SYSTEM

The center-weighted system, like the averaging system, measures light over much of the frame. However, the center area of the frame contributes a larger percentage of sensitivity than the surrounding areas, Fig. 6-55. The subject is metered with the center area. However, the light intensity of the entire scene also contributed to the light reading.

Study the operating manual that came with your camera. It will show and tell you how to use the metering system for best exposure results. It will also provide information on how to meter unusual lighting situations, Fig. 6-56.

HOW METERS ARE CALIBRATED

Exposure meters are designed to give readings that will properly expose a medium gray subject. As the average subject has a reflectivity very close to 18 per-

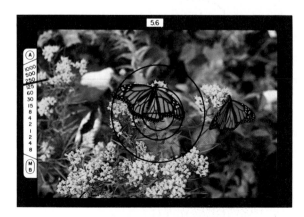

Fig. 6-52. Viewfinder of automated camera displays the f-stop and shutter speed.

Fig. 6-53. In the averaging system, two or more meters average the light values reflected from the subject.

AREA OF SUBJECT
SENSORS METER

Fig. 6-54. Spot metering system measures only light striking a small circle in the center of the frame.

SENSORS METER ENTIRE SCENE
BUT HAVE GREATEST SENSITIVITY
IN CENTER

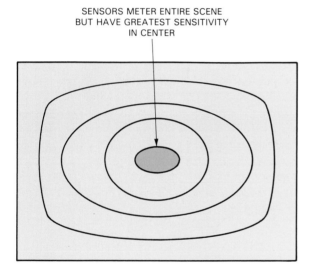

Fig. 6-55. Center-weighted system measures light values over much of the screen.

Fig. 6-56. Your camera's operating manual will explain how to use its metering system with unusual lighting conditions.

Fig. 6-57. Normal metering of a snow scene will result in gray snow.

cent, the medium gray used to set meters reflects 18 percent of the light striking it. Exposure will be satisfactory for most subjects. The process of setting the meter is called calibration.

Unfortunately, very shiny (high reflectivity) or very dark (low reflectivity) subjects will also be treated as if they had 18 percent reflectivity. A subject with high reflectivity will reflect more light than does 18 percent gray. The meter will recommend aperture/shutter speed settings that will under expose the picture. A subject with low reflectivity will be overexposed. In both situations, the subject is reproduced as 18 percent gray tones. A snow scene is a highly reflective subject. Fig. 6-57 shows what will happen using normal metering.

To compensate (make up) for these metering errors, the aperture should be opened or closed about one stop when such extremes in light reflectivity occur.

To avoid guessing at the setting, an 18 percent gray card can be used, Fig. 6-58. The gray card is placed in the same light as the subject. Light reflected off the card is metered. The camera is set to this reading.

A gray card can be used for all lighting situations. It will assure a properly exposed picture.

Any situation with a big brightness difference between the subject and the background needs special metering, Fig. 6-59. All meters, except spot meters, will try to average in the background. An improperly exposed negative will result.

Fig. 6-58. Subject in this photo is located against a brightly lighted background. To avoid errors in guessing the compensation necessary, an 18 percent "gray card" is placed in the same light as the subject. Light reflected from the card is metered and used to assure a properly exposed picture.

Fig. 6-59. Special metering was used to photograph this scene. Note the difference in brightness between the subject and the background.

The subject should be metered separately, preferably using a gray card to prevent the background from affecting the reading. An example of this type of a situation would be a backlighted subject, Fig. 6-60. A backlighted situation occurs when the subject is much darker than the background. Most meters will recommend an exposure in which the subject will appear as a silhouette, Fig. 6-61.

Any important picture with "tricky" lighting should be BRACKETED. Bracketing means taking several identical pictures using aperture settings or shutter speeds on either side of the recommended meter calculation. This will provide a full range of exposures from which the best negative is selected.

COMPOSITION TECHNIQUES

Composing a scene involves arranging the parts of the picture into a harmonious (elements belong together) and pleasing situation, Fig. 6-62. Of course, what is pleasing and harmonious to one person may not be to someone else. Still, there are some basic guidelines and techniques that will help create a better photograph. They include:
1. Camera angle (camera-to-subject position).
2. Panning (swinging the camera).
3. Framing the scene.
4. Background.
5. Selective focus.
6. Point of interest.

CAMERA ANGLE

Camera angle refers to the point where the photo will be taken. Certain angles can make the viewer feel a part of the scene, Fig. 6-63. Try unique camera angles. They often produce refreshingly different pictures, Fig. 6-64.

PANNING

Panning means moving the camera to follow a subject that is also moving, Fig. 6-65. The technique keeps the subject in focus but blurs the background. It gives a feeling of motion and directs attention to the subject. Panning is also used when a moving object must be "frozen" but a high shutter speed cannot be used.

Fig. 6-60. A bright background affected the meter reading on the scene. A gray card or a fill-in flash should have been used.

Fig. 6-62. A nicely composed scene. Can you tell why it is pleasing?

Fig. 6-61. A backlighted situation occurs when the subject is darker than the background. Most meters will recommend an exposure that causes the subject to appear in silhouette (black against white).

Fig. 6-63. Low camera angle puts viewer in the path of these aircraft preparing for takeoff.

Fig. 6-64. Try to use unique camera angles to produce refreshingly different pictures. This photo can be viewed from any position and still be interesting.

Fig. 6-65. Panning (moving camera to follow subject) was used to produce feeling of motion. (Kawasaki)

FRAMING

Framing is the technique of partially or totally surrounding the primary subject with an object or objects in the foreground, Fig. 6-66. The objects can be

branches, a flower, or an archway. Framing gets rid of boring borders and gives the photograph a feeling of depth.

BACKGROUND

A proper background is important with certain pictures. Use care to avoid such things as a tree "growing" out of the subject's head. Study the background when composing so the picture you take does not have unwanted and possibly embarrassing background when you develop and print it, Fig. 6-67. If you wish to play down a background, try using a large aperture opening. This will produce a shallow depth of field and cause a blurred and less noticeable background, Fig. 6-68.

When in doubt, use a background that will be uncluttered. Busy surroundings take interest away from the main subject.

Shapes and lines in a photograph can direct attention. Shapes formed by objects in a scene can add interest and symmetry, Fig. 6-69. Vertical lines accent height while diagonal lines can suggest movement and action.

SELECTIVE FOCUSING

Selective focusing can be employed to direct attention to the subject. A shallow depth of field causes most elements in the scene to be blurred, Fig. 6-70. In this case, a wide open lens is used to produce the effect.

Fig. 6-66. Trees make an attractive frame for the subject.

Fig. 6-69. Shapes and lines direct the eye and attention in a photograph. The lines in this scene—pickets, trees, and chimneys—are all vertical.

Fig. 6-67. Compose your picture carefully. If you ignore background, you may have quite a surprise when you develop your photographs.

Fig. 6-68. A shallow depth of field produces a blurred and unobtrusive background in this photo.

Fig. 6-70. An example of selective focusing. A wide-open lens produced a shallow depth of field. As a result foreground only is in sharp focus.

Great depth of field can be used to direct attention from the foreground in the scene to the main subject, Fig. 6-71. A stopped down lens will produce this type of picture.

Fig. 6-71. Great depth of field can be used to direct attention from the foreground to the remainder of the scene.

POINT OF INTEREST

An interesting photograph should have a point of interest. It gives the picture meaning and can rid the scene of monotony. The point of interest can be a part of the surrounding scene, or it can be totally unexpected.

ADDED SUGGESTIONS

Always avoid any obstruction in front of the camera lens. Fingers, lens caps, and camera straps can ruin a photograph. Obstructions between the camera and the subject, such as power lines, poles, and cars, can also ruin a picture. They can usually be eliminated by careful placement of the camera, changing the camera angle, moving closer to the subject, or using a wide angle lens, Fig. 6-72.

Hold the camera level. Tilting horizons or backgrounds can spoil a picture, Fig. 6-73.

Use the film format to advantage. Rectangular format cameras should be rotated to capture vertical objects, Fig. 6-74.

Avoid deep shadows. Use fill-in flash or change the subject's position to remedy.

Be sure the subject appears complete and balanced in the picture, Fig. 6-75. Chopped off heads render a photograph useless.

Reflections on glasses can often be eliminated by having the subject move his or her head slightly so light reflects in a different direction.

Avoid "red eye" ("white eye" in black and white pictures) by asking the subject not to look directly at the flash. Moving the flash to one side may also eliminate the problem.

When using a rangefinder or simple camera be

Fig. 6-72. Eliminating obstructions by changing lenses. Left. Photo taken with a normal lens. Pole and trees in foreground spoil the scene. Right. Unwanted pole and trees were removed by using wide angle lens.

careful. Avoid having obstructions like a finger or strap across the lens opening, Fig. 6-76. It will ruin the photo.

WORDS TO KNOW

Averaging meter system, backlighted subject, bracketing, center-weighted metering system, focusing zone, follow pointer system, framing, incident-light exposure meter, LED display, meter calibration, metering, panning, "red eye," reflected-light exposure meter, single needle display, spot metering, TTL metering.

Fig. 6-73. Hold camera level. Few pictures are improved by photographing the scene at an angle.

Fig. 6-75. Be sure to have the entire subject framed before making the exposure.

Fig. 6-74. Using the film format to advantage. This scene was taken with camera turned 90 degrees.

Fig. 6-76. Camera strap or a finger over the lens will create a poor photograph such as this one.

TEST YOUR KNOWLEDGE — CHAPTER 6

1. A good photographer must be part _____ and part _____.
2. Film is manufactured in four basic forms. List them.
3. Film must be loaded into the camera so that the _____ faces the lens.
4. If the camera is not well supported when a photo is taken, the picture will be _____.
5. A tripod should be used when: (Check the correct answer or answers.)
 a. There is not enough light for at least a 1/30 second shutter speed.
 b. Using a view camera.
 c. Making close-up photos.
 d. All of the above.
 e. None of the above.
6. A quick "jab" on the shutter release usually results in a _____ picture. The shutter release should be depressed in a _____, _____ manner.
7. (Select proper answer/s.) A sharp picture requires (proper exposure, focusing, expensive camera, fast lens).
8. Rangefinder cameras use a _____ _____ focusing system. Two images are seen in the viewfinder until the lens is properly focused. The two images then become one image.
9. Sketch the superimposed focusing system used on many cameras.
10. Make a sketch of a split-image focusing system showing an out-of-focus condition.
11. Two basic types of focusing screens are used on SLR cameras.
 a. _____. A circular spot in the center of the focusing screen breaks the image into two parts that do not match up. The lens is properly focused when the two images form a single image.
 b. _____. A small circle in the center of the focusing screen appears dark and the image within the spot is blurred until the lens is properly focused.
12. What does depth of field mean?
13. How can the depth of field be controlled?
14. Why is a light or exposure meter used?
15. List the two types of hand-held exposure meters.
16. How do they differ?
17. Why is a through-the-lens metering system preferred over a hand-held exposure meter?
18. List the three main ways exposure meters measure light. Briefly explain each method.
19. How are exposure meters calibrated?
20. The technique of taking a picture several times with different aperture/shutter speed combinations to assure proper exposure is called _____.
21. When should panning be used?

THINGS TO DO

1. Carefully read the instruction book that came with your camera. Learn the names and location of the various camera parts. Practice using them until their location and operation become second nature.
2. Using scrap film, practice loading and unloading the film in your camera.
3. Practice changing the lens on your camera.
4. If different kinds of cameras are available, get permission to study their operation and how they differ from your camera.
5. Practice holding your camera and framing scenes until the action becomes a habit. Load your camera with black and white film and practice taking actual pictures. Keep notes on the aperture/shutter speed settings you used.
6. Do not shoot another roll of film until you have processed and studied the results on your first roll. Discuss the pictures with your instructor and determine what improvements can be made.
7. Take a series of photos using slow shutter speeds. Hand hold the camera for some and use a tripod for others. Process the film and evaluate the differences.
8. Examine different focusing systems.
9. Practice using hand-held exposure meters. Take several photos using both a reflected and incident type meter. Process the film and evaluate the differences.
10. Take additional photos similar to those you took in *Activity 9*. However, use a camera with through-the-lens metering. Evaluate the differences between these pictures and those made using hand-held meters.
11. Take a series of photos under various lighting conditions. Make identical photos using direct metering and metering using an 18 percent gray card. Compare and evaluate the results.
12. Make photos using different camera angles.
13. Use the panning technique to take action photos.
14. Take several photos where framing is used to good advantage.
15. Take a series of photos that use different depth of fields to enhance the pictures.
16. Make a series of photos where the shape of the objects are used to add interest. Have your other students critique your work.
17. Make pictures using silhouettes to add interest.
18. Make a series of photos in which the film format is used to advantage. Explain to the class the reasons you used the vertical or horizontal format.
19. Take a series of photos that will show your school to best advantage. Prepare an exhibit of your pictures.
20. Take a series of photos that will show areas of your school where improvements can and should be made. Prepare a display of your pictures.

7 LIGHTING

After studying this chapter you will be able to:
- ☐ Describe various types of outdoor lighting and light angles.
- ☐ Take outdoor photographs using available light, reflectors, and fill-in flash.
- ☐ Describe types of artificial light and explain how to use each.
- ☐ Compute proper exposures using guide numbers for various flash and film combinations.
- ☐ Use automatic electronic flash units.
- ☐ Use a dedicated electronic flash unit.

Light is as essential to photography as it is to the human eye. It is the energy source that puts an image onto photographic film. To take quality photographs, every photographer must understand light, light angles, and know how to make light work effectively.

Many characteristics of a photograph are due to the lighting conditions at the time of exposure. Boats sailing into a setting sun would give an effect completely different from the same scene taken at noon. Success in capturing a subject depends on the photographer's skill in controlling or using light.

OUTDOOR LIGHTING

Outdoor lighting in the daytime is quite variable. The day may be overcast resulting in shadowless light. Or bright sunlight could be shining on the front, side, or back of your subject. Understanding outdoor lighting will result in better photographs and increase creative possibilities. The appearance of a scene varies with the time of day and lighting conditions. Observe the conditions and take the photograph when conditions are best, Fig. 7-1.

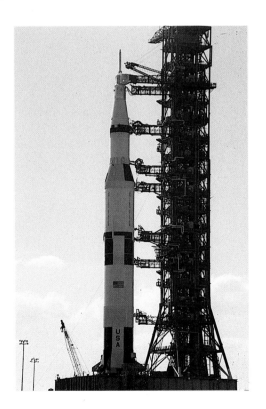
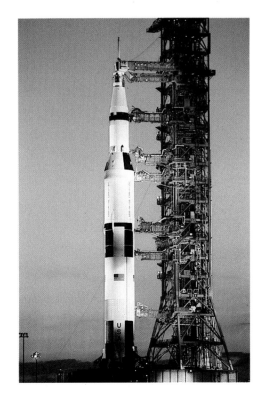

Fig. 7-1. Time of day can make or break the photograph. These two photos were taken less than an hour apart. Which is more appealing? Why?

91

Bright sunlight shining on a subject or scene is very popular for outdoor photography. Bright colors, a blue sky, shadows, or reflections will produce brilliant photographs, Fig. 7-2.

An overcast or rainy day is no reason to put the camera away. Rain can actually increase the color saturation of a scene, Fig. 7-3. (Color saturation is the intensity of any color.)

ANGLES OF LIGHT SOURCE

Good photographs of people are easy to take in bright sunlight. Keep the sun behind the camera for a FRONTLIGHTED scene with bright colors, Fig. 7-4. Be careful to avoid squinting subjects who are facing the sun.

Although frontlighting is the basic way to take good photographs, SIDE LIGHTING and BACK-LIGHTING can create additional possibilities. In side lighting the light comes from the side; in backlighting from in back of the subject.

Shadows can add depth to a photograph and help

Fig. 7-2. A combination of bright colors, blue sky, shadows, and reflections produce outstanding photographs.

Fig. 7-3. Bad weather is often a good time to take photographs. Top. A foggy, rainy day in the Great Smoky Mountains. Bottom. Rain can increase color saturation of a scene.

add texture to a surface, Fig. 7-5. Backlighting can produce interesting highlights, Fig. 7-6, or cause a silhouette effect as with a sunset, Fig. 7-7.

FILL-IN LIGHT

A REFLECTOR can lighten shadows on a nearby subject on a sunny day, Fig. 7-8. A simple reflector can be made with a large white sheet of paper or highly reflective fabric, Fig. 7-9.

The other way to reduce CONTRAST (the difference between bright highlights and shadow areas) is with fill-in flash. Fill-in flash will be discussed later in this chapter.

Fig. 7-4. For frontlighted scene, keep sun behind camera.

INDOOR LIGHTING WITH LAMPS

Floodlights, Fig. 7-10, are often used for indoor photography. MUSHROOM shaped floodlights are silvered to act as a built-in reflector. BULB shaped floodlights are used with an auxiliary reflector. See Fig. 7-11 for one type of reflector.

Both types of bulbs are available in various wattages. (WATTAGE indicates the brightness of the floodlight.) A 500 watt (W) bulb is very powerful and is generally used as a main light. Lower wattage bulbs are often used as auxiliary light sources.

Knowing the wattage of a bulb is important in calculating how many bulbs can be safety used in an electrical circuit. The normal household circuit usually can carry 15 amperes (A) of current. If the

Fig. 7-6. Backlighting can produce interesting light patterns. Caution: never look directly into the sun.

household voltage is 110 V, divide the wattage of the bulb by this. A 500 W bulb draws almost 5 A. Therefore, three 500 W bulbs could be used on this

Fig. 7-5. The sun skimming across the wood grain adds the appearance of texture while the shadow adds depth.

Fig. 7-7. Sunset silhouettes Seal Rock at Monterey, California, as another example of backlighting.

93

Fig. 7-8. Reflector helps to eliminate shadows and evens out harsh lighting. (Larson Enterprises)

Fig. 7-10. Floodlights. A—Mushroom shaped floodlights have built-in reflectors. B—Bulb shaped floodlights require an auxiliary reflector.

Fig. 7-11. A reflector for bulb shaped floodlights. (Smith-Victor Corp.)

Fig. 7-9. A reflector is constructed of highly reflective fabric. (Larson Enterprises)

circuit. No other lights, stereos, or other electrical loads should be added.

Floodlights are commonly used for portraiture, Fig. 7-12. As with sunlight, varying the angle of the light source can produce different effects, Fig. 7-13. Placement and number of lights used depends on the subject and the desired effect. The manufacturers of lighting equipment provide brochures on this subject.

A light table, Fig. 7-14, is extremely useful for photographing small objects. Shadows can be controlled or removed by varying the position of the lights.

A copy stand is often used to copy photographs or drawings, Fig. 7-15. A camera is attached to a movable bracket on a vertical post. Lights are placed in built-in holders.

Fig. 7-12. Floodlights and reflectors are often used in studio photography. (Larson Enterprises)

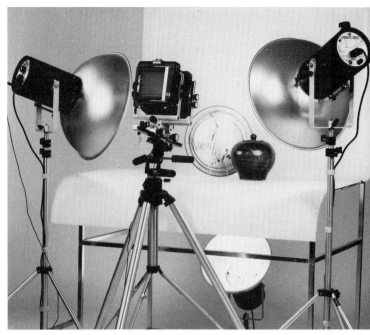

Fig. 7-14. A light table is useful for photographing small objects. (Bogen Photo Corp.)

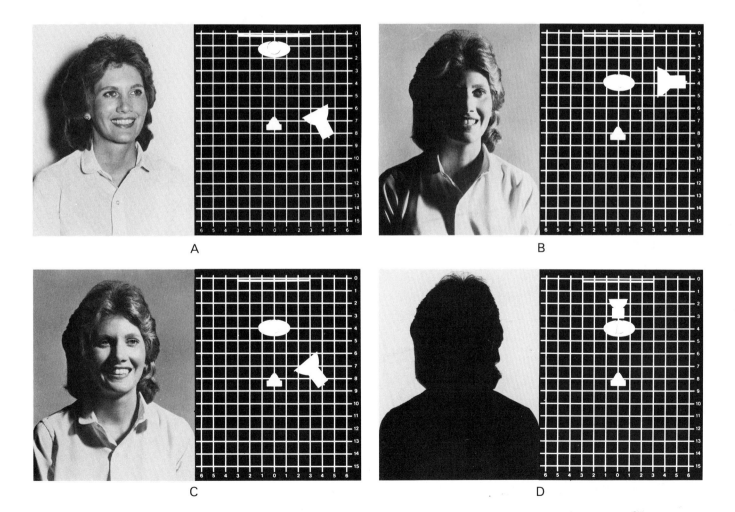

A

B

C

D

Fig. 7-13. By varying angles and placement of lights you can produce different lighting effects. A—Flat frontal lighting. B—90 degree lighting. C—45 degree lighting. D—Backlighting. (Smith-Victor Corp.)

FLASH ILLUMINATION

There is not always enough natural light to make a satisfactory exposure. When this occurs, flash illumination is an easy way to put more light on the subject being photographed, Fig. 7-16. Flash can also be used to improve or modify existing light

Two types of flash illumination are available to the photographer:

1. PHOTOFLASH LAMP. This type is better known as a FLASH BULB.
2. ELECTRONIC FLASH or STROBE.

FLASH BULBS

All flash bulbs operate in the same way. A filament (thin wire) in the bulb glows when an electric current is passed through it. A battery provides electrical power. The glowing filament ignites a ball of magnesium or zirconium wire. Oxygen, under pressure in the bulb, causes the wire to burn almost instantaneously.

Flash bulbs come in several sizes, Fig. 7-17. The smaller bulbs do not have a metal base. They are the least expensive and most widely used. The larger, more powerful bulbs are used mainly by the profes-

Fig. 7-15. A copy stand is used to copy photographs and drawings. (Bogen Photo Corp.)

Fig. 7-16. Flash is an easy way to put more light on a subject that is dimly lit. Top. Available light was too dim. Film was underexposed. Bottom. Flash lighting produced proper exposure. (Photos printed by permission of Preservation Hall, New Orleans.)

Fig. 7-17. Flash bulbs are made in a variety of sizes.

Fig. 7-18. Flash bulbs are placed into a holder that is fitted with a reflector. The reflector focuses the light from the flash bulb onto the subject.

sional photographer for special situations.

Flash bulbs fit into a holder with a reflector, Fig. 7-18. The unit is mounted onto the camera. Batteries provide the power to fire the bulb. They are housed in the holder. The reflector focuses the light on the subject.

Flash bulbs are either clear or tinted blue. Blue flash bulbs have a light quality similar to daylight. They can be used with color and black and white films. *Clear bulbs should be used only with b&w films.*

Flash bulbs are also separated into classes. Each class has a letter designation: F, M, S, FP. The letter is an indication of the time needed (in milliseconds) for the bulb to reach peak light output.

Most inexpensive cameras are synchronized (timed) with flash bulbs at slow shutter speeds, usually 1/30 sec. This means that at this speed the shutter will be fully open when the flash is at peak intensity.

Some cameras have several speeds that can be synchronized with flash units. Refer to the camera's instructional manual for the correct way to set up and adjust your camera for use with a flash unit.

GUIDE NUMBERS

Exposure with flash bulbs is calculated with a guide number. A guide number is assigned to each type of bulb. It varies with different film speeds. This information is found on the side of the flash bulb container or on the film data sheet, Fig. 7-19.

The correct aperture setting is found by dividing the guide number by the distance to the subject (in feet): $\dfrac{\text{Guide Number}}{\text{Distance (feet)}}$

The guide number is only an average. If the subject is dark, or in a low reflective area, the lens aperture

GUIDE NUMBERS FOR BLUE FLASH						
Reflector	Flash	Shutter Speed				
		X Sync	M Synchronization			
		1/30	1/30	1/60	1/125	1/250
	Flashcube	100	70	65	55	44
	HI-POWER FlashCube	140	90	90	80	65
	AG-1B	75	50	50	42	36
	AG-1B	100	70	70	60	50
	M2B	100	NR	NR	NR	NR
*	AG-1B	150	100	100	85	70
	M2B	130	NR	NR	NR	NR
	M3B, 5B, 25B	140	130	120	100	85
	6B†, 26B†	NR	140	100	70	50
*	M3B, 5B, 25B	200	180	180	150	120
	6B†, 26B†	NR	200	140	100	70

*Polished bowl. †Bulbs for focal-plane shutter. NR—Not Recommended.

Fig. 7-19. Flash guide number information can be found on the film information sheet. (Eastman Kodak Co.)

must be opened one stop. When the subject is light in color, or in a reflective area (a room with light colored walls), the aperture must be closed down one stop.

Flashcubes, magicubes, flipflash, and flashbars are variations of the basic flash bulb, Fig. 7-20. The flashcube has four flash bulbs (with reflectors) fitted into a clear plastic box. It plugs into the camera as a single unit. When the flash is used, a new bulb pivots into position each time the film advance lever is used.

A magicube is like the flashcube. It does not, however, need a battery. A firing pin ignites the filament. It can only be used on cameras especially designed for it.

A flipflash contains 8 or 10 bulbs. The entire unit is fitted to the camera. The bulbs on one side are fired in sequence. When all have been used, the unit is "flipped" over so the other half can be used.

A flashbar contains 10 bulbs, five on each side. When the first five bulbs have been used, the unit is turned to put the next five bulbs in position.

Flashcubes, magicubes, flipflash units, and flashbars are not interchangeable. They are used on inexpensive fixed aperture cameras. *Photos taken with flash bulbs must be taken within 5 to 10 ft. (1.5 to 3 m) from the subject. Photos taken at greater distances will usually be too dark.*

SAFETY NOTES

Although each flash bulb is safety coated, a damaged bulb may shatter when flashed. Use additional protective shielding at distances less than 4 ft. (2 m).

Static electricity may cause unexpected flashing. Keep bulbs in their cartons until ready for use.

Do not use flash bulbs in an explosive atmosphere. Flash bulbs are very hot immediately after use.

Handle them with care. The hot bulb can cause a painful burn.

Discard used flash bulbs in a suitable container. Do not litter. Many people and animals have received painful injuries from carelessly discarded flash bulbs.

ELECTRONIC FLASH UNITS

Electronic flash units are rapidly replacing flash bulbs, Fig. 7-21. They are like flash bulbs that can be used over and over. They cost less per picture, are more convenient, more reliable, and give better results.

Modern electronic flash units can "freeze" action, Fig. 7-22, because they produce a flash with a duration of 1/50,000 sec.

POWER FOR ELECTRONIC FLASH

An electronic flash may be powered by several sources, Fig. 7-23.
1. AC "house current" power.
2. Rechargeable nickel cadmium batteries.
3. Disposable batteries. Alkaline cells are the most economical.

HOW ELECTRONIC FLASH WORKS

An electronic flash has three main parts, Fig. 7-24.
1. Voltage converter.
2. Capacitor.
3. Flash tube.

The electronic flash unit used by most amateur photographers is powered by two or four 1.5 volt batteries, usually AA size. See Fig. 7-25. An electronic flash, however, needs high voltage (400 volts or more). To produce the needed voltage, energy from the batteries (3 or 6 volts) passes through a voltage converter. The converter output is high voltage dc.

Fig. 7-20. Modern variations of the flash bulb. A—Flashcube. B-Magicube. C—Flipflash. D—Flashbar.

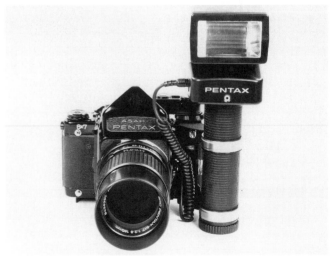

Fig. 7-21. An electronic flash has many advantages over the flash bulb. How many can you name? (Pentax)

The capacitor stores the high voltage current from the converter. A small signal light (ready light) on the unit, Fig. 7-26, goes on when the capacitor is charged and ready for use.

As the picture is taken, the capacitor discharges through the flash tube. The tube gives off a very

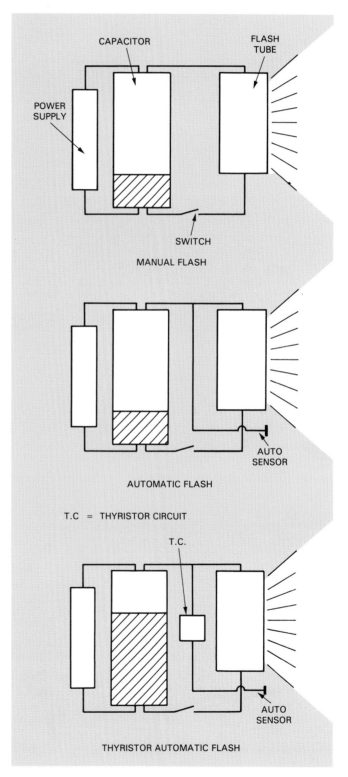

Fig. 7-24. All electronic flash units have three main parts: the power supply, capacitor, and flash tube.

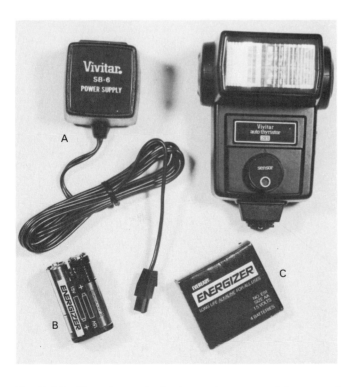

Fig. 7-23. The electronic flash can be powered by any of several sources. A—AC power (house current). B—Rechargeable nickel cadmium batteries. C—Disposable batteries.

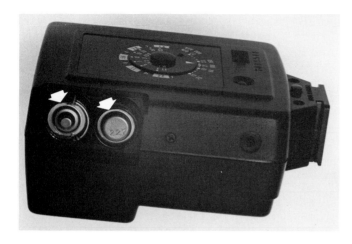

Fig. 7-25. Most electronic flash units are powered by two or four batteries (see arrows). Caution: Do not allow batteries to remain in the flash if the unit is not used regularly.

Fig. 7-26. The ready light (arrow) indicates when the capacitor is fully charged and ready for use.

bright light. The light is turned off when the voltage drops to a certain value and the unit turns off. The flashed light is focused on the subject by a built-in reflector.

Select an electronic flash with a light beam width just a little wider than the lens' angle of view, Fig. 7-27. This will assure ample light over the entire frame of the film.

LIGHT OUTPUT

Each electronic flash unit has a guide number. The number indicates the light output of the unit. The higher the guide number, the farther away a properly exposed flash picture can be taken.

Guide numbers are usually stated for film with an ASA or ISO rating of 25. The unit's instruction manual will list guide numbers for other film ratings.

Light output is sometimes given in beam candle power seconds (BCPS). This value is useful when calculating the exposure from information on the film's data sheet, Fig. 7-28.

It is not hard to determine exposure settings with an electronic flash. Most units have a built-in calculator, Fig. 7-29. The calculator takes all exposure factors into account such as guide number, film speed,

ELECTRONIC FLASH

Use this table with electronic flash units rated in beam candlepower seconds (BCPS). To determine f-number, divide guide number for flash unit by distance in feet from flash to subject. If exposure is unsatisfactory, change guide number as described under "Blue Flash."

Output of Unit BCPS	350	500	700	1000	1400	2000	2800	4000	5600	8000
Guide Number	45	55	65	80	95	110	130	160	190	220

Fig. 7-28. The guide number for flash units of various beam candle power seconds (BCPS) can be found on the film information sheet. (Eastman Kodak Co.)

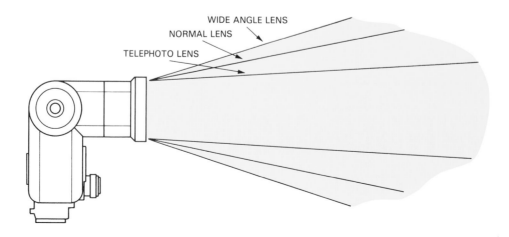

Fig. 7-27. The beam of the flash must be wider than the lens' angle of view.

Fig. 7-29. Most electronic flash units have a built-in calculator to determine exposure settings for the various types of films and flash-to-subject distances. (Sunpak Div., Berkey Marketing Companies, Inc.)

HOW TO USE AN ELECTRONIC FLASH

Many different electronic flash units are available. Refer to the unit's instruction manual for answers to specific questions or problems. In general, they are used as follows:

1. Connect the unit to the camera by a hot shoe or bracket, Fig. 7-31. With bracket mounted units,

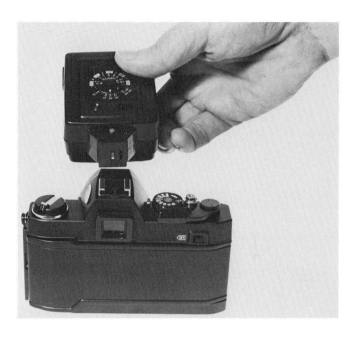

Fig. 7-31. Connect the flash unit to the camera at the "hot shoe" if the camera is fitted with one.

distance-to-subject, and aperture setting.

Keep in mind that as the distance between the flash and subject increases, so does the amount of light needed for the exposure, Fig. 7-30.

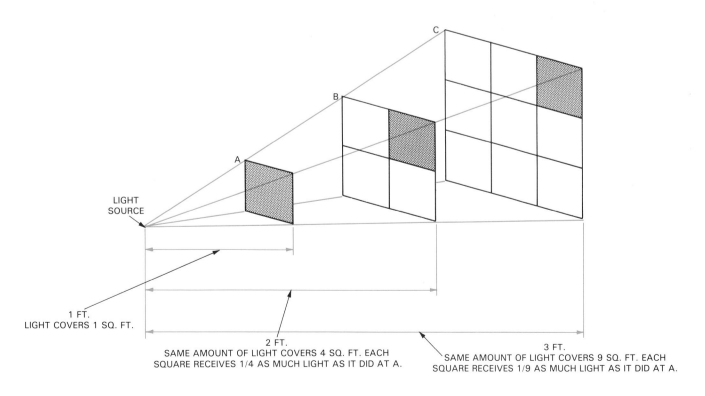

LIGHT SOURCE

1 FT.
LIGHT COVERS 1 SQ. FT.

2 FT.
SAME AMOUNT OF LIGHT COVERS 4 SQ. FT. EACH SQUARE RECEIVES 1/4 AS MUCH LIGHT AS IT DID AT A.

3 FT.
SAME AMOUNT OF LIGHT COVERS 9 SQ. FT. EACH SQUARE RECEIVES 1/9 AS MUCH LIGHT AS IT DID AT A.

Fig. 7-30. As distance from the flash to the subject increases, the amount of light needed to make the exposure also increases, but at a faster rate.

plug the flash cord into the socket marked "X," Fig. 7-32. The hot shoe provides a connection without the cord.

2. Set the shutter speed of the camera (usually 1/60 sec.). Some cameras have a setting marked "X" or use a symbol, Fig. 7-33. If in doubt, refer to the camera's instruction manual.

3. Set the flash unit's calculator for the correct exposure by dialing in the ISO/ASA film rating. See arrow No. 1 in Fig. 7-34.

4. Focus on the subject. Read the distance between the camera and the subject. This distance is found on the focusing ring of the lens. Note this distance on the flash unit's calculator dial, arrow No. 2 in Fig. 7-34.

5. The f-stop opposite that mark is the proper aperture setting. See arrow No. 3 in Fig. 7-34.

6. Turn on the flash unit. The ready light will glow

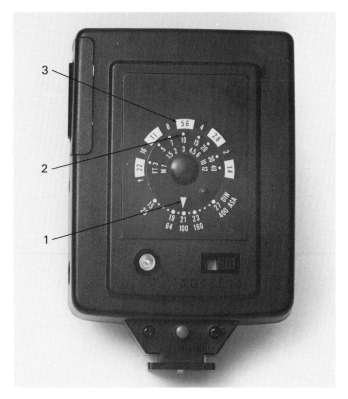

Fig. 7-34. How to use an electronic flash. 1. Set the flash unit to the correct film speed (100 ASA). 2. Focus on subject and note distance indicated on lens. (10 ft. or 3 m). 3. The f-stop opposite the distance (10 ft. or 3 m) is the proper aperture setting.

Fig. 7-32. Cameras not fitted with a "hot shoe" use a flash cord that must be fitted into the "X" socket.

Fig. 7-33. Many cameras have a shutter setting marked "X" that must be used when making flash pictures.

when the capacitor is fully charged. Take the picture. It usually takes 5 to 15 sec. for the unit to recharge for the next flash. Longer recycle times indicate weak batteries that should be replaced.

AUTOMATIC ELECTRONIC FLASH UNITS

Many of the newer electronic flash units are automatic in operation. Like other units, the flash is triggered by the shutter. Light reflected from the subject strikes a SENSOR built into the flash, Fig. 7-35. When enough light (determined by the sensor) strikes the subject, the flash is extinguished by shorting out the remaining power in the capacitor. The calculator dial must be set to the film speed and the lens aperture set for automatic operation. Exposures will be correct through a range of distances. Automatic flash units may also be used manually.

More expensive automatic flash units have THYRISTOR circuits that save the energy usually shorted out. Depending on the distance to the subject, recycle time may be as short as 1/2 sec. This means more flashes for each set of batteries.

DEDICATED FLASH

Dedicated flash is a special kind of automatic flash unit, Fig. 7-36. A dedicated flash will only operate

Fig. 7-35. An automatic electronic flash has a sensor built into the flash. Calculator dial must be set to film speed and lens aperture must be set for automatic operation.

automatically with the camera for which it was designed. Electrical contacts on the hot shoe couple the flash to the camera for special operations. Many automatically set the camera to the correct shutter speed, select the f-stop, indicate when the flash is ready in the viewfinder, and indicate if the light output is sufficient for correct exposure.

An even more advanced dedicated flash and camera measures correct exposure through the lens (TTL), Fig. 7-37. The camera's meter measures the light reflected off the film and signals the flash to turn off when sufficient light for correct exposure is sensed. This is an extremely accurate method for correct flash exposures.

WARNING: USE DEDICATED FLASH UNITS ONLY ON THE CAMERAS FOR WHICH THEY WERE DESIGNED. OTHERWISE, SEVERE ELECTRONIC DAMAGE CAN RESULT. ALWAYS FOLLOW THE MANUFACTURERS' DIRECTIONS FOR CORRECT OPERATION.

TIPS FOR USING ELECTRONIC FLASH

If an electronic flash has not been used for some time, it will be necessary to "form" the capacitor. This is done by "flashing" the unit a few times. Otherwise, the flash may not produce full-power brightness.

When storing the flash unit, charge it until the ready light glows. Turn the unit off. Do not trip the flash. This will help keep the capacitor operating properly.

A

B

C

Fig. 7-36. Dedicated flash units transmit exposure information to the camera for which they are designed. A—Olympus Corp.). B—(Vivitar Corp.). C—(Sunpak Div., Berkey Marketing Companies,Inc.)

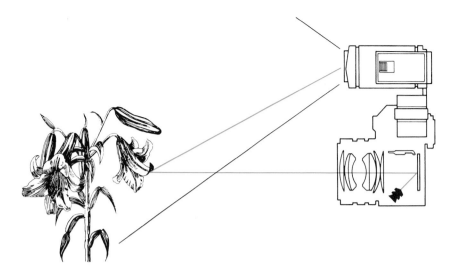

Fig. 7-37. Through the lens (TTL) flash metering measures light actually reaching film plane to calculate correct exposure.

BOUNCE FLASH

Bounce flash will produce light similar to light on a hazy day. It is an indoor lighting technique that illuminates the subject by reflecting light from the flash off the ceiling or a wall. This diffuses (spreads) the light and produces a less contrasty photo than a straight-on flash would produce, Fig. 7-38.

To use bounce flash, measure the flash-to-subject distance along the light path, Fig. 7-39. Since no surface reflects light 100 percent, it is necessary to open the lens one-half to one full stop beyond the calculated setting. A colored reflecting surface will produce colored light and will affect color film.

FILL-IN FLASH

Fill-in flash is used outdoors when part of the subject is shaded, Fig. 7-40. It lightens the deeply shaded areas of the subject and reduces contrast.

To use fill-in flash:
1. Pose the subject.
2. Set the shutter speed for flash.
3. Meter the subject and set the lens aperture.
4. Using the lens f-stop and flash guide number, calculate the subject distance:

$$\text{Distance} = \frac{\text{Guide Number}}{\text{f-stop}}$$

Another method is to read the distance opposite the metered aperature on the flash calculator dial. If either procedure places the subject too far from the camera, change to a longer focal length lens, or use a neutral density filter on the existing lens. These will allow a reduction in distance from camera to subject.

TIPS FOR USING ALL TYPES OF FLASH EQUIPMENT

1. Photographs made with flash often show the subject, human or animal, with "red eye." This effect

Fig. 7-38. Top. Photo taken straight on with a flash. Note shadows beside the head and reflections in the eyes. Bottom. Photo taken with bounce flash off ceiling. Diffused light eliminated shadows and "white eye."

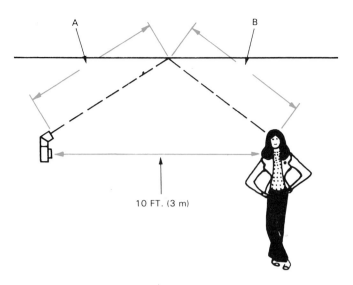

Fig. 7-39. To calculate correct exposure when using bounce flash, measure flash-to-subject distance, AB, along light path. Since no subject reflects 100 percent, it is necessary to open the lens one-half to one full stop beyond calculated setting.

is seen as "white eye" on b&w film, Fig. 7-38. The problem is caused when light from the flash is reflected back to the camera from the blood vessels within the eyes. It can be eliminated by:

a. Moving the flash a short distance away from the camera as in Fig. 7-41.

b. Having the subject look slightly away from the flash.

2. Avoid flash reflections from mirrors and windows, Fig. 7-42.

3. To avoid reflections from eye glasses, shoot the subject from an angle.

Fig. 7-41. "Red eye" and "white eye" can be eliminated by moving the flash farther away from the lens. Top. Extender. Bottom. Flash bracket.

Fig. 7-40. Fill-in flash lightens shaded areas of a subject and reduces contrast. Left. Photo taken without fill-in flash. Right. Photo with fill-in flash. Notice the difference! (Sunpack Div., Berkey Marketing Companies, Inc.)

4. Use fresh batteries in the flash. Alkaline batteries have a longer working life than regular flashlight batteries.
5. Keep the battery compartment clean. Remove the batteries when the flash will not be used for several days. Clean the battery contacts with a slightly abrasive eraser before they are installed in the unit. *Do not rub your fingers over the contacts to clean them.*
6. Use the recommended shutter speed. Too fast a shutter speed (when used with flash) will cause a partially underexposed photograph, Fig. 7-43. A shutter speed that is too slow may cause a GHOST IMAGE if there is strong natural light. This will also cause a moving subject to be blurred.

WORDS TO KNOW

Backlighting, beam candle power seconds, bounce flash, capacitor, color saturation, copy stand, electronic flash, filament, fill-in flash, flash tube, frontlighted, ghost image, guide number, photoflash lamp, ready light, "red eye," side lighting, strobe, thyristor, voltage coverter, wattage.

TEST YOUR KNOWLEDGE

1. Give an example of the type of scenes that might be photographed outdoors using frontlighting, side lighting, and backlighting.
2. A reflector is useful to _____.
3. List two types of floodlamps. How do they differ?
4. A household circuit usually can carry 15 A of current at 110 V. How many 250 W bulbs can be used on this circuit?
5. A flash unit offers a photographer several advantages. List four of these advantages.
6. Clear flash bulbs should be used with: (Check the correct answer or answers.)

Fig. 7-42. Reflections in glass, top, can be eliminated by shooting the subject at an angle to the glass, bottom.

Fig. 7-43. A focal plane shutter speed too fast for flash will cause "shutter cut-off." Use recommended shutter speed to eliminate the problem.

a. Black and white film.
b. Color film.
c. Both color and black and white film.
d. All of the above.
e. None of the above.

7. You are using a film and flash bulb combination with a guide number of 80. If the subject is 10 ft. away, what is the recommended aperture setting (f-stop)?

8. List some of the advantages an electronic flash unit has over flash bulbs.

9. An electronic flash unit is composed of what three components?

10. What is the correct f-stop for photographing a subject at 10 ft. using the electronic flash unit shown in the photograph?

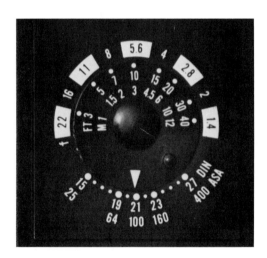

11. What is the advantage of using an automatic electronic flash unit?

12. How should an electronic flash unit be stored if it is not to be used for a while?

13. Bounce flash is a technique often used to _____
_____.

14. A photographer will frequently use fill-in flash to _____
_____.

15. "Red eye" can be eliminated by: (Check the correct answer or answers.)
a. Changing to a larger lens aperture.
b. Moving the flash unit a short distance away from the camera.
c. Using a faster shutter speed.
d. Having the subject look slightly away from the flash.
e. All of the above.

THINGS TO DO

1. Take a set of photographs outdoors to demonstrate frontlighting, side lighting, and backlighting. Repeat this exercise indoors using floodlamps. Evaluate the results.

2. Find a location and subject where a reflector would be useful. Using a large sheet of white paper for the reflector, photograph the scene. Compare the results to a photograph of the same scene without the reflector.

3. Check over the flash unit you are using. Test the batteries and replace them if necessary. Carefully study the instruction manual that came with your unit.

4. Make a series of photos (of the same subject and under identical conditions) using various types of flash illumination — flash bulb, manual electronic flash unit, and automatic electronic flash unit. Prepare a written evaluation of the photos.

5. Take a series of photos using flash. Evaluate the results. List problems encountered and improvements you can make when you use flash.

6. Take a series of photos using bounce flash. Evaluate your results.

7. Take a series of photos using fill-in flash. Evaluate your results.

8. Prepare a bulletin board display on flash photography. Contact several equipment manufacturers and distributors for information on their flash units.

A simple photographic darkroom organized for efficient development and printing. Enlargers are located well away from solution trays so that stray light from printing operations cannot fog prints being developed.

8 THE BASIC DARKROOM

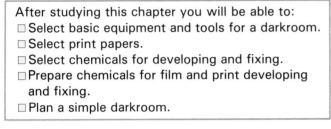

After studying this chapter you will be able to:
☐ Select basic equipment and tools for a darkroom.
☐ Select print papers.
☐ Select chemicals for developing and fixing.
☐ Prepare chemicals for film and print developing and fixing.
☐ Plan a simple darkroom.

Making a print from a photographic negative requires the use of a darkroom. A darkroom is a light-tight room equipped for photographic work.

If a specially designed darkroom is not available, a closet or a storage room will do. A temporary darkroom can be set up in a bathroom or kitchen, Fig. 8-1. In fact, any area that can be made light proof is suitable. Running water, while not absolutely necessary, should be available nearby.

Every darkroom must contain certain essential equipment and supplies:

Enlarger
Easel
Print washer
Safelight
Dust removal
 equipment
Paper safe
Paper cutter
Focusing aid
Processing trays

Print tongs
Timer (enlarger)
Timer (processing)
Print dryer
Mixing aids
Thermometer
Paper towels
 (lint free)
Protective apron
Disposable plastic
 gloves

In addition, print paper and processing chemicals are also needed.

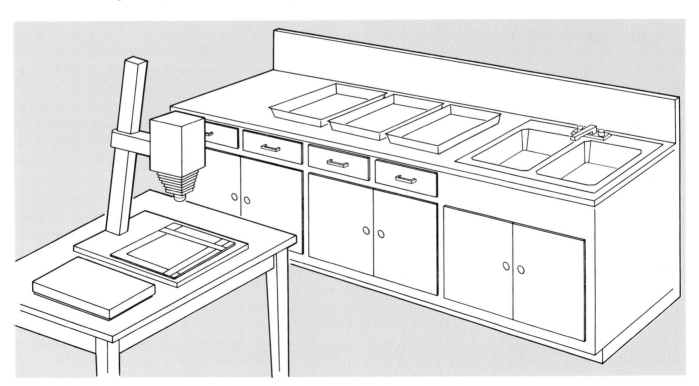

Fig. 8-1. A darkroom can be set up in any area that can be made light tight. A kitchen counter and sink as shown here work very well.

ENLARGER

The enlarger, Fig. 8-2, projects (casts) an enlarged image from the negative onto a sheet of print paper. It consists of a head, base, and a column.

The head holds a light source and LENS. A negative carrier holds the negative being printed. It is fitted into a slot between the lens and light source. The projected image is focused by increasing or decreasing the lens' distance from the negative. FOCUSING CONTROLS are located on the side of the head.

The size of the projected image is changed by moving the head up or down on the column.

Lenses, Fig. 8-3, used with an enlarger contain an aperture control much like the one in a camera's lens. The aperture on the enlarger lens controls the amount of light projected by the lens.

Enlargers are made in many sizes. Small, low-power enlargers take only small format negatives. Other enlargers are designed to accept both large and small format negatives.

Negatives are supported in a NEGATIVE CAR-RIER. The carrier holds the negative flat (very important for good prints) and centers it in the enlarger. A carrier also prevents stray light from passing through to the print.

There are two types of negative carriers:

1. DUSTLESS, Fig. 8-4. It is made of two hinged

Fig. 8-3. The enlarger lens controls the amount of light projected to the print paper.

Fig. 8-4. Negative carrier holds negatives to be enlarged. This one is a dustless type. Two sizes are shown.

metal plates with an opening in the center for the negative. The negative is sandwiched between the plates. Guide pins hold the negative in alignment. When closed, the plates hold the negative or strip of negatives by the edges.

2. GLASS SANDWICH CARRIER, Fig. 8-5. Two sheets of glass are mounted in a wood or metal frame. This type of carrier is preferred for large format negatives. It keeps them flat. Glass sandwich carriers have one disadvantage. They must be cleaned often since dust, lint, and fingerprints on the glass become part of the projected image.

EASEL

The enlarging easel, Fig. 8-6, holds the print paper flat under the enlarger lens. It also provides the mask for the white border around the print.

Some easels have masks for common print sizes, Fig. 8-7. Others have adjustable borders so that prints of any size can be made.

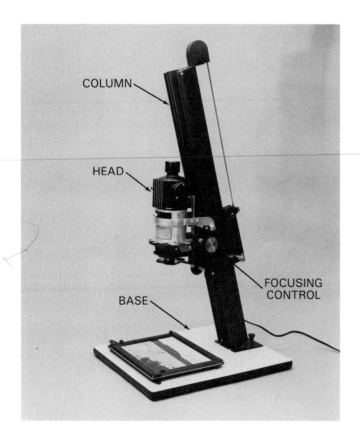

COLUMN

HEAD

BASE

FOCUSING CONTROL

Fig. 8-2. An enlarger of this type is found in many school darkrooms.

TIMER FOR ENLARGER

An enlarger lens has no shutter. Instead, a separate TIMER, Fig. 8-8, controls length of exposure. Exposure time is set on the timer dial. A bypass switch on the timer permits the enlarger to be used for focusing and composing without activating (starting) the timer.

Fig. 8-5. Glass sandwich type negative carrier holds large negatives flat between two pieces of glass.

Fig. 8-6. Enlarging easel holds print paper flat under enlarger lens.

Fig. 8-7. Some easels have openings for common size prints.

SAFELIGHT

A safelight, Fig. 8-9, is a special light fitted with a filter to screen out light that can fog black and white print paper. However, no light is completely safe. Refer to the data sheet furnished with your print paper for the safelight filter to be used and how far it should be kept from the paper.

Most black and white print paper is relatively insensitive to (does not react to) an amber filter safelight when it is used with a 15 watt bulb. The print paper must be kept at least 3 ft. (about 1 m) from the safelight. *Note: Undeveloped film is sensitive to rays from the safelight and will be fogged. Never load film into a developing tank with a safelight on.*

REMOVING DUST FROM A NEGATIVE

The usual way to clean a negative is with compressed air or a soft brush, Fig. 8-10. The best brushes are of the camel's hair and special antistatic types. Use brushes made for photo work. Other types of brushes may scratch the negatives.

Fig. 8-8. Since an enlarger lens does not have a shutter, a timer is needed to control the length of the exposure.

Fig. 8-9. A safelight is fitted with a special filter that screens out light that can fog print paper.

Fig. 8-10. Negatives are usually cleaned with clean, dry compressed air or a soft brush made especially for the purpose.

PAPER SAFE

A paper safe, Fig. 8-11, is a light-tight container used to store photographic papers. It is easier to remove print paper from the safe than from the envelope or box in which it was purchased.

PAPER CUTTER

The paper cutter, Fig. 8-12, is needed to trim print paper to size. Scissors and knives are difficult to use in the dim light of a darkroom.

FOCUSING AIDS

A focusing aid, Fig. 8-13, magnifies (makes larger) the image projected on the easel. When the image is focused in the aid, it will also be in focus on the easel.

Some aids greatly magnify a section of the projected image so the actual silver grains in the negative can be seen. These focusing devices are called GRAIN ANALYZERS. When the silver grains are in sharp focus, so is the projected image.

PROCESSING TRAYS

Developing solutions are held in processing trays, Fig. 8-14. At least three trays are needed. They should

Fig. 8-12. Paper cutter has adjustable stop. It is easy to use in dim light.

Fig. 8-13. There are many different kinds of focusing aids. They are a great help in focusing the enlarger to get the sharpest image on the print paper.

Fig. 8-11. A paper safe is a light-tight container used to store print paper.

Fig. 8-14. Processing trays hold chemicals for printmaking.

be arranged so the print is processed in an orderly way from exposure to fixing bath.

Wash the trays thoroughly after each processing session. Otherwise, the fresh chemicals may be contaminated the next time the trays are used.

Label the trays so the chemicals will always be used in the same trays. If they cannot easily be labeled, purchase trays of three different colors.

TONGS

Tongs, Fig. 8-15, should be used to move prints from tray to tray since they keep your hands out of the chemicals. Many people are allergic to the chemicals and may develop severe skin irritation as a result of direct contact with the solutions.

At least two pairs of tongs are needed. One is used with the developer. The other pair is used with the stop bath and fixer. Wash the developer tongs thoroughly should they accidentally be placed in the stop or fixer baths.

Fig. 8-15. Tongs are recommended to move prints from tray to tray. Avoid using bare hands. Two tongs are required. One is used with the developer, the other is used with the stop bath and fixer.

Use the tongs cautiously. Careless handling will scratch the prints.

TIMER (PROCESSING)

A timer, Fig. 8-16, is often recommended to keep track of processing times. It is started when tray processing begins. Poorly developed prints result when processed too long or not long enough. Most processing timers have a buzzer to indicate when processing time is up.

PRINT WASHER

Print washers are trays, Fig. 8-17, or rotating cylinders that provide a steady flow of clean water over the newly processed prints. All print papers require some wash time to remove traces of processing chemicals.

Fig. 8-17. Print washers provide steady flow of clean water over paper just processed. Data sheet provided with print paper will give information on washing times.

Fig. 8-16. Timers for processing. Left. This type is usually found in school darkrooms. Hands and numerals glow slightly so they can be seen in the dark. The light may cause some fog. (GraLab) Right. Programmable digital timer can be used for both processing and enlarging without disconnecting it from enlarger circuit. (Creative Phototronics, Inc.)

PRINT DRYER

There are several ways to dry prints. BLOTTERS or SQUEEGEES can be used to rid prints of water. RC (resin coated) papers need no more than this. Then they can be hung up or laid out to dry.

Fiber base papers must be dried with a heated PRINT DRYER, Fig. 8-18. The dryer maintains a constant temperature. Papers with glossy finish (but not RC papers) should be dried on a FERROTYPE PLATE. This is a polished chrome plate. Wet prints are placed face down on it. A ROLLER removes air bubbles. Then plate and prints are placed in the dryer. A glossy print lifts off of the ferrotype plate when the print is completely dry.

MIXING AIDS

Several tools are useful for mixing chemical solutions. STIRRING RODS are needed to agitate chemicals so they will dissolve more quickly when mixed with water, Fig. 8-19. A FUNNEL makes pouring liquids into containers easier.

Chemical STORAGE CONTAINERS, Fig. 8-20, should have covers or caps. They should be air and light tight to prevent oxidation (air entering) and breakdown of the chemical solutions.

Caution: Avoid using glass containers for safety reasons.

GRADUATES, Fig. 8-21, are used for mixing and measuring processing solutions. They must be

Fig. 8-20. Chemical storage containers should be air and light tight to prevent oxidation and breakdown of the processing solutions.

thoroughly cleaned each time they are used. This will prevent contamination of the solutions.

THERMOMETER

An accurate thermometer, Fig. 8-22, is required for photo processing. Solutions must be mixed at recommended temperatures. They should also be maintained at a constant temperature when processing prints. Refer to the data sheet furnished with the print paper.

TOWELS

Lint-free paper towels are recommended for the darkroom. They can be discarded after use. The towels will keep your hands dry and lessen the chance

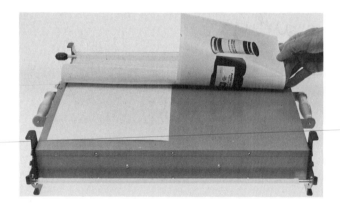

Fig. 8-18. Fiber base print papers should be dried on a heated print dryer. Otherwise, the prints will buckle and curl during the drying process.

Fig. 8-19. Stirring rod is needed to agitate processing chemicals so they will dissolve more quickly when mixed with water.

Fig. 8-21. Measuring graduates. Most have metric and U.S. Customary graduations.

Fig. 8-22. An accurate thermometer is required for photo processing. Many types are available.

Fig. 8-23. Print papers are manufactured in many finishes, contrasts, weights, and sizes. Use the one best suited for the job you are printing.

of contaminating print paper. Use them to wipe up spilled chemicals so the work area can be kept clean and dry.

APRON

An apron will protect your clothing from stains and damage by spilled processing chemicals. Aprons are usually made of plastic.

MISCELLANEOUS EQUIPMENT

Other tools and equipment will be useful in the darkroom. An EXPOSURE METER helps to analyze the density of a projected image. DODGING and BURNING-IN TOOLS and EXPOSURE GUIDES can make darkroom work easier.

Into this category also falls the darkroom VENTILATING SYSTEM. Some type of forced ventilation should be built into a darkroom that is used for long periods of time.

PRINT PAPERS

Print papers are available with two types of bases:
1. Fiber base.
2. Resin coated (RC) papers.

RC paper has a plastic coating that does not absorb processing chemicals. Processing and washing times for RC papers are greatly reduced.

Print papers are made in a variety of finishes, contrasts, weights, and sizes, Fig. 8-23. Finishes include glossy, matte, and textured.

Print papers can be obtained in a full range of contrasts. Grade 1 is the lowest contrast paper while a paper in Grade 5 will offer the highest contrast. Many print papers have VARIABLE CONTRAST. Contrast is controlled by special filters that are fitted to the enlarger, Fig. 8-24.

Paper weight refers to the thickness of the backing. Typical weights are single, medium, and double weights. *Unit 10* on *Making Black and White Prints* will cover print papers in more detail.

Fig. 8-24. Filters used with variable contrast papers. The filter selected to provide the required contrast is fitted into a special filter holder in the enlarger.

PRINTMAKING CHEMICALS

For best results, print processing chemicals must be fresh, free from contamination, and mixed as recommended by the manufacturer. Not all papers are compatible with all processing chemicals. Check with the paper's data sheet for the chemicals recommended for it. Also, check the sheets for the developing times.

Caution: Wash your hands thoroughly after each printing session.

NOTE: Processing chemicals are covered in more detail in the unit on *Making Black and White Prints*.

WORDS TO KNOW

Dodging, enlarger, easel, ferrotype, grain analyzer, negative carrier, paper safe, print dryer, print roller, print washer, processing tray, safelight, squeegee, tongs.

THINGS TO DO

1. Check over the darkroom. Clean and organize the area. Examine all equipment and make necessary repairs and/or replace broken or damaged items.
2. Plan a darkroom use schedule for your class.
3. Prepare a supply of developing chemicals. Label the contents of each container, when they were mixed, and who mixed them.
4. Devise a way to control darkroom supplies.
5. Organize and implement a maintenance program for the darkroom. Each student should be expected to accept their responsibilities in keeping the area clean and in proper operating condition.
6. Plan a temporary darkroom for your home.

TEST YOUR KNOWLEDGE

1. A _____ is a light tight room equipped for darkroom work.
2. Which of the following statements best explains why a timer is needed on an enlarger?
 a. A shutter would not be accurate enough for exposure of print paper.
 b. An enlarger has no shutter; thus, exposure must be accurately timed by another means.
 c. The shutter on the enlarger must be activated by the timer.
3. Which of the following devices protect print paper from exposure to light:
 a. Safelight.
 b. Paper safe.
 c. Darkroom.
 d. Developer.
 e. None of the above.
 f. All of the above.
4. Name the two types of negative carriers and describe their construction.
5. A (soft brush, squeegee) is best for removing dust from a negative.
6. A _____ may be used to magnify the image on the print paper so that you can see the actual grains of silver in the negative.
7. Explain why you might purchase developing trays of three different colors.
8. At least (two) (three) pairs of _____ are needed to remove prints from solutions.
9. There is no need for more than one timer in the darkroom. True or False?

MATCHING TEST: On a separate sheet of paper match the correct definition in the right-hand column with the name or term in the left-hand column. Place the correct letter in the blank opposite the number.

10. ____Graduates.
11. ____Thermometer.
12. ____Variable contrast print paper.
13. ____Resin coated papers.
14. ____Print dryer.
15. ____Ferrotype plates.

a. Print paper having selective contrast for different density negatives.
b. Checks solution temperatures.
c. An aid for drying fiber base prints.
d. Used for measuring chemical solutions.
e. Plastic coated print paper.
f. Polished metal sheets for drying glossy finish fiber base print paper.

9 HOW TO DEVELOP BLACK AND WHITE FILM

After studying this chapter you will be able to:
☐ Describe what happens during the process of developing and fixing film.
☐ Mix and store chemicals for darkroom work.
☐ Load film into developing tanks working in complete darkness.
☐ Process film through developer, stop bath, and fixer solutions using proper temperature and time.
☐ Wash and dry film.

As we have said before, a photograph is a picture made with the aid of a camera, film, and light. However, when a photograph is taken by conventional means, nothing can be seen until the film is developed.

Developing is a method of bringing the image out of the film so it can be seen. It is done with chemicals. The process must usually be carried out in complete darkness. The information sheet packed with the film will give exact instructions.

After it has gone through the development process the film is known as a NEGATIVE. It is so called because the image is the exact opposite of the subject photographed, Fig. 9-1. That is, light areas of the subject, are seen as dark areas on the negative. Dark areas of the subject are light areas on the negative.

Film development is perhaps the most crucial (important) of all photographic activities. An error here can ruin an entire roll of exposed film. *Take your time and carefully follow instructions.*

CHEMICALS NEEDED TO DEVELOP BLACK AND WHITE FILM

Three basic chemical solutions are needed to develop exposed black and white film:
1. DEVELOPER.
2. STOP BATH.
3. FIXER.
It is recommended that commercially prepared chemicals be used, Fig. 9-2.

Caution: Mix the chemicals in plastic jugs. They do not shatter when accidentally dropped.

HOW DEVELOPING CHEMICALS WORK

The developer changes exposed silver salts, which cannot be seen, into black metallic silver which can be seen. The information sheet enclosed with your film,

Fig. 9-1. A negative shows the subject photographed in reversed tones.

117

Fig. 9-2. Chemicals needed to develop black and white film. Commercially prepared processing chemicals are recommended.

Fig. 9-3, will recommend developers.

It is important to use the correct one. In addition to bringing out the image on the film, a developer must do two things without damaging the film, emulsion, or the quality of the image:

1. Absorb many of the chemicals released during the process of changing silver salts into metallic silver.
2. Cause the emulsion to swell for easier and greater penetration of the developer.

STOP BATH

Stop bath is a weak acid solution used after the developer. It neutralizes (makes inactive) the developer and prevents further development. Acetic acid is most often used for the stop bath. It comes in concentrated (strong) form and must be diluted with water.

Caution: Pour the acid into the water not the water into the acid. Wear a full face shield, protective gloves, and a rubber or plastic apron when mixing chemicals.

Stop bath may have a color indicator added. The solution, yellow when first mixed, starts turning purple as it loses strength.

FIXER

After the film has gone through developer and stop bath, the image can be seen. However, it is still light-sensitive and opaque. Fixer dissolves all remaining unexposed silver salts in the film emulsion. Then the salts can be removed by washing the film in running water.

Sodium thiosulphate or sodium hyposulphite, commonly called HYPO, is most often used as a fixer. Ammonium thiosulphate is employed in rapid fixers because it works faster.

After fixing, the film will no longer react to light.

Do not expose the film to light until the fixing cycle is complete.

Most fixers contain a hardener, usually potassium alum. The hardener firms and toughens the emulsion. A negative treated with hardener is less likely to be damaged from normal handling.

There are two types of fixers:

1. Regular fixers which take 5 to 10 minutes to do their job properly.
2. Rapid fixers needing only 2 to 5 minutes to fix the film emulsion.

The exact time your film must remain in the fixer is shown on the information sheet. These instructions should be carefully followed.

Film must be thoroughly washed to remove all tracers of fixer before the negative dries. Wash temperature must be kept between 60-75°F (16-24°C)

Fig. 9-3. Information sheet furnished with your film lists the developers, processing times, and temperatures recommended. (Eastman Kodak, Co.)

118

for best results. Wash film for 20 to 30 minutes in clean, running water.

A fourth chemical solution, HYPO CLEARING AGENT, may be used after fixing to reduce wash time. It also saves water. Procedure and wash time will vary according to the product used.

MIXING DEVELOPING SOLUTIONS

All chemical solutions should be mixed according to the instructions provided. Use special care to mix the solutions at the right temperatures. Improperly mixed chemicals can cause poor quality negatives or may even destroy them.

Caution: Most chemicals used to develop film can cause skin irritation. Wear protective gloves when mixing and using the chemicals. The solutions can also stain and damage your clothing. It is recommended that you wear a rubber or plastic apron.

The chemical solutions can be stored in the jugs in which they were mixed. *Never let them freeze or get warmer than room temperature.*

All developers have a WORKING LIFE. This is the period of time that the mixed solutions retain their usefulness. After that time they should be replaced. Working life is indicated on the mixing instructions included with the chemical. Clearly label the contents of each container and the mixing date, Fig. 9-4.

REPLENISHERS are made for some developers. This chemical is added to a developer to extend the solution's working life. A replenisher should only be used if an accurate count is kept of how much film has been processed with the developer.

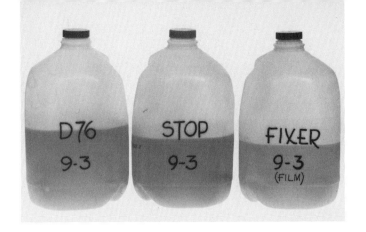

Fig. 9-4. Containers storing processing chemicals should be clearly labeled and dated.

Note: Until you have acquired more experience developing film, it is recommended that the developer be thrown away after each use.

HOW TO USE DEVELOPING SOLUTIONS

Check solution temperature before use. Developer temperature is most important. Again, refer to the film's instruction sheet for the best temperature range. Usually several temperatures are given. Each will produce suitable results. However, 68°F (20°C) is preferred for best results.

Development takes longer when developer temperature is less than 68°F. Shorter developing times are required when developer temperature is higher than 68°F. Avoid temperatures at either extreme. They can cause graininess and uneven development. See the graph in Fig. 9-5.

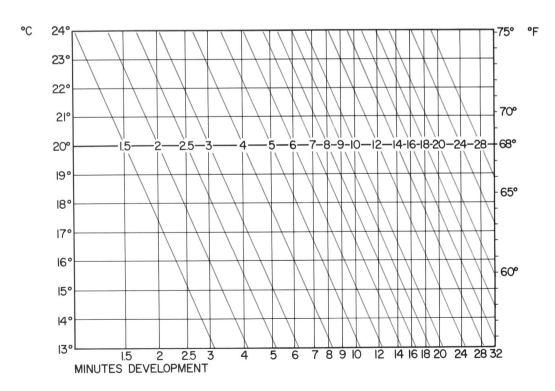

Fig. 9-5. Development times vary with solution temperatures. (Ilford, Inc.)

ADJUSTING TEMPERATURE

Solution temperature can be adjusted. Pour the required amount of solution into a thin-walled container. Place the container in a plastic tub of warm or cool water, Fig. 9-6. Remove the container when the correct temperature is reached. Check temperature with an accurate photographic thermometer, Fig. 9-7.

Stop bath and fixer temperatures are not as critical. However, for best results, they should be held to within 3 to 5 degrees of developer temperature.

DEVELOPING TANK

The easiest way to develop 35 mm and 120 film is in a developing tank, Fig. 9-8. Once film is loaded into the tank, lights can be turned on.

Developing tanks are either metal or plastic. They are made to hold various film sizes. Some can hold

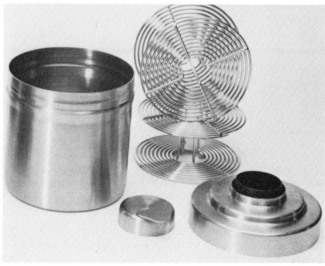

Fig. 9-8. Developing tanks are made of either plastic or stainless steel.

Fig. 9-6. Processing temperatures can be adjusted to and maintained at the recommended processing temperature by placing the containers in a water bath of the proper temperature.

more than one reel. Thus, more than one roll of film can be developed at a time. However, the film must be of the same type (for example, Tri-X) and must be exposed at the same speed.

When metal reels are used with the tanks, attach the film to the center of the reel, Fig. 9-9. Then gently

Fig. 9-7. An accurate thermometer is a must when processing film.

Fig. 9-9. Metal reels used in some developing tanks are made so the film is attached to the center of the reel. Then by gently squeezing the edges of the film, it is wound around the reel's spiral.

squeeze in the edges of the film. At the same time, wind it around the reel's spiral. Practice with an old length of film before trying to load exposed film in the dark.

When handling film, do not touch the surfaces of the exposed film. Handle it carefully by the edges. This will prevent scratches and finger prints on the prints.

Most plastic tanks have a ratchet type reel. The ratchet device automatically winds the film on the reel. Film is inserted into the starting slot, Fig. 9-10. Twist the reel flanges (rims) back and forth until the film is wound into place.

Exposed film must be wound on the reel in complete darkness. However, the tanks are light tight. Lights can be turned on after the loaded reel is placed in the tank and the lid is locked in place.

Tank covers have openings so the tank can be filled and emptied without removing them. The openings are light tight. The tank can be filled and emptied in full light.

The openings in some tank lids are capped to prevent spillage during agitation. Agitation is done in some tanks by inverting the tank (turning upside down) at timed intervals. Agitation assures that fresh solution will be touching the film at all times.

When multi-reel tanks are used, empty reels must be placed on top of the film reel to fill the tank. This prevents the film reel from sliding about and causing uneven development.

HOW TO REMOVE FILM FROM ITS CANISTER

Film must be removed from its canister before it can be wound onto the tank reel. This must be done in complete darkness. A darkroom or a light-tight FILM CHANGE BAG, Fig. 9-11, is recommended.

Fig. 9-11. A film change bag can be used to load film into a developing tank.

When using a darkroom or a closet for this purpose, wait a few minutes for your eyes to adjust to the darkness. Sometimes faint light is not noticed by your eyes until they are adjusted. This faint light may cause light streaks on the developed film. Also, illuminated dials on the timer and other equipment should be covered.

To use the film change bag put all needed equipment in the bag. Then seal the bag and insert your hands, Fig. 9-12.

Before turning off the light, or sealing the film change bag, be sure you know where everything is located, Fig. 9-13. You will need the tank, reel, tank lid, film canister (if 35 mm), canister opener, and scissors.

The film canister can be opened with a bottle opener if a commercial opener is not available. With either type, one end of the canister is popped off, Fig. 9-14. Slide the plastic spool out of the canister and cut

Fig. 9-10. Most plastic tanks use a ratchet type reel. The ratchet device automatically "pulls" the film onto the reel.

Fig. 9-12. Place all of the equipment shown into the bag and seal it. Then insert your hands.

Fig. 9-13. If using a darkroom, have all equipment placed where you can find it in the dark.

Fig. 9-15. Round the leader for easier insertion of the film onto the tank reel.

Fig. 9-14. Opening a film canister. Caution: Open it in a lightproof area.

off the film leader. Round the leader so the film will slide into the tank reel more easily, Fig. 9-15.

Roll the exposed film onto the tank reel. Do not let the film drag on the floor. Scratching may result. When the end of the film is near, cut away the film spool.

Use care when winding the film on a metal reel. Be sure the film does not crimp and touch film already on the reel. Dark marks will occur where contact is made ruining the negatives at this point.

Place the properly loaded reel in the developing tank. Check to be sure the lid is locked in place. The lights may now be turned on.

HOW TO USE THE DEVELOPER

Developer can be used as mixed or it can be diluted (mixed with more water). The instruction sheet furnished with the film will suggest dilutions. The list will show numbers like 1:1 or 1:3. These are DILUTION FACTORS. A 1:1 mixture contains equal amounts of developer and water. The 1:3 mixture contains one part developer and three parts water.

When using a diluted developer solution, mix only

enough to fill the developing tank. This is usually 8 or 9 oz. for a 35 mm reel. (A multi-reel tank will need this amount for each reel the tank holds.)

Diluted developer is less expensive. It also gives better grain results in some instances. However, a longer development time is needed with diluted solutions.

To develop the film, measure out the proper amounts of developer, stop bath, and fixer. Check their temperatures. Warm or cool them as necessary. Pour developer into the tank, Fig. 9-16. Start the TIMER, Fig. 9-17.

Rap the filled tank on a hard surface several times during the first minute of development. This will dislodge air bubbles that may be clinging to the film.

Agitation also starts at this time. Again, the film instruction will show how often the tank must be agitated. Remember, agitation times (along with development times) vary when more than two rolls of film are being developed in the same tank.

Fig. 9-16. Start timing as soon as the developer is poured into the tank.

Fig. 9-17. Any of these timers can be used to assure accurate processing times.

Some tanks are agitated by inverting (turning upside down) and then righting them. Caution: The tank lid must be tightly capped to prevent spillage. Most plastic developing tanks are agitated by rotating the thermometer fitted into the film reel, Fig. 9-18.

Agitate the film at the specified intervals until 30 seconds before development time is up. Remove the lid cap and gently pour the developer from the tank. *Do not remove the tank lid at this time. The film is still light sensitive.*

Diluted developer should be discarded. It will not develop more than one roll of film properly.

When undiluted developer is used it can be saved. Return it to its original container. Keep a record of the number of rolls it has developed. When it has reached its capacity it loses its ability to properly develop the film. It should then be discarded.

When many people are using the same chemicals it is hard to keep count. Then it is best to discard the developer after each use.

HOW TO USE STOP BATH

After the developer has been drained from the tank, pour in the stop bath. Use the same amount of stop bath as developer.

At the end of 30 seconds pour out the stop bath solution. This can be poured back into the original container and reused. Discard the entire batch of stop bath when it changes color.

HOW TO USE FIXER

Pour the fixer into the tank. Agitate at the same time intervals as the developer. Fixing times vary according to the type of fixer used. Set the timer for the length of time indicated on the instruction sheet.

Fixer can also be reused. As with the developer, keep a record of the number of rolls fixed. You can determine the freshness of fixer with a HYPO CHECK, Fig. 9-19. Place a drop or two of this solu-

Fig. 9-18. Many plastic developing tanks are agitated by rotating the thermometer fitted into the film reel.

Fig. 9-19. Check the fixer with a hypo check from time to time to be sure it is usable.

tion in the fixer. If a white precipate (solid material) forms, discard the fixer. A gallon of fix will process about 60 rolls of 35 mm film. When fixing is complete, the tank lid can be removed, Fig. 9-20.

WASHING

When you have poured off the fixer, immediately wash the film (while on the reel) with running water. Wash for 25 to 30 minutes to remove all traces of fixer.

To wash, leave the reel in the tank and place the tank under a water tap. The water should be near the developing temperature. Empty the tank several times during washing.

If hypo clearing solution is used, Fig. 9-21, the film is washed for at least a minute. Then pour enough of the solution into the tank to cover the film reel. Agitate as recommended. Hypo clearing solution removes all traces of the fixer chemically. This greatly reduces washing time and saves much water.

When the film has been submerged (covered with liquid) in the solution for the required time, the

chemical can be discarded. Wash again. Wash time is shown on the hypo clear container.

After the film has been thoroughly washed, a WETTING AGENT can be added to the water, Fig. 9-22. The wetting agent prevents water from beading on the film and forming water marks. (Water marks are little spots left on the negative as the film dries. They will show up when the prints are made.)

DRYING

After washing, the film may be removed from the tank reel and hung to dry, Fig. 9-23. Let one end of the film hang loose but place a clip on the loose end. This will reduce film curl.

Fig. 9-22. A wetting agent prevents water from beading on the film as it dries.

Fig. 9-20. After the film has been fixed, the tank lid can be removed and fix poured off.

Fig. 9-21. A hypo clearing solution will greatly reduce wash time. It chemically removes all traces of fixer.

Fig. 9-23. Hang film to dry in an area free of dust. A second clip attached to the loose end of the film will reduce film curl.

If no wetting agent is used, excess water must be removed from the film. This can be done with a photographic grade sponge or squeegee, Fig. 9-24.

Fold the sponge around the film under medium pressure and slowly move it down the film. Only light pressure need be applied when a squeegee is used to dry the film.

Regardless of whether the sponge or squeegee is used to dry the film, these tools must be kept very clean. *Use them only on film and store in clear plastic bags to prevent contamination.* Even a small speck of dust on the sponge or the squeegee can put a scratch down the entire length of the film.

Fig. 9-24. If no wetting agent is used, excess water may be removed from the film with a photographic grade sponge or a squeegee. A clean sponge is preferred to the squeegee.

After removing as much water as possible let the film dry in a dust-free area. *Keep dust from the film.* Allow the film to dry for at least an hour or two. Use a film drier when speed is necessary.

When the film is completely dry, cut the negative into convenient lengths. Place each length into its own plastic or glassine sleeve, Fig. 9-25. Sleeves can be labeled and filed for easy access. *Never store film negatives in regular postal envelopes. Chemicals in the paper can damage the negatives.*

PROCESSING CHROMOGENIC FILM

Since chromogenic black and white film is similar in structure and characteristics to color film, it is processed using a color negative (C41) developer, or a special developer formulated especially for the film, Fig. 9-26.

Like color film, chromogenic film must be processed at elevated temperatures (100°F or 38°C). Normal developing time is 5 minutes. The complete processing cycle, including washing, takes about 15 minutes. Only two solutions, a developer and bleach/fix, are required.

Caution: For best results, carefully follow instruction sheets furnished with the film and processing chemicals.

WORDS TO KNOW

Developer, dilution factor, film change bag, fixer, hypo, hypo clearing agent, replenishers, stop bath, wetting agent, working life.

Fig. 9-25. Store film negatives in plastic or glassine sleeves made for the purpose. They can be labeled and filed for easy access.

Fig. 9-26. For best results, chromogenic black and white film should be processed in developer especially made for it.

TEST YOUR KNOWLEDGE

1. When developed, each picture on a strip of film is known as a _____ because _____ _____.
2. Film is developed by a _____ process.
3. List the steps in the developing sequence that must be done in complete darkness.
4. After what step in the developing sequence can the film be safely viewed in normal light?
5. In addition to bringing out the latent image on the film, the developer must do what two things without damaging the film, emulsion, or image quality?
6. The stop bath is used in the developing sequence to _____.
7. The fixer must be used in the developing sequence because if must_____ _____.
8. To reduce film washing time, a _____ may be used.
9. The working life of a developing chemical solution is: (Check the correct answer or answers.)
 a. The length of time the chemical is used during development.
 b. The length of time the chemical can be used after mixing.
 c. The time needed to mix the chemical.
 d. All of the above.
 e. None of the above.
10. The temperature of the developer should be carefully checked because_____ _____.
11. When winding film onto a developing reel handle the film by the _____ to prevent scratches

and fingerprints.
12. A diluted developer solution: (Check the correct answer or answers.)
 a. Is less expensive to use.
 b. Will, in some instances, produce better grain results.
 c. Requires a longer development time.
 d. All of the above.
 e. None of the above.
13. What can be done to determine that the fixer you are using is satisfactory?
14. A wetting agent may be used after the film has been thoroughly washed to _____.
15. After the film has been dried and cut into convenient lengths, it should be _____.

THINGS TO DO

1. Secure the materials needed to develop black and white film. Carefully read the instructions and safety precautions that should be observed when mixing and using the solutions. Prepare a written list of the precautions and how you plan to observe them.
2. Observing the mixing precautions listed on each chemical packet, mix the chemicals as instructed. Label the containers with the name of the solution, its dilution, and the date it was mixed. Thoroughly clean the area after the mixing is done and carefully wash your hands.
3. Using scrap or outdated film, practice loading the film on a developing tank reel until you are able to do it in the dark.
4. Get your film ready to be developed. Load it on a reel and place it in a daylight developing tank. Check the temperature of the developer and determine how long normal development will take. Develop your film. When the film has dried, cut it into suitable lengths. Evaluate the quality of your work. Prepare a short report on the problems encountered and how you plan to correct them.
5. Shoot a roll of film. In the darkroom, cut the unprocessed film into suitable lengths and develop each segment differently. Overdevelop one section. Underdevelop another. Other segments can be developed in solutions warmer and colder than recommended temperatures (at least 10°F or 5°C difference). Another segment can be developed without "rapping" the tank on a hard surface to dislodge air bubbles. Other segments can be developed without using stop bath or fixer. Label each film section after it has dried.

 Evaluate your work and prepare a report on your findings. Mount the segments on a light box so your class can more easily see the results.

10 MAKING BLACK AND WHITE PRINTS

After studying this chapter you will be able to:
☐ List and discuss characteristics of print paper including paper bases, textures, weight, and contrast.
☐ Produce photographic prints by contact and enlargement.
☐ Use printing aids including projection print scale and print exposure meter.
☐ Improve prints by cropping, dodging, burning-in and scratch removal.
☐ Describe stabilization printing processes.

To get a photograph which looks like the original scene or subject the image on the negative must be transferred to light-sensitive paper. This transfer process is called PRINTING. The paper to which the image has been transferred is called a PRINT. In black and white photography, printing reverses the tones. Parts of the image that are white or clear on the negative are dark on the print. What is dark on the negative comes out light on the print.

HOW PRINT PAPER WORKS

Photographic or print paper works a great deal like film. A support or BASE of paper is coated with a light-sensitive EMULSION.

To make the emulsion, tiny silver halide crystals are suspended in a special gelatin. Fig. 10-1 is a sketch of the paper with emulsion crystals magnified.

When the paper is exposed to light through a negative, a LATENT IMAGE forms. This is an invisible image formed by the reaction of light upon the silver halide crystals. It becomes a visible image after it is soaked in special chemicals, Fig. 10-2.

DEVELOPING CHEMICALS

DEVELOPER is an alkaline chemical that causes the light-struck silver crystals to turn black, Fig. 10-3. Particles not struck by light are unaffected by the developer. (Alkaline means the substance contains a salt such as is obtained from the ashes of plants.)

An acidic (contains acid) STOP BATH halts the

Fig. 10-2. Three special chemicals, developer, stop bath, and fixer, are necessary to change the latent image on exposed print paper to a visible image.

Fig. 10-1. Print paper emulsion consists of microscopic silver particles suspended in a special gelatin.

Fig. 10-3. Silver particles that have been struck by light during exposure turn black when processed in developer.

developing process. The undeveloped silver particles are dissolved by another acidic chemical called FIXER. These are removed by washing the print in running water, Fig. 10-4.

The remaining black silver particles form a positive image. The latent image is now visible. The different shades of black and gray are really clumps of silver called GRAIN in varying degrees of concentration. Dark areas are very concentrated. They are referred to as being dense. DENSITY is the amount of silver left after exposure and development.

CHARACTERISTICS OF PRINT PAPER

Print paper has many characteristics. Each interacts (act upon one another) to make the many types of print paper unique.

These characteristics are:
1. Paper bases.
2. Surface texture.
3. Weight.
4. Contrast.

PAPER BASES

The emulsion rests on a supportive base. There are two base types, fiber and resin coated (RC), Fig. 10-5.

Fiber base paper, until recently, was the only type of printing paper available. Since the fibers soaked up large quantities of chemicals and water, they required long washing and drying times.

Resin coated paper has a waterproof base. RC

Fig. 10-4. Unexposed silver particles are dissolved by fixer and washed away. Only silver particles affected by light remain and form the visible image.

paper prints are just as permanent as prints made on fiber base paper. The RC image, however, must be protected from solvents which affect the plastic coating. Since RC papers do not absorb processing chemicals, fixing, washing, and drying times are much shorter. See Fig. 10-6. As a result, there are savings in water and heat (for drying).

SURFACE TEXTURES (FINISHES)

Print papers are made in a large range of surface textures. Included are:
1. Glossy finish.
2. Semi-matte finish.
3. Pearl finish.
4. Silk finish.
5. Fabric finish.

Most print paper is produced in pure white. However, off-white, cream, buff, tan, gray, and blue tint can be had on special order.

The glossier the surface, the darker the blacks and the brighter the whites appear to be. Glossy surfaces also show details most clearly. It is usually required for prints that will be reproduced in books, magazines, and newspapers.

Semi-matte, pearl, and silk surfaces reflect less light and yield less apparent contrast. They seem to avoid the fingerprints to which the glossy surface is sensitive.

PAPER WEIGHT

The weight of a print paper refers to its thickness. Single weight paper is relatively thin. It and medium weight paper are used for most general photo purposes because they are less expensive.

Double weight paper is generally used for large prints or for prints that will get rough usage.

CONTRAST

Contrast is the difference in density (blackness) between the light and dark areas on a print. For normal contrast prints it is necessary to match the contrast grade of the paper to the negative.

A high contrast paper is used with a low contrast negative (little difference in density), Fig. 10-7. With

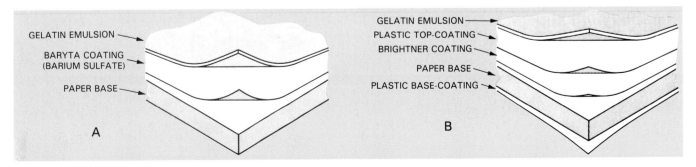

Fig. 10-5. Structure of print paper. A—Fiber base print paper. B—Resin coated (RC) print paper.

TYPE OF PRINT PAPER	TIME IN DEVELOPER*	TIME IN STOP BATH	TIME IN FIXER**	WASHING TIME***
Fiber base papers	3/4 — 2 min. (1 min. recommended)	5 sec. (minimum)	5 — 10 min. (10 min. maximum)	60 min. (minimum)
Resin coated (RC) papers	3/4 — 2 min. (1 min. recommended)	5 sec. (minimum)	2 min.	4 min.

*Developed at 68 °F (20 °C)
**Agitate the prints by interleafing them during fixing.
***Washing must be done by running water at 65 to 75 °F (18.5 to 24 °C). Interleaf prints frequently.

Fig. 10-6. Table shows difference in times needed to wash and fix fiber base and RC print papers.

high contrast negatives (great differences in densities), use low contrast paper, Fig. 10-8.

GRADED CONTRAST PAPERS are designated No. 1 through No. 5, or soft, medium, hard, extra hard, and ultra hard.

Until you have gained some experience, it will only be necessary to be concerned with:
1. Grade No. 1 (soft) for high contrast negatives.
2. Grade No. 2 (medium) intended for normal contrast negatives.
3. Grade No. 4 (extra hard) intended for low contrast negatives.

VARIABLE CONTRAST PAPERS are used with special filters, Fig. 10-9. These papers provide the entire contrast range in one sheet of print paper.

The filter kit has seven filters numbered 1, 1 1/2, 2, 2 1/2, 3, 3 1/2, and 4. The half steps give finer control with negatives needing an in-between grade for best results. The filter numbers correspond with the numbers of graded contrast papers.

MAKING THE PRINT

There are two ways to make a print. The first is to place a negative on a piece of print paper and expose it to light. This is called a CONTACT PRINT. The second is to place the negative in an optical device called an ENLARGER. A print is made by projecting

Fig. 10-7. A low contrast negative can be printed on a high contrast paper to produce a print of near normal contrast.

Fig. 10-8. A high contrast negative can be printed on a low contrast paper to produce a print of near normal contrast.

129

the image onto print paper. This is called an ENLARGEMENT.

Fig. 10-9. Variable contrast filters are fitted in the enlarger to provide a range of contrasts with one type of print paper.

CONTACT PRINTING

You can see the content and quality of the pictures on a roll of negatives by making a CONTACT or PROOF SHEET, Fig. 10-10. This is an actual size print of all of the negatives on a roll. Close examination will show which of several similar negatives is best for enlarging. All negatives do not have the same density so some individual prints will be darker or lighter than others on the proof sheet.

HOW TO MAKE A CONTACT PRINT

Any room that can be darkened will serve for printing. Paper is not as sensitive to light as film. Minor light leaks such as from under the door probably will not affect the paper.

Caution: Keep any room used as a darkroom spotlessly clean. Dust and dirt will cause spotted prints.

Follow this procedure for making a contact print.

Fig. 10-10. A contact sheet is an actual size print of all of the negatives on a roll of film.

The following steps can be carried out with the lights turned on:

1. Assemble the following equipment for printing. See Fig. 10-11.
 a. Contact printing frame. A piece of 10 x 12 in. (250 mm x 300 mm) plate glass will do if no printing frame is available.
 b. Light source, preferably an enlarger.
 c. Four trays, each large enough to hold the largest print sheet.
 d. Chemicals—developer, stop bath, and fixer.
 e. Safelight.
 f. Resin coated (RC) variable contrast print paper.
 g. Timer or watch.
 h. Graduates, thermometer, and tongs.
 i. Sponge, squeegee, and lint free paper towels.
2. Mix all the chemicals according to the manufacturer's directions. Make sure the solutions are within the recommended temperature range.

Caution: Read and follow the warnings on the chemical packaging, Fig. 10-12. Avoid prolonged skin contact. Eye irritations may result to persons wearing contact lenses. Mix chemicals in a well ventilated area. Wash hands thoroughly after mixing and/or using processing chemicals.

3. Arrange trays so prints are processed in an orderly way from exposure to fixing bath and washing, as illustrated in Fig. 10-13.
4. Pour 1 in. (25 mm) of developer into the first tray. Pour stop bath into the center tray and fixer into the remaining tray. This arrangement helps prevent mistakes in the dark.
5. Clean the contact printing frame to remove dust and fingerprints.
6. Place the negatives in the frame's slots so the shiny side of the negatives face the glass. Failure to do this will produce reversed prints.

The following steps must be carried out with lights off and safelight on:

7. Remove a single sheet of paper from the pack or

Fig. 10-11. Gather darkroom equipment and supplies for printing. Top. Contact printing frame, negatives, and RC print paper. Bottom. Other equipment needed to make a contact print. How many can you name?

Fig. 10-12. Read and observe the warnings on processing chemicals. Mix them exactly as specified by the manufacturer.

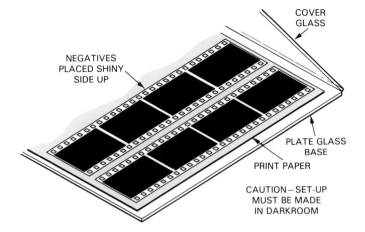

Fig. 10-14. If a sheet of glass is to be used, assemble negatives on top of paper shiny side up. Cover negatives with the glass. Be sure the glass is clean.

Fig. 10-15. Put the red filter under the lens before turning on the enlarger's light. The red light will not affect the paper.

paper safe. Place it in the printing frame emulsion (shiny) side up. If using a sheet of glass, assemble the negatives on top of the paper, Fig. 10-14. Close the frame or cover the negatives and paper with the glass.

8. Place an empty negative carrier in the enlarger. Open the lens to the largest opening. Position the enlarger's red filter under the lens, Fig. 10-15. Turn the enlarger light ON. Adjust the enlarger head so all of the negatives are covered by light, Fig. 10-16. The red filter prevents the paper from being exposed while the frame is positioned.

9. Turn the enlarger light off. Remove the red filter. Stop down the lens to f/11. Set the timer to 10

sec. and expose. A little experimentation may be necessary to determine the best exposure.

10. Remove the exposed paper from the printing frame. Handle the sheet only by the edges. With

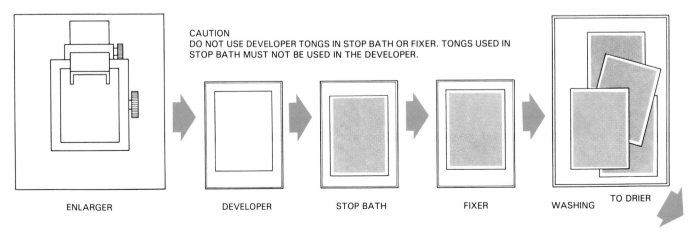

Fig. 10-13. Arrange the processing trays in an orderly way from developing to fixing and then on to washing.

Fig. 10-16. Adjust the enlarger's head so all of the negatives are covered with light.

1/8 - 3/16 DIA. DOWEL

Fig. 10-18. Rock the developer tray for 1 to 1 1/2 minutes. A small dowel can be used as a pivot to improve rocking motion.

one swift motion, slide the paper into the developer, shiny side up, Fig. 10-17. If any portion of the sheet remains above the surface, push it under with the tongs.

11. Rock the tray gently for about 1 1/2 minutes, Fig. 10-18.

12. Remove the print from the developer. Grasp it with tongs by the edge, Fig. 10-19. Drain for 5 sec. and immerse in stop bath. Agitate for 15 sec.

13. Remove the print from the stop bath. Drain and immerse in fixer, Fig. 10-20.

The following steps can be carried out with the lights on:

14. Fix the print for two minutes with gentle agita-

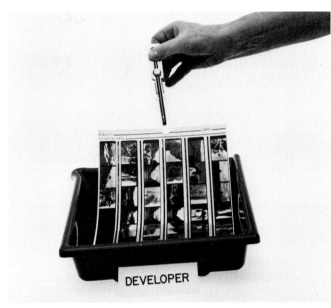

Fig. 10-19. Remove the print from the developer with tongs and drain over the tray for about five seconds.

Fig. 10-17. Slide exposed print paper into developer with one swift motion.

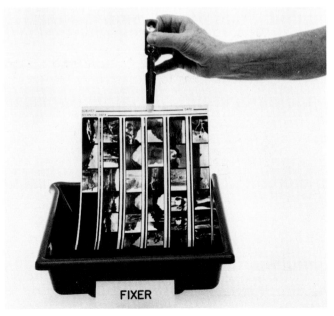

Fig. 10-20. Immerse the developed and stopped print in fixer for two minutes.

tion. If the print is too light, double the exposure time. If too dark, expose for half the time.

15. Wash the fixed print in running water for four minutes, Fig. 10-21.
16. Place the print on clean news print or a blotter made for photo work. Remove excess water with a photo sponge or squeegee, Fig. 10-22.
17. Place the print on a clean, flat surface and allow it to dry at room temperature.

HOW TO MAKE AN ENLARGEMENT

A good negative can be made into an excellent print by careful enlarging. Detail almost lost in a negative,

Fig. 10-21. Wash the print in running water for four minutes.

Fig. 10-22. Remove excess water with a clean photo sponge or squeegee.

Fig. 10-23. A good negative can make an excellent print on resin-coated paper.

such as a face in a group, can be made the center of interest. Unwanted details can be eliminated from the edges of a negative. The range of tones can be changed with different print papers. It is even possible to compensate for poor exposure on some negatives.

To make an enlargement on variable contrast resin-coated (RC) paper, Fig. 10-23, use the following procedure:

With the lights on:

1. Prepare the chemicals. They are the same used to make the contact prints. Arrange the trays so the print will be processed in an orderly manner from exposure to washing.
2. Select the negative.
3. Holding the negative(s) by the edges, remove dust from both sides, Fig. 10-24.
4. Insert the negative into the negative carrier, emulsion (dull) side down. Slide the carrier into the enlarger, Fig. 10-25. Open the enlarger lens to maximum aperture.

With lights off and safelight on:

5. Turn the enlarger on and project the image. Position the easel under the projected image. If necessary, adjust the height of the enlarger head so the image will fill the easel frame, Fig. 10-26.
6. Using a focusing aid, adjust the lens for the sharpest possible image, Fig. 10-27.
7. Set the lens aperture to f-11. Turn the enlarger off.
8. Take a sheet of print paper by the edges. Insert it

Fig. 10-24. Hold negative by its edges and dust both sides. On hot, humid days wear lint-free cotton gloves that are available at most photo supply shops.

Fig. 10-26. Adjust height of enlarger head so the portion of the negative you want to print will fill easel frame.

TURNING THIS KNOB RAISES AND LOWERS ENTIRE HEAD TO INCREASE OR DECREASE SIZE OF PROJECTED IMAGE

TURNING THIS KNOB RAISES AND LOWERS LENS INTO FOCUS

Fig. 10-25. Place negative in carrier, emulsion (dull) side down. Insert carrier into enlarger.

Fig. 10-27. Using a focusing aid will produce the sharpest image possible.

in the easel emulsion (shiny) side up. If a paper safe is not used, be sure the paper pack is completely reclosed and light tight after removing the sheet.

9. Secure a sheet of cardboard. Place it over the easel so that about 2 in. (50 mm) of the print paper is uncovered, Fig. 10-28.

10. Set the enlarger timer for five sec. and make an exposure. Move the cardboard so that an additional 2 in. of paper is exposed. Make a second five sec. exposure. Do this until five such exposures have been made. The first section will have a 25 sec. exposure and the last section only five sec.

11. Remove the exposed sheet from the easel. Slide it into the developer, emulsion side up. Push it completely under the developer with tongs, if necessary.
12. Develop for 1 1/2 minutes while slowly rocking the tray.

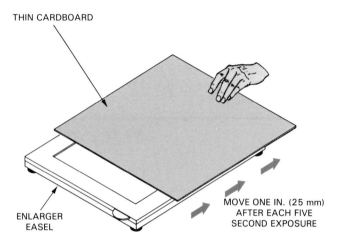

THIN CARDBOARD

ENLARGER EASEL

MOVE ONE IN. (25 mm) AFTER EACH FIVE SECOND EXPOSURE

Fig. 10-28. Use a section of cardboard over the easel to make test exposures. Make each exposure five sec. long.

13. Using the developing tongs, remove the sheet by the edge. Drain for five sec. Immerse (dip) in the stop bath. *Do not allow the developer tongs to come into contact with the stop bath.*
14. After 15 sec., remove the print from the stop bath. Drain and immerse it in the fixer.
With the lights on:
15. Strips representing 25, 20, 15, 10, and 5 sec. exposures will be seen. Select the exposure time that will produce the best overall print appearance. See Fig. 10-29.
With lights off, safelight on:
16. Place a second sheet of paper in the easel. Set the timer for the length of time selected and make the exposure.
17. Develop for 1 1/2 min. with a slow rocking motion, Fig. 10-30.
18. Immerse in stop bath for 15 sec.
19. Remove from stop bath. Drain for at least five sec. Fix for two min., agitating gently. Fig. 10-31.
With the lights on:
20. Wash the print in running water for four min.
21. Sponge or squeegee excess moisture from both sides of the print, Fig. 10-32. Dry at room temperature, Figs. 10-33 and 10-34.

The print can be examined while still in the fixer. If it looks too light, make another print adding five sec. to the exposure time. Subtract five sec. from the exposure time if the print is too dark.

If your negative did not have normal contrast, use variable contrast filters. Fig. 10-35 shows how these

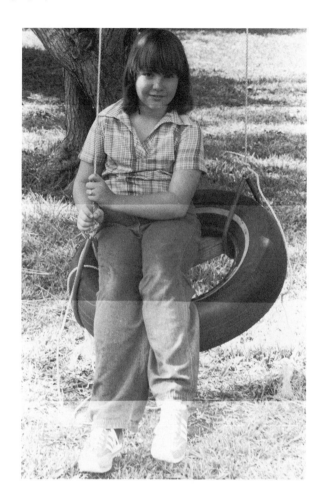

Fig. 10-29. The lightest area has been exposed for five sec. The darkest area has been exposed for 25 sec. Select exposure time that will produce the best overall print appearance and quality.

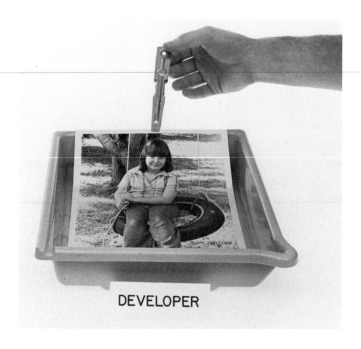

DEVELOPER

Fig. 10-30. Develop exposed print for about 1 1/2 minutes. Gently rock tray during processing.

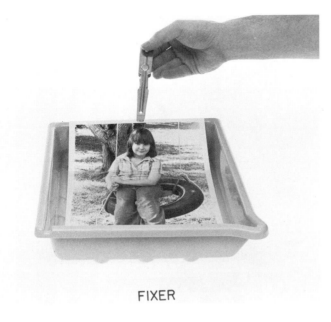

Fig. 10-31. Fix print for at least two minutes.

Fig. 10-33. You can dry prints at room temperature in special drying racks.

Fig. 10-32. Sponge or squeegee excess water from washed photographic print.

Fig. 10-34. Prints may also be air dried on a clean photo blotter.

Fig. 10-35. Print contrast can be changed by adding variable contrast filters to the enlarger. Left. Normal negative printed with a No. 1 filter will be flat. Middle. The same negative will look good if printed with a No. 2 filter. Right. When printed using a No. 4 filter, the negative will produce a print that is too contrasty.

filters can affect print contrast. Use longer exposure time because the filters hold back some light. The filter may be held under the lens during exposure or it may be fitted into the enlarger's filter tray, Fig. 10-36. *Keep the filters clean.*

Special note: Paper that is not resin coated must be fixed for 10 min. and washed for at least one hour. Fiber based papers must be dried on a special drier. See Fig. 10-37.

PRINTING AIDS

In addition to the equipment already described, there are several devices that will increase printmaking efficiency.

Fig. 10-36. Variable contrast filter can be held under the lens during exposure or fitted in the enlarger's filter tray as shown.

Fig. 10-37. Fiber base print papers must be dried in a special drier. Do not dry RC papers in this type of drier.

PROJECTION PRINT SCALE

A projection print scale, Fig. 10-38, may be used instead of a test strip. It is a piece of plastic with pie-shaped sections of different density. Each section has a number for identification which relates to exposure time.

The scale is placed on a sheet of print paper and the paper is exposed at f/11 for 1 min. After processing you can select the pie-shaped section with the correct exposure. Read the number of the section and set the enlarger for that exposure time in seconds.

PRINT EXPOSURE METER

With a print exposure meter, Fig. 10-39, there is no need to make print test sheets. The meter is placed under the projected image. It will indicate the correct exposure time for the negative in the enlarger.

IMPROVING THE PRINT

There are several techniques that can be used to improve print quality. Included are:
1. Removing scratches.
2. Cropping.
3. Dodging and burning-in.

Fig. 10-38. A projection print scale is used to make a test print. Numbers indicate exposure times.

138

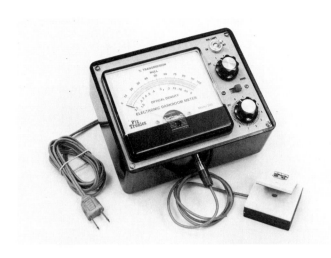

Fig. 10-39. Print exposure meter electronically registers best exposure for negative. Test prints are not needed.
(Pix Tronics)

SCRATCH REMOVAL

The presence of fine white or black lines on a print usually indicates a scratched negative. They result from careless processing and/or handling of the negative.

A scratched negative can often be saved by using a scratch remover, Fig. 10-40. However, you cannot remove scratches on the emulsion side. (These leave black lines on the negative.)

Use scratch remover as recommended by the manufacturer. Place the treated negative in a glassless carrier and project as usual. After printing, wipe the negative dry with a soft cleaning tissue.

CROPPING

You may want to enlarge only part of a negative. The elimination of unwanted areas is called cropping,

Fig. 10-40. Scratched negative can often be saved with scratch remover. Use according to manufacturer's instructions.

Fig. 10-41. *Remember to increase exposure time as magnification increases.*

DODGING AND BURNING-IN

Dodging and burning-in are methods used to decrease and increase exposure to different areas of a print. If part of an enlargement is too dark, it is possible to lighten the area by holding back some of the projected light, Fig. 10-42. This is called dodging.

Fig. 10-41. Part of negative or print can be cropped out to improve composition.

Fig. 10-42. This photo was saved by dodging the dark face. Top. Straight print, no dodging. Bottom. Dodging lightened man's face.

Circles of cardboard in various sizes are attached to wire rods. They are moved over the area that is to be lightened, Fig. 10-43.

Burning-in is used when part of the print is too light. The paper is exposed normally. The light area is given additional exposure. This is done with a piece of cardboard larger than the print which has an opening cut into it. See Fig. 10-44. Keep the cardboard moving in a circular pattern. This allows the surrounding areas to blend in, Fig. 10-45.

STABILIZATION PROCESSING

A stabilization processor, Fig. 10-46, produces a print within 10 seconds. It uses two chemicals, an activator and a stabilizer.

Special paper is exposed in the normal way. After exposure, it is fed into the machine. The image will

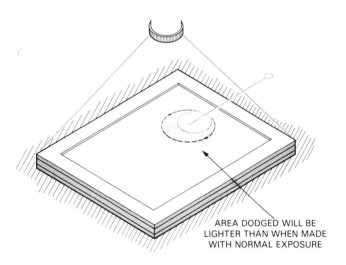

Fig. 10-43. Dodging holds back some of projected light. Dodging tools are made by attaching circular pieces or cardboard to wire rods. They are moved back and forth or in a circular pattern over area to be lightened.

Fig. 10-45. This photo was greatly improved by burning-in. Note how the light areas have been darkened. Top. Straight print. Bottom. Background burned-in.

Fig. 10-44. Burning-in is used when part of print is too light. The negative is exposed normally. Light area is given additional exposure through opening in cardboard.

Fig. 10-46. Stabilization processor can produce print in about 10 seconds after exposed print paper is inserted into machine. Print is not permanent until fixed and washed in normal way.

eventually fade if exposed to constant bright light. However, normal fixing and washing will make the print permanent.

RC paper can be used in the processor if activator (a special additive) is placed in both chambers of the processor. The print must be fixed and washed immediately after it comes from the machine.

WORDS TO KNOW

Contact print, contrast, dense, developer, enlargement, paper safe, positive image, printing, proof sheet, resin coated paper, stabilization process, stop bath, surface texture, weight.

TEST YOUR KNOWLEDGE

1. Explain the differences between fiber based and resin coated (RC) print papers.
2. Many types of surfaces are available on print papers.
 a. A print paper with a _____ surface will show fine details better than other surface finishes.
 b. A print paper with a _____ is resistant to fingerprints.
3. A print made from a low contrast negative is often improved when printed on _____ contrast paper.
4. Variable contrast print paper offers the following advantage/s over single contrast print paper: (Check the correct answer or answers.)
 a. It is less costly per print.
 b. It is easier to use.
 c. Low contrast and high contrast negatives can be printed on the same paper if special filters are used.
 d. All of the above.
 e. None of the above.
5. Why is a proof sheet useful?
6. List the processing chemicals in the order they are used to develop a print.
7. Test exposures indicate an exposure time of eight sec. at f/8 will produce a satisfactory print. If the exposure time is increased (everything else remains the same) the resulting print will be _____ than a print made at the recommended exposure time.

8. Which of the following methods will help determine the correct exposure for a negative? (Check the correct answer or answers.)
 a. Test strip made at various exposure times.
 b. Trial and error.
 c. Projection print scale.
 d. All of the above.
 e. None of the above.
9. Unwanted areas on a negative can often be eliminated by careful _____.
10. What is the purpose of dodging?
11. Burning-in is done to _____.

THINGS TO DO

1. Prepare a chart listing the precautions that must be taken when mixing processing chemicals. Post it in the area where the chemicals are mixed.
2. Demonstrate the correct way to mix processing chemicals.
3. Clean and organize the darkroom. Vacuum to remove all dust and dirt that could cause spots on a print. Check the room for light tightness. Make repairs where necessary. Organize a system to keep the darkroom clean.
4. Develop an inventory control and accounting system for dispensing darkroom supplies.
5. Prepare a display of prints showing the various weights and surface textures of print papers.
6. Demonstrate the proper way to make a print.
7. Make a display that will show how graded contrast and variable constrast print paper can affect the visual appearance of a print. Use negatives of both low and high contrast.
8. Demonstrate how to make a contact print without using a darkroom.
9. Construct a proof frame.
10. Demonstrate how a projection print scale is used.
11. Demonstrate how a print exposure meter is used.
12. Demonstrate how dodging is used to improve a print.
13. Demonstrate how burning-in is used to improve a print.
14. Have a local photo supply store demonstrate the operation of a stabilization processor to the class.
15. Make a series of prints showing how to process film and how to make a print.

Color film brings out the natural beauty of scenery such as this seascape. Sometimes, the aid of a filter is employed to get a more faithful reproduction of what the eye sees.

11 FILTERS

After studying this chapter you will be able to:
- [] List three classifications of filters and discuss how filters affect films.
- [] Name three kinds of filters for black and white film and give their purposes.
- [] Name three types of color film filters and give their purposes.
- [] Discuss the use of polarizing filters.
- [] Determine proper adjustment of exposure to account for filter factors.

Filters, Fig. 11-1, are optical (sight) devices fitted to camera lenses. They are used to change or control light as it enters the camera. Most filters absorb light of certain colors while allowing light of other colors to pass.

One kind of filter will reduce haze. Another will reduce or eliminate reflections and glare from non-metallic surfaces. A third kind can simulate (imitate) night effects at midday. Most filters screw into the front of the lens, Fig. 11-2.

TYPES OF FILTERS

There are three basic classifications of filters. They are divided according to the film with which they are to be used:
1. Black and white (b&w) films.
2. Color films.
3. Both b&w and color films.

FILTERS FOR B&W FILMS

Most b&w films record light reflected from the subject. This reflected light (natural and/or artificial) is, in most cases, colored, Fig. 11-3. B&w films record these colors as shades of gray, Fig. 11-4.

It is often possible to improve b&w picture quality by using:
1. Correction filters.
2. Contrast filters.
3. Haze reduction filters.

CORRECTION FILTERS

Most b&w films for general photography are PAN-CHROMATIC. That is, they are sensitive to all col-

ors. They record nearly all of the colors in about the same degree of brightness as seen by the normal eye. Blue and green, however, do not photograph at the same degree of brightness as they are seen. Blue usually appears darker than green to the eye. Since b&w film is more sensitive to blue than the eye, blue will appear lighter than green on a print.

Fig. 11-1. Filters are visual devices fitted to camera lenses. They alter or control light as it enters the camera.

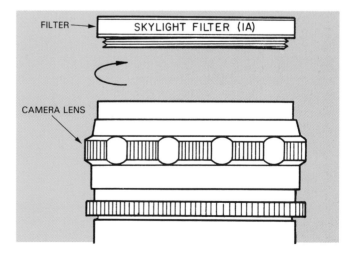

Fig. 11-2. Most filters screw into the front of the lens.

143

Fig. 11-3. Nearly all reflected-light scenes are in color.

Fig. 11-4. Black and white film records the color scene in shades of gray.

Fig. 11-5. Correction filters. Top. Photo taken without filter. Sky is washed out. Bottom. Same scene taken with a yellow filter. Sky is darkened and clouds stand out.

Filters of the proper color will correct these differences. The subject's color will then be recorded at about the same degree of brightness as they are seen by the eye. For example, a blue sky (remember, most b&w film is more sensitive to blue) will appear on a print as a very light gray. There will be little difference between the sky and clouds. A yellow filter will reduce the film's sensitivity to the blue sky. The sky will appear darker and any clouds in the scene will be emphasized, Fig. 11-5.

CONTRAST FILTERS

Contrast is the amount of difference between light and dark areas in a photograph. Sometimes it may be desirable to improve contrast between two colors that photograph as nearly the same shade of gray. For example, red and green appear on a photograph as almost the same shade of gray. It would be difficult, for instance, to distinguish red flowers from their green foliage (leaves) background in a b&w photo.

To increase contrast between the flowers and foliage, a green or red filter should be fitted over the lens. See Fig. 11-6.

HAZE REDUCTION FILTERS

Panchromatic film is not only sensitive to all visible light, it can also "see" ultraviolet light. The human eye cannot. Ultraviolet light can be seen as haze on photographs taken of snow scenes, seascapes, landscapes, and those taken at high altitude.

An ultraviolet (UV) or HAZE filter will reduce or eliminate the haziness caused by ultraviolet light. The filter will not eliminate smoke or fog, however.

A UV filter requires no exposure compensation. It

can be left on the lens at all times. The filter will have no effect on regular photo work. In fact, leaving the UV filter in place will protect the lens. A scratched or damaged filter is much less expensive to replace than the front element of a lens.

Fig. 11-6. Contrast filters. Top. Subject photographed in full color. Middle. B&W film records the scene in various shades of gray. Bottom. When a red filter is added to the lens, the red flower is lightened and the green leaves are darkened.

FILTERS FOR COLOR FILMS

Three types of filters are used solely with color films:
1. Skylight filters.
2. Conversion filters.
3. Color-correcting filters.

SKYLIGHT FILTERS

A skylight filter will reduce the bluish cast seen in unfiltered photos of snow scenes, subjects photographed in shade or under overcast skies. It also reduces the blue tint seen on color film exposed at high altitude.

A skylight filter requires no exposure compensation. It may be left on the lens.

CONVERSION FILTERS

Unlike the eye, film must be made sensitive or BALANCED to different sources of light. When used with its recommended light source, film needs no color corrections. If, however, film made for natural light (balanced for daylight) is used indoors with regular household lighting, the photo will have a yellow cast, Fig. 11-7. A conversion filter will reproduce the correct colors, Fig. 11-8. Filters are also made for tungsten films used in natural light.

Conversion filters permit the same film to be used indoors with artificial light and out-of-doors in daylight.

Fig. 11-7. A picture taken with daylight balanced color film under tungsten light has a yellow cast.

Fig. 11-8. A conversion filter (blue) color corrects the daylight balanced color film so the scene photographs normally under tungsten light.

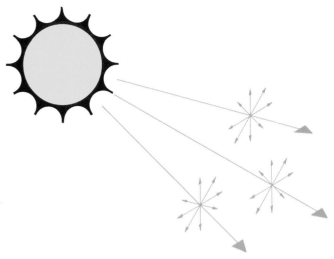

Fig. 11-9. Light rays from the sun are unpolarized. They vibrate in all directions.

COLOR CORRECTING FILTERS

Unlike conversion filters, COLOR COMPENSATING (CC) filters control only a part of the color spectrum such as red, green, or blue. The filter will transmit the other two colors.

These filters change the response of the film so that all colors are recorded at approximately the same brightness values as seen by the eye. A light blue (82A) filter will reduce the excessive warmth (reddish tones) in photos taken in the early morning or late afternoon.

FILTERS USED WITH B&W AND COLOR FILMS

There are several types of filters that can be used with either b&w or color films.
1. Polarizing filters.
2. Neutral density filters.
3. Special effects filters.

POLARIZING FILTERS

A polarizing filter has many uses. It can:
1. Darken skies.
2. Reduce or eliminate haze.
3. Reduce or eliminate reflections from nonmetallic surfaces such as glass and water.

Light rays from the sun are unpolarized, Fig. 11-9. They vibrate in all directions at right angles to their path of travel. When passing through a polarizing

filter, the vibrations continue but in only one direction, Fig. 11-10. If you rotate the filter 90 degrees the direction of vibration changes, Fig. 11-11.

Blue light from the sky is unpolarized. It is reflected by air molecules. The maximum visual effect on the film occurs when the filter is adjusted to be at right angles to the sun's path, Fig. 11-12. The sky darkens and white clouds stand out. Foliage also darkens, Fig. 11-13.

When unpolarized light strikes a nonmetallic reflective surface, the light becomes polarized, Fig. 11-14. Reflections or glare result. A polarizing filter, when properly adjusted, will reduce or eliminate these reflections, Fig. 11-15.

The filter is mounted so it can be rotated easily. Most have a mark or handle to aid in adjusting the filter. See Figs 11-10 and 11-11. When either is pointed towards the light source, the filter will not

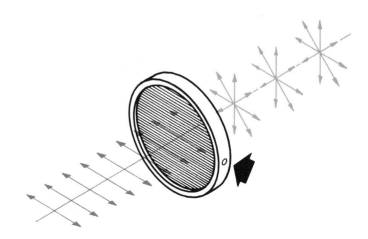

Fig. 11-10. The light rays, after passing through a polarizing filter, vibrate in only one direction.

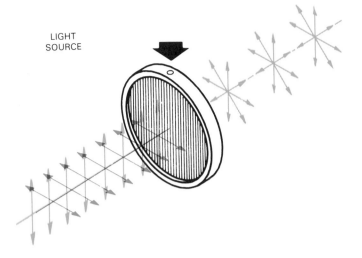

LIGHT
SOURCE

90°

PHOTOGRAPHER

LIGHT IS POLARIZED
FROM ALL DIRECTIONS INDICATED

Fig. 11-11. When rotated 90 degrees (note dot on filter rim) the screen in the filter absorbs the polarized light. This removes reflections and darkens the blue sky.

Fig. 11-12. The maximum visual effect of polarized light on film occurs when the polarizing screen is at a right angle to the path of the sun.

pass polarized light. This effect can be seen in the viewfinder of a SLR camera when the filter is rotated.

A polarizing filter is gray. It does not change the color sensitivity of color films.

NEUTRAL DENSITY FILTERS

A neutral density (ND) filter will reduce image brightness without affecting color rendition (how film reproduces color). It is useful outdoors when you have high speed film in the camera and conditions are extremely bright such as on the beach or snow. It per-

mits slower shutter speeds or wider aperture settings for creative effects, Fig. 11-16.

SPECIAL EFFECTS FILTERS

Special effects filters are used to create or produce unusual effects on film. A CROSS-SCREEN filter

Fig. 11-13. Photo on left was taken without a polarizing filter. Photo on right was photographed using the filter. Note how sky and foliage are darkened and their color improved.

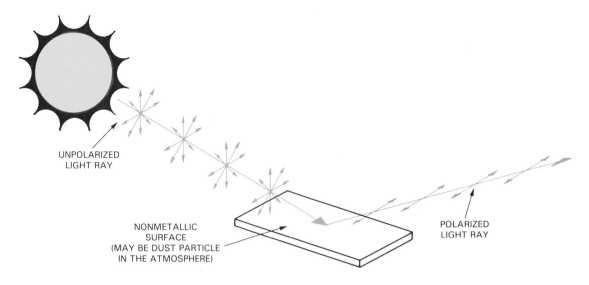

Fig. 11-14. Light becomes polarized when striking a nonmetallic surface (glass or water).

Fig. 11-15. Photo at top was taken without a polarizing filter. Little can be seen in the water. Bottom. When photographed through the filter most of the reflections from the water are eliminated. The fish can easily be seen.

Fig. 11-16. A neutral density filter can be used for creative effects by reducing light levels. Top. This photo was taken without using such a filter. Bottom. When photographed through a neutral density filter—a 15 sec. exposure in this case— the traffic disappears. Cars moved too fast to register on the film.

will cause star shaped flares or highlights in night scenes, seascapes, and still lifes, Fig. 11-17. A SOFT FOCUS filter will enhance a portrait by eliminating small wrinkle lines, blemishes, and other skin faults.

Color filters are normally used with b&w film. They can, however, be used to improve the color of a sunset, fireworks, or to produce unusual color effects, Fig. 11-18.

FILTER FACTORS

Since most filters REDUCE the amount of light transmitted by a lens, it is necessary to increase film exposure time. This increase is expressed as FILTER FACTOR. Exposure is multiplied by the factor. For example, when a filter with a factor of 2 is used, normal exposure time must be doubled. The factor is engraved on the filter mount, Fig. 11-19, or printed in the data sheet furnished with the filter.

No changes in exposure times are necessary when filters are used on cameras with through-the-lens metering. The metering system automatically compensates (makes up) for the filter factor. The camera's

Fig. 11-18. Color filters can be used to improve the color of a sunset, fireworks, or to produce unusual color effects.

Fig. 11-19. The filter factor for exposure compensation is usually engraved on the rim of the filter. Cameras with through-the-lens metering adjust themselves for the filter factor.

Fig. 11-17. A cross-screen filter turns point light sources into stars. (NASA)

meter is set for the speed of the film. No exposure compensation is necessary when using the filters.

FORMS OF FILTERS

Filters are used in three forms:
1. Glass disc.
2. Gelatin squares.
3. Glass squares.

GLASS DISC FILTERS

A glass disc filter is made by cementing a dyed gelatin sheet between two discs of optical glass. The glass and gelatin sandwich is then mounted so it can be fitted to the camera lens. Glass disc filters are made in many sizes called SERIES NUMBERS. There are two ways this type of filter is fitted to the lens:
1. SCREW TYPE. The filter is bonded to a threaded

metal ring. It screws directly into the lens barrel, Fig. 11-20.

2. ADAPTER RING TYPE. This unit consists of a metal adapter ring and a threaded retainer. The adapter either fits over the lens barrel or threads directly into the lens front. A filter disc is fitted into the adapter where it is held in place by the threaded retainer, Fig. 11-21.

GELATIN SQUARE FILTERS

Gelatin square filters are inexpensive. They must, however, be handled with care as they are easily torn and damaged. The filter is cut from a sheet of dyed gelatin. The gelatin is fitted into a special holder that slides over or screws into the lens barrel, Fig. 11-22.

GLASS SQUARE FILTERS

A glass square filter consists of a dyed gelatin square cemented between two squares of optical glass. Like the gelatin square filter, it fits into a holder that positions the square over the lens.

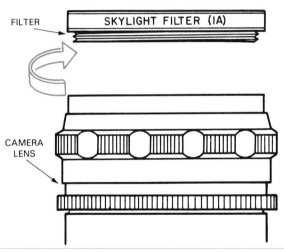

Fig. 11-20. Most filters screw directly into the front of a lens.

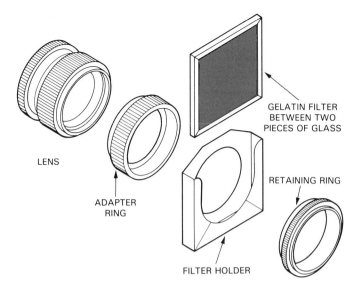

Fig. 11-22. Gelatin squares fit in a special holder attached to the lens.

NOTES ON FILTERS

STEP-UP and STEP-DOWN RINGS permit different sizes of filters to be used on the same lens, Fig. 11-23. The ring screws into the lens front and the filter screws into the ring. For example, a filter with 55 mm threads can be fitted to a lens with 52 mm threads by using a 55-52 mm step-down ring.

VIGNETTING (pronounced vin-yetting) is a problem where the corners of the photo show no details. It often occurs when two or more filters are stacked on a lens, Fig. 11-24.

Handle filters by their edges. Keep filters free of dust and fingerprints that will affect picture quality. Clean filters with a soft brush or lens cleaning fluid and lens tissue. Discard filters which have become damaged or discolored.

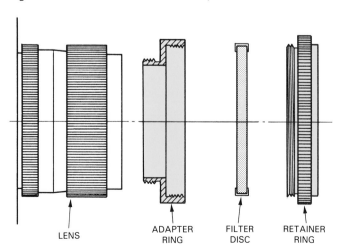

Fig. 11-21. Some glass disc filters fit between an adapter ring and a retaining ring. The adapter fits on the lens.

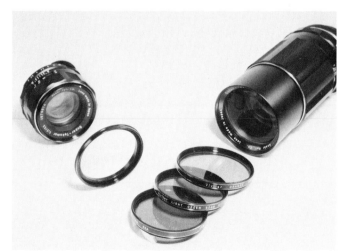

Fig. 11-23. Stepping rings permit one size of filter to fit a lens of a different size. (Porter's Camera Store)

Fig. 11-24. Vignetting occurs when two or more filters are "stacked" on a lens.

Fig. 11-25. For safekeeping, store filters and carry them in plastic containers, filter cases, or filter caps. (Porter's Camera Store)

To keep from damaging filters, store and carry them in plastic containers, filter cases, or filter caps. See Fig. 11-25.

WORDS TO KNOW

Color rendition, color spectrum, contrast filter, conversion filter, filter factor, haze filter, neutral density filter, polarizing filter, stepping rings, vignetting.

TEST YOUR KNOWLEDGE

1. List three types of filters for use with b&w films.
2. When using b&w films, a green filter will _____ green foliage. A red filter will _____ green foliage.

 lighten darken change not change
3. List two uses for a UV (ultraviolet) filter.
4. A color daylight film can be used under tungsten light if a _____ filter is added to the lens.
5. If the filter in Question 4 is not used, how will the tungsten light source affect the color daylight film?
6. _____ filters control only one fraction of the color spectrum. They transmit the remainder of the color spectrum.
7. A polarizing filter: (Check the correct answer or answers.)
 a. Darkens blue skies.
 b. Reduces haze.
 c. Eliminates reflections from metallic surfaces.
 d. Reduces reflections on glass and water.
 e. Lightens foliage.
8. Exposure time must be doubled if the filter factor is _____.
9. A 52 mm threaded filter can be fitted to a 49 mm threaded lens by using a _____.

MATCHING TEST: On a separate sheet of paper, match the appropriate definition in the right-hand column with the name or term in the left-hand column. Place the correct letter in the blank opposite the number.

10. ____Red filter.
11. ____Skylight filter.
12. ____Conversion filter.
13. ____Polarizing filter.
14. ____Neutral density filter.
15. ____Cross-screen filter.
16. ____Soft focus filter.

a. Allows tungsten film to be used in daylight.
b. Useful when photographing at right angles to the sun.
c. Permits high speed film to be used under bright lighting conditions.
d. Increases contrast between red flowers and green foliage.
e. Turns point light sources into stars.
f. Diffuses the image for a soft effect.
g. Reduces the bluish cast of high altitude.

THINGS TO DO

1. Inspect and clean all of the filters you own. Replace damaged and discolored filters. Prepare a list of the filters you own. Label the plastic filter containers with the type of filters they carry.
2. Design and construct a teaching aid that will explain how a polarizing filter works.
3. Demonstrate how contrast filters can be used to improve picture quality.
4. Prepare a chart that will explain when a particular type of filter should be used. Duplicate the list for the class.
5. Take a series of photographs using neutral density, cross-screen, soft focus, and polarizing filters to get experience in using them to best advantage.
6. Prepare a bulletin board display on filters and when they should be used.

Color photography
can faithfully reproduce
all of nature's colors.

12 COLOR PHOTOGRAPHY

After studying this chapter you will be able to:
☐ Define the light spectrum and theory of color.
☐ List the four types of color film.
☐ Give the purpose of each type of color film.
☐ Explain how color film is made.
☐ Describe how color film produces colored images.
☐ Develop color film successfully.
☐ Make color prints using filters and enlarger with color head.
☐ Discuss emulsion of color print paper.
☐ Produce colored prints.

Color photography is the art or craft of making a photograph that is identical in color to the original subject, Fig. 12-1. Color films and print papers can faithfully reproduce all of nature's colors. Of course, they must first be properly exposed and processed.

HOW WE SEE COLOR

To understand how color photography works, you must understand how we see color. Color is a visual experience. It requires light. Without light there can be no color.

HOW LIGHT TRAVELS

Color has a great deal to do with how light travels. You learned in Chapter 11 that light vibrates sideways even while it travels in a straight line. If you traced this path it would be a wavy line which would loop up and down in evenly spaced crests and valleys. The distance from one crest to the other is called the wavelength of the light. Not all of the visible light waves have the same wavelength. They vary from 0.000015 to 0.000031 in. in length.

Each different length represents a different color. That is why when you break up white light with a prism you will get all the colors of the rainbow as shown in Fig. 12-2. The band of color is continuous with one color gradually blending into another.

This band, with all of its colors, is called the LIGHT SPECTRUM. The total spectrum includes many wavelengths we cannot see, like infrared and ultraviolet. Just as the continuous band of color coming out of a prism represents a great variety of color, we can get an infinite (unending) number of different hues by simply combining blue, green, and red light into various combinations. See Fig. 12-3.

These three hues are called the ADDITIVE PRIMARY COLORS. They are so called because, as you have just seen, they can be combined in different ways to get any color wanted. Likewise, when you

Fig. 12-1. Modern color films and print papers, when properly exposed and processed, will accurately reproduce the colors of the original subject.

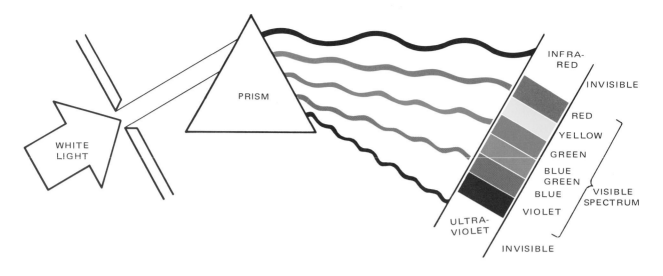

Fig. 12-2. White light, if broken into different wavelengths with a prism, appears as all colors of the rainbow.

Fig. 12-3. It has been found that this array of color can be reproduced by combinations of blue, green, and red light.

blend the three colors together in lights of equal intensity the result will be white light, Fig. 12-4. The sun at noon produces just this kind of white light.

Mixing light to create a color is quite different from creating a color by mixing pigments as was done to paint this picture, Fig. 12-5.

Any color can be produced by blending the three primary colors. Each color has an OPPOSITE or COMPLEMENTARY COLOR. The complementary color for blue is yellow; for green it is magenta (bluish-red) and for red it is cyan (bluish-green), Fig. 12-6.

Fig. 12-4. When light of the three primary colors (blue, green, and red) are added together, white light results. For this reason, they are called additive primary colors.

Fig. 12-5. It must be remembered that mixing light to create a color is quite different from creating a color by mixing pigments as they were to paint this picture. (Rockwell International)

Fig. 12-6. Every color has an opposite or complementary color. The complementary color is always opposite as shown on the drawing above. The complementary color of a primary color is a combination of the other two primary colors.

The complementary color of a primary color is a combination of the other two primary colors.

Your eyes (unless you suffer some degree of color blindness) have three types of color sensing cells or RECEPTORS. Each set of receptors (receivers) sees one of the primary colors. We see color because the receptors are stimulated in different combinations and degrees. These differences cause the brain to "see" a specific color.

Color photography and color perception (seeing) by the human eye are based on similar principles.

COLOR FILM

Color films are made in the same sizes as b&w films. They are also similar in construction. Both have a plastic backing and antihalation layer. Color film, however, has three different layers of emulsion (like the receptors in the eye). As you know, b&w film has but one emulsion layer.

Factors such as graininess, resolution, and speed, used to describe b&w film qualities, all apply to color films. Special care must be taken when using color film. Excessive heat can damage color emulsions and cause poor color reproduction. The emulsions are easily scratched. In addition, color film should be processed as soon after exposure as possible. Color shifts occur with time.

FILM TYPES

Four types of color film are used in color photography, Fig. 12-7:

1. Instant color film, Fig. 12-8, produces a finished print in less than a minute. The prints develop in the light. A special camera is required.
2. Color negative film is normally used to make color prints. Slides can also be made from the negatives. In addition, b&w prints can be made from the negative using Kodak Panalure or similar print paper.
3. Color slide film is also known as COLOR REVERSAL FILM because the image on the film is reversed from a negative to a positive during processing. The film yields a transparency which can be viewed by projection. Prints can be made from a transparency.
4. Color infrared film, Fig. 12-9, is sensitive to both visible and infrared light. A transparency is produced when the film is processed. This film is used for scientific purposes, but can be used by amateurs to produce unusual and often unpredictable colors on the slide.

Color reversal and negative films are designed for either of two types of light sources—daylight and tungsten lamps. Photos made indoors with daylight balanced film and ordinary household lighting tend to have a yellowish cast. This can be corrected with the proper filter. See the information sheet that comes with the film. (Also, refer to the chapter on filters.)

Tungsten balanced color film will reproduce the original colors when exposed under most indoor lighting. This does not hold true, however, with fluorescent lights.

Tungsten film should not be exposed in sunlight unless the right filter is used. Otherwise, the photo will have a bluish tint.

HOW COLOR FILM WORKS

Since color negative and reversal films are the most popular, only these films will be described. Both films have three separate light-sensitive emulsion layers. Each layer is sensitive to one of the three primary col-

Fig. 12-7. There are four types of color film used by amateur photographers: instant color film, color negative film, color slide film (color reversal film), and color infrared film.

Fig. 12-8. Instant color film produces a finished print in only a few minutes. Special cameras, like the one shown, must be used to carry out the processing of the exposed film.

Fig. 12-9. Color infrared film is sensitive to both visible and infrared light. It is often used for scientific purposes as was this photograph. The red is forest land while the pink and brown are marshes. The white stripe is a highway.

ors. The top layer is sensitive to blue light. The middle layer reacts only to green light and the bottom layer only to red light. See Fig. 12-10.

The emulsion layers are similar to the emulsion on b&w films. Silver salts are the light-sensitive substance used. In fact, each layer of color film emulsion is really a b&w emulsion that is sensitive to one color.

While the top blue sensitive emulsion is blind to green and red light, the other two emulsions are partially sensitive to blue light. A yellow filter is placed between the blue sensitive emulsion and the other emulsions. The filter absorbs any stray blue light. The yellow filter is dissolved later during processing.

Together, the three emulsion layers form what is called a TRIPACK. The layers acquire color during processing. Most color films have COUPLERS added to the tripack. Couplers are chemical compounds. They react with the developer to form color dyes.

KODACHROME films are an exception. They have no couplers in their emulsions. Couplers must be added during processing. For this reason, Kodachrome processing requires commercial photo finishing equipment.

COLOR NEGATIVE FILM

Color negative film, Fig. 12-11, produces a negative image. The tones are reversed. All colors are recorded as the complements of the colors in the subject. All color negatives have an orange tint which im-

Fig. 12-11. Color negative film produces a negative image (the tones are reversed) in which all colors are recorded as the complements of the colors of the subject. The overall orange tint is added to improve color quality in the prints.

proves color quality in the prints.

When negative film is exposed, a latent image forms in each emulsion layer. During processing, metallic silver forms where light of the specific color struck each layer. At the same time, chemical dye couplers form the complementary color dyes of the negative image. The density of the dyes depends upon the degree of exposure. The greater the exposure the more metallic silver. More silver means more dye. Later, the metallic silver and yellow filter are bleached out. Only the dye remains. Fixing removes unexposed silver salts.

COLOR REVERSAL FILM

Color reversal film is very similar to color negative film. However, additional processing steps are required to produce the positive dye image, Fig. 12-12.

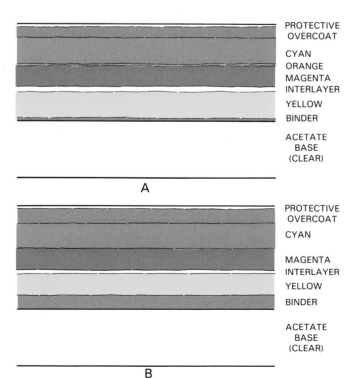

PROTECTIVE OVERCOAT

CYAN

ORANGE
MAGENTA
INTERLAYER

YELLOW

BINDER

ACETATE BASE (CLEAR)

A

PROTECTIVE OVERCOAT

CYAN

MAGENTA
INTERLAYER

YELLOW

BINDER

ACETATE BASE (CLEAR)

B

Fig. 12-10. Two types of color film. A—Cross section of exposed and processed color negative film. B—Cross-section of exposed and processed color reversal film.

Fig. 12-12. Color reversal film is like color negative film in structure. Additional processing steps produce the positive dye image that can be projected or used to make prints.

When color film is exposed, latent negative images of each primary color of the subject form in the appropriate emulsion layers. Cyan images form on the cyan sensitive layer and so on.

The film is first processed in a b&w developer (FIRST DEVELOPER). This produces a negative image. A stop bath halts development. Dye coupling does not occur during this stage.

Unexposed and underdeveloped silver salts remain in the emulsions. They are still light sensitive.

After the stop bath, the film is exposed once more using either white light or chemicals. Film must not be allowed to dry during re-exposure.

Re-exposure produces a latent positive image. Processing with a second developer (COLOR DEVELOPER) forms a positive silver image and three positive dye images. The dye images are:
1. A yellow image in the top emulsion layer.
2. A magenta image in the middle layer.
3. A cyan image in the bottom layer.
 The film now has:
1. A negative silver image.
2. A positive silver image.
3. Three positive dye images.

Bleaching and fixing remove the silver images and yellow filter, leaving a positive color transparency.

PROCESSING COLOR FILM

Color film processing can be done with the same equipment used to process b&w film. The equipment must be thoroughly cleaned. You may use one of the many kits available for processing color negative and reversal films, Fig. 12-13. Be sure to use the kit made for the film you plan to develop.

Manufacturers of color processing kits revise and up-date developing instruction periodically. Carefully read the instructions furnished with the kit before attempting to process your film. Follow the instructions closely.

Color processing is harder than processing b&w film. Many additional steps are required. Chemicals must be mixed exactly as specified by the manufacturer.

Caution: Color processing chemicals can cause severe skin irritation. Carefully read and follow the instructions on the warning label printed on each chemical container in your processing kit.

Processing temperatures are critical. Higher and more precise temperatures are required than with b&w films. *An accurate thermometer is an absolute necessity.*

Processing chemicals must be maintained at the required temperatures. This is best handled by putting premeasured amounts of each chemical in a suitable container. Small glass food jars, clearly labeled, are ideal. Place the container in a water bath of the correct temperature, Fig. 12-14.

Water depth in the bath should be at least equal to the height of the solutions in the containers. Maintain bath temperature with a constant flow of hot water at the correct temperature. If hot running water is not available, temperature can be maintained by adding hot water to the bath.

Solution temperatures are critical. Check by stirring with the thermometer.

Chemicals are added to and removed from the developing tank in the same way as b&w chemicals. Solution in the tank is also agitated in the same manner.

Use care when removing developed film from the tank reel. Wet emulsion is easily damaged. *Do not wipe or squeegee color film to speed drying.* Do not judge colors until the film is dry.

Fig. 12-13. Many kits are available for processing color negative and color reversal films. Be sure to use the kit made to process the film you plan to develop.

Fig. 12-14. Processing chemicals must be kept at the required temperature. To regulate, place the containers of chemicals in a water bath of the correct temperature.

MAKING COLOR PRINTS

Color printing requires much of the same equipment used in b&w printing. A b&w enlarger is satisfactory if fitted with a heat absorbing filter and a UV filter. Color correction filters, Fig. 12-15, are also required. Some enlargers are fitted with, or can be fitted with, a COLOR HEAD, Fig. 12-16. Then needed filtration can be dialed into the system.

One color film may reproduce its colors in a slightly different way from another film. These differences are usually not noticeable until the print is made. Color correction filters are used to correct these variations. Most color paper processing kit manufacturers recommend filtration for each type of film.

Color correction filters are made in different densities of yellow, cyan, and magenta. They are added to the enlarger's light source. These filters are also used to compensate (make up) for color differences in paper.

Color prints can be processed in a tube or drum processor, Fig. 12-17, or in trays. The tubes are light-tight containers. You can process paper in them with lights on.

The exposed print paper is fitted to the inner wall of the tube. The emulsion side of the paper must face inward, Fig. 12-18. Chemicals are added and removed

Fig. 12-15. Color correction filters are needed to make color prints if the enlarger is only equipped to make b&w prints.

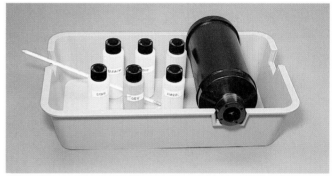

Fig. 12-17. Color prints can be processed in a tube or drum processor or in trays. Unless a large number of prints are to be made at one time, the tube processor is recommended. This processor is partially submerged in a hot water bath to maintain the proper processing temperature.

Fig. 12-16. Some enlargers are designed for both b&w and color work. The color head allows you to dial in the required color correction.

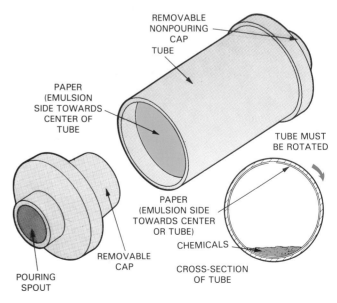

Fig. 12-18. After exposure, the print paper is inserted into the processing tube, emulsion side in.

through light-tight openings on either end of the tube. See Fig. 12-19.

After pouring the chemical into it, place the tube on its side. Process timing begins at this point. Gently roll the tube to keep the paper in contact with the processing solution. See Fig. 12-18. This will keep the entire paper wet with the solution all through the processing period.

Some color developing tubes are motorized. They automatically rotate at a constant speed.

A few color print papers permit the use of a safelight for a brief time. *Check the paper's data sheet before using a safelight.*

COLOR PRINT PAPER

Color print papers are constructed much like color film. However, the emulsions are applied to a white paper base instead of to a film base. Print paper is available in most of the same sizes and textures as b&w print paper. It is not made in different contrast grades, however.

Color print paper should be stored in a freezer until ready for use. This prevents color shifts (changes). Allow the paper to warm to room temperature before using it.

EMULSIONS

Like color film, color print paper has three emulsion layers. Each layer is sensitive to one of the three primary colors, Fig. 12-20. Color print paper is not as sensitive to light as color film. Thus, there is no need for the yellow filter between emulsions. Dye couplers are incorporated in the emulsion of each layer.

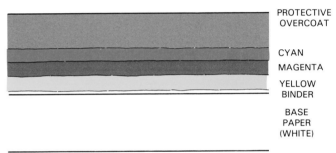

PROTECTIVE OVERCOAT

CYAN

MAGENTA

YELLOW
BINDER

BASE PAPER (WHITE)

Fig. 12-20. Cross section of exposed and processed color print paper.

HOW COLOR PRINT PAPER WORKS

The same type of paper cannot be used to print both color negatives and slides. Paper for color negatives works the same way as color negative film. The enlarger projects (shines) an image onto the paper. The negative's colors are complements of the original scene's colors. The paper, like negative film, records the complementary colors of the negative's colors. This produces, on the paper, a positive image of the correct colors.

PROCESSING COLOR NEGATIVE PAPER

Processing color negative print paper is simpler than processing color reversal paper. Some color negative print processing kits require only two solutions:
1. The developer.
2. A combination bleach/fixer, Fig. 12-21.

Color reversal print paper is processed in much the same way as color reversal film. This type of print paper, however, requires more processing steps than does color negative print paper, Fig. 12-22.

After exposure, the paper is placed in the first developer. No dyes are formed during this stage. Development is ended with a stop bath. The paper is

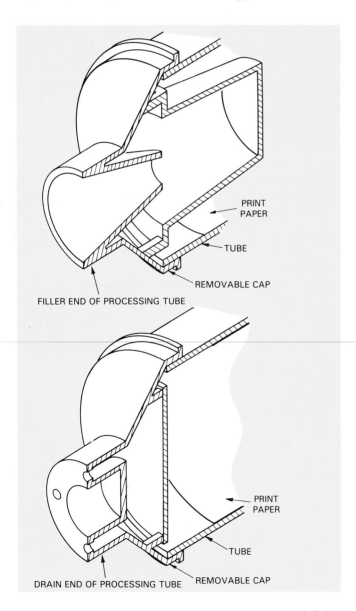

PRINT PAPER

TUBE

REMOVABLE CAP

FILLER END OF PROCESSING TUBE

PRINT PAPER

TUBE

REMOVABLE CAP

DRAIN END OF PROCESSING TUBE

Fig. 12-19. Chemicals are added and removed through light-tight openings at either end of the tube. These caps are removable for inserting the exposed print paper and for cleaning.

Fig. 12-21. This color negative print processing kit requires only two solutions—the developer and a combination bleach/fixer called Blix.

Fig. 12-23. Color reversal print paper starts out black (if developed before exposure, the sheet will be black) and is lightened by exposure. This is the exact opposite of b&w and color negative print paper.

HOW TO MAKE A COLOR PRINT

The first step in color printing is the selection of the paper and chemistry. If you work with color negatives, one type of chemistry and paper is needed. Color reversal film requires another kind of paper and chemistry. They are not interchangeable.

Most color print paper comes with instructions on the basic filtration to be used with it and recommended trial exposures. There are differences in the color responsiveness of each batch of color paper. The filtration to be added to the basic filter pack is given on the paper package, Fig. 12-24.

Fig. 12-22. Color reversal print paper (used with slides) requires more processing steps than does color negative print paper.

then chemically re-exposed.

The color developer produces a dyed positive image. All metallic silver and unexposed silver salts are removed in a bleach-fixer step. The finished print is a color correct positive image.

Borders on a color reversal print will be black, Fig. 12-23. It is important to understand that a reversal print starts out black and is lightened by exposure. Areas receiving no light, like the borders, remain black.

Fig. 12-24. There are differences in the color responsiveness of each batch of color print paper. The filtration to be added to the basic filter pack is printed on each print paper box or package.

161

DETERMINING BEST EXPOSURE

To establish the best exposure time for the paper and film being used, expose a test sheet at the recommended exposure time. Then make other exposures, some at longer and some at shorter times. For example, if 4 sec. at f/11 is recommended, make an exposure at those settings. Make additional exposures at 2 sec., 8 sec., and 16 sec. Use a cardboard mask like the one shown in Fig. 12-25.

After processing, determine the best exposure time from the results observed on the test sheet, Fig. 12-26. If the color is not true, add or subtract filters until the color is right. See Fig. 12-27. See the chart in Fig. 12-28. With experience you will have little difficulty determining what filtration changes, if any, have to be made.

Burning-in and dodging can also be done on color print papers. With color negative paper, the technique is the same as with b&w paper.

The reverse of the above technique is used with color reversal paper, however. Longer exposure will lighten the image. Reduce exposure time to make the image darker.

Processing times and temperatures are provided on the information sheet furnished with the chemicals and paper. Also included with the information sheet will be special processing data and any precautions that should be observed. Read and follow all instructions carefully.

Most color processing requires high solution temperatures. Place the solutions in suitable containers and keep them in a constant-temperature bath.

TUBE AND DRUM PROCESSORS

Many types of tube and drum processors are available. Some allow the tube to be partially submerged in a hot water bath while it is rotated. There is usually enough space in the bath to hold the solution containers and maintain them at the proper processing temperatures. Others have a motor drive to rotate the tube automatically.

TRAY PROCESSING

Tray processing is carried out in the same manner as b&w printing. The trays must be surrounded with heated water to maintain proper processing temperatures. Placing the trays in a rectangular basin or large sink partially filled with hot water is the easiest way to do this.

Fig. 12-25. To establish the best exposure time, expose a test sheet at the recommended exposure time and at other exposure times also.

Fig. 12-26. Test sheet. A flat black, cardboard mask is used to block out areas of the test sheet.

Fig. 12-27. Color head of enlarger. You can correct color exposure by adjusting dials.

If color balance is too:	Subtract these color filters:	or	Add these color filters:
Yellow	Yellow		Magenta & Cyan
Magenta	Magenta		Yellow & Cyan
Cyan	Cyan		Yellow & Magenta
Blue	Magenta & Cyan		Yellow
Green	Yellow & Cyan		Magenta
Red	Yellow & Magenta		Cyan

NOTE: A test print might indicate a predominant color balance. Filters can be added or subtracted to correct the problem. This table is for reversal paper.

If color balance is too:	Subtract these color filters:	or	Add these color filters:
Yellow	Magenta & Cyan		Yellow
Magenta	Yellow & Cyan		Magenta
Cyan	Yellow & Magenta		Cyan
Blue	Yellow		Magenta & Cyan
Green	Magenta		Yellow & Cyan
Red	Cyan		Yellow & Magenta

Color correction table for prints made from negatives.

Fig. 12-28. If the color of your test print is not correct, add or subtract filters using the above recommendations.

Solution agitation is very important in tray color processing. *Caution: Several steps in tray processing color prints must be done in total darkness.*

Do not attempt to judge print colors until the print is thoroughly dry. Color changes as it dries.

Color printing is more difficult than b&w printing. It is also more time consuming and expensive. You should be proficient at b&w processing before attempting color work. Color prints are, however, well worth the time, effort, and expense.

WORDS TO KNOW

Color correction filter, color developer, color head, color infrared film, color negative film, color reversal film, complementary color, couplers, daylight film, drum processor, emulsions, filtration, first developer, instant color film, light spectrum, receptors, tripack, wavelength.

TEST YOUR KNOWLEDGE

1. Color is a _____ sensation. Without _____ there can be no color.
2. Name the three additive primary colors and their complements.
3. Why are they called additive primary colors?
4. The complementary color of a primary color is _____.
5. Color film should be processed as soon after exposure as possible because _____ _____.
6. List the four types of color film. Briefly describe each.
7. Tungsten balanced color film should be used indoors under ordinary household lighting because _____.
8. Describe how color film works.
9. How is the positive image produced on color reversal film?
10. Why is an accurate thermometer an absolute necessity in process color films and paper?
11. Explain how processing chemicals can be maintained at proper temperatures when developing color film.
12. Before using a safelight when developing color print paper check the paper's _____ _____.
13. What is the first step in making a color print? Why is this step important?
14. Color filters must be used in the enlarger when making color prints because: (Check the correct answers or answers.)
 a. This is the way color is added to the print.
 b. There are differences in the color responsiveness of each batch of color print paper.
 c. Filters make it possible to use the same print paper with both color negative and color reversal film.
 d. All of the above.
 e. None of the above.

THINGS TO DO

1. Expose and develop a roll of color negative film.
2. Expose and develop a roll of color reversal film. Mount the transparencies so they can be projected.
3. Research color infrared film and how it is used in science, agriculture, and industry.
4. Expose a roll of color infrared film under different lighting conditions. Expose a roll of regular color reversal film under the same conditions. Show the results to the class.
5. Make a color print using color negative film.
6. Make a color print using color reversal film.

Greatly magnified views of these moon rocks were made possible through special camera lenses.

Extremely sophisticated instruments may be used in photomicrography. (Bausch & Lomb)

13 CLOSE-UP AND PHOTOMACROGRAPHY

After studying this chapter you will be able to:
☐ Discuss the differences between close-up photography, photomacrography, and photomicrography.
☐ List and describe six different systems of close-up photography and macrography.

Most adjustable lenses focus as close as 2 to 3 ft. (1.5 to 2 m). Fixed lenses usually produce sharply focused pictures from infinity to 6 ft. (2 m). This is fine for most subjects. However, 6 ft. is not close enough when photographing small objects. Close-up photography makes small things larger. Besides copying other photos, typical subjects include flowers, insects, coins, and stamps. See Fig. 13-1.

Imagine a frame of 35 mm film in a camera. It is about 1 in. (25 mm) high. An object 3 in. (75 mm) high filling this frame is reproduced as 1/3 life size, Fig. 13-2. This example has an image to subject ratio of 1:3.

A 1 in. (25 mm) high object filling the 35 mm frame

Fig. 13-2. A 3 in. (75 mm) subject that fills a 35 mm film frame vertically has an image to subject ratio of 1:3.

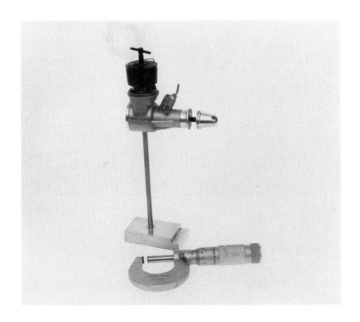
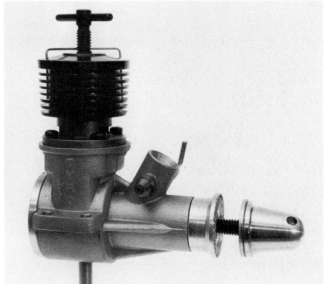

Fig. 13-1. Macro lens make photos larger than actual size. Left. Subject as seen by a regular camera lens positioned at minimum focusing distance. Right. Photo taken with close-up lenses (+diopters) fitted to the regular lens.

has a 1:1 ratio that is LIFE SIZE. A 1/2 in. (12.5 mm) high subject filling the frame must be enlarged. It has a ratio of 2:1 or a MAGNIFICATION OF 2X. The symbol "X" indicates magnification or "times."

MAGNIFICATION TERMS

The term CLOSE-UP is generally understood to cover the range of 1:10 through 1:1 (1/10 size to life size). Photographing objects larger than life size through 25:1 (25X) is called macrography, macrophotography or PHOTOMACROGRAPHY.

A camera may also be mounted on a microscope, Fig. 13-3, for even greater magnification. This technique is called PHOTOMICROGRAPHY.

Magnification of 15,000X (times) and higher can be made on a SCANNING ELECTRON MICROSCOPE. Fig. 13-4 shows a photograph taken by this method.

This unit will describe six systems of close-up and macrography:
1. Close-up lenses.
2. Reversing ring.
3. Lens extension.

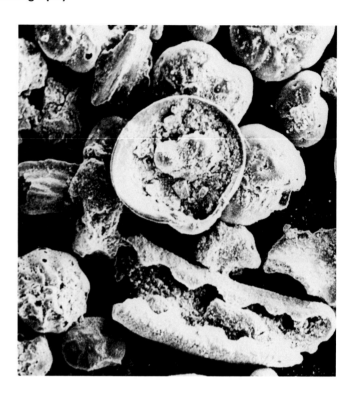

Fig. 13-4. A photo of carbonate mud (15,000X) made with the aid of a scanning electron microscope. Geologists use such photos in their study of the earth. (Pat Cowan)

4. Bellows attachment.
5. Macro lenses.
6. Close-focus lenses.

See Fig. 13-5 for the magnification range for each of these devices.

CLOSE-UP LENSES

Close-up lenses are an inexpensive way to close-up photography. They can be added to almost any camera.

Close-up lenses are positive supplementary lenses that shorten the focal length. They are available in different powers. Each is good for a different limited range of close-up distances.

The lenses usually come in a set of three, +1, +2, and +4, Fig. 13-6. The higher the number the more magnifying power. They may be stacked, but you should always attach the highest number to the lens first. A +1 and +2 equals a +3. Stacking reduces sharpness.

Close-up lenses are easy to attach. Like filters, they are threaded to fit the front of the regular lens, Fig. 13-7. These lenses are simple, convenient, portable, and do not require exposure compensation.

REVERSING RING

A reversing ring, Fig. 13-8, is an adapter that permits the lens to be reversed on a camera. It is the least expensive way to photomacrography.

Fig. 13-3. A 35 mm camera mounted to microscope. This photographic technique is called photomicrography.
(Bausch & Lomb)

Close-up and Photomacrography

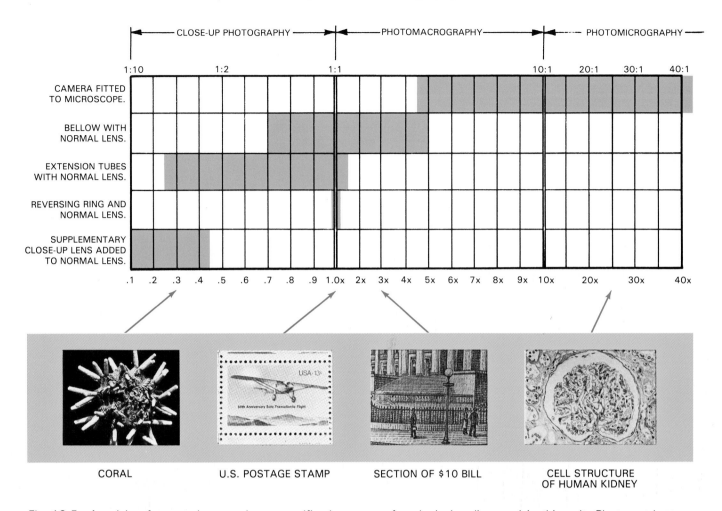

	CLOSE-UP PHOTOGRAPHY			PHOTOMACROGRAPHY			PHOTOMICROGRAPHY	

CAMERA FITTED TO MICROSCOPE.

BELLOW WITH NORMAL LENS.

EXTENSION TUBES WITH NORMAL LENS.

REVERSING RING AND NORMAL LENS.

SUPPLEMENTARY CLOSE-UP LENS ADDED TO NORMAL LENS.

.1 .2 .3 .4 .5 .6 .7 .8 .9 1.0x 2x 3x 4x 5x 6x 7x 8x 9x 10x 20x 30x 40x

CORAL	U.S. POSTAGE STAMP	SECTION OF $10 BILL	CELL STRUCTURE OF HUMAN KIDNEY

Fig. 13-5. A quick reference chart to show magnification range of each device discussed in this unit. Photos at bottom demonstrate types of photos taken in four different ranges. (Raymond Lund)

Fig. 13-6. Close-up lenses are positive supplementary lenses that shorten the focal length of the regular lens.

Fig. 13-7. Close-up lenses are threaded to attach onto the front of the regular lens.

The reversed lens will give a magnification ratio of 1:1 or life size. However, the automatic features of the lens are lost.

LENS EXTENSION TUBES

Closer focusing of a lens is possible by using an extension (device for moving lens farther from film plane). Extension tubes, Fig. 13-9, are usually used to extend the lens. This technique has limitations. As lens extension increases, so does exposure time. Image sharpness decreases.

There are some things to remember when using extension tubes:
1. Longer focal length lenses will give a greater working distance.
2. Wide angle lenses do not give a greater depth of

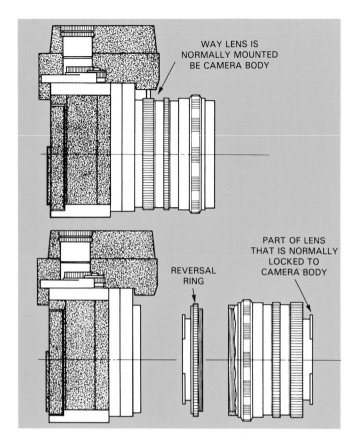

WAY LENS IS
NORMALLY MOUNTED
BE CAMERA BODY

REVERSAL
RING

PART OF LENS
THAT IS NORMALLY
LOCKED TO
CAMERA BODY

Fig. 13-8. A reversing ring is an adapter that permits the lens
to be reversed on the camera for very close focusing.

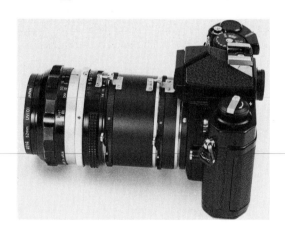

Fig. 13-9. Extension tubes are fitted between the lens and
camera body. They can be used singly or in combination. The
longer the tube, the closer the lens can be focused on the
subject.

field than normal lenses when used with extension tubes. However, they do give greater magnification of the subject.

3. Magnification ratios must be determined from data charts furnished with the extension tubes.

4. If your camera does not have through-the-lens metering, exposure compensation must be calculated. Again, refer to the data charts furnished with the extension tubes. In general, as the lens is moved farther from the film more light is needed to make the exposure. This requires a larger lens opening or slower shutter speed. Bracketing shots are recommended.

5. Extension tubes give best results when the subject is larger than 1 in.

BELLOWS

Bellows, Fig. 13-10, are not a variation of extension tubes. They have a different range of magnification. Bellows are best used when the subject is smaller than 1 in. They are rather bulky for portable operations and are expensive.

Usually, bellows have a scale showing magnification ratio. As with extension tubes, additional exposure time is required with bellows.

Fig. 13-10. Bellows are more costly and cumbersome to use than close-up lenses or extension tubes. They are, however, more flexible and permit life size or larger images to be made.
(Pentax Corp.)

MACRO AND CLOSE-FOCUS LENSES

Macro lenses will focus much closer than regular lenses. Magnification ratios are usually engraved on the macro lens barrel, Fig. 13-11. Generally, they focus to 1/2X or 1:2 ratio, but may be fitted with an extension ring to allow focusing down to life size.

Macro lenses should not be confused with "macro zoom" lenses. The latter are really close-focus lenses. They do not focus as close as macro lenses and are not optically corrected for flatness. They are fine for taking close-ups of flowers, insects, and the like, but should not be used for flat subjects.

FOCUSING AND FRAMING

With a single lens reflex camera, close-up focusing is no different than regular subject focusing.

Fig. 13-11. A macro lens focuses much closer than a regular lens. Note the magnification ratios engraved on the lens barrel. (Vivitar Corp.)

Rangefinder and twin lens reflex cameras present a slight problem. At close distances, the viewfinder does not show exactly what will be photographed. You know this as PARALLAX.

Parallax occurs because the viewfinder and taking lens are separated. It can be corrected by slightly tipping the lens toward the viewfinder just before the picture is taken. You may prefer to add about 10 percent more in the viewfinder in the direction of the lens than normal.

Many close-up photos are taken outdoors. In such cases, it may be necessary to supplement or modify available light. Shadows can be eliminated by using a white cardboard reflector, Fig. 13-12.

An electronic flash allows the use of a higher shutter speed and smaller aperture. This will provide for a greater depth of field. The distracting background will be very dark, Fig. 13-13. It may be necessary to experiment.

There are three basic requirements for taking good close-up and macro pictures.
1. If your camera does not have through-the-lens metering, it will be necessary to compensate for the reduced light reaching the film.
2. Keep the camera steady. Use a brace or tripod.
3. Use a small aperture setting for maximum depth of field.

WORDS TO KNOW

Bellows, close-up lens, extension tube, life size, macro lens, macro zoom lens, parallax, photomacrography, photomicrography.

Fig. 13-13. An electronic flash allows the use of a high shutter speed and small aperture. It will provide a greater depth of field and usually darkens a distracting background.

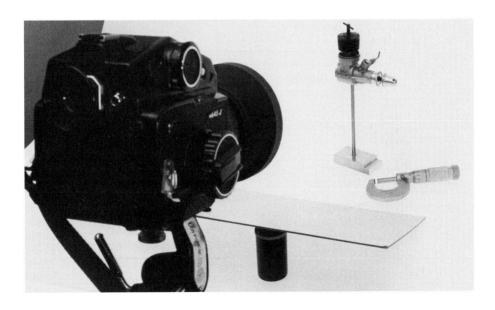

Fig. 13-12. Lighting can be a problem when doing close-up photography. Shadows can often be eliminated on the underside of the subject by using a white cardboard reflector.

TEST YOUR KNOWLEDGE

1. A 3 in. (75 mm) high subject that fills a 35 mm film frame has an image to subject ratio of __:__.
2. A subject having an image to subject ratio of 5:1 has a magnification of: (Check the correct answer or answers.)
 a. 1/5X.
 b. .2X.
 c. 5X.
 d. All of the above.
 e. None of the above.
3. How does photomicrography differ from photomacrography?
4. The optical device that permits close-up photography by shortening the lens' local length is called a _____.
5. A reversing ring offers the following advantage when making close-up photographs: _____

_____.
6. The reversing ring, however, has the following disadvantage when making close-up photographs: _____

_____.
7. Lens _____ _____ are used to extend the lens for closer focusing.
8. Bellows are considered: (Check the correct answer or answers.)
 a. A very complicated way to make close-up photos.
 b. A variable length extension tube.
 c. Useless if the subject is less than 1 in. high.
 d. All of the above.
 e. None of the above.
9. What problem can be caused by parallax when making close-up photographs?
10. The following are necessary for good close-up and macro photographs: (Check the correct answer or answers.)
 a. Exposure compensation for reduced light if the camera does not have through-the-lens metering.
 b. A lens free of fingerprints.
 c. A steady camera. Use a brace or tripod if necessary.
 d. Use of a small aperture for maximum depth of field.
 e. All of the above.
 f. None of the above.

THINGS TO DO

1. Prepare a term paper on the industrial or medical uses of photomacrography.
2. Secure samples of photomicrography used in industrial or medical research.
3. Take a series of close-up photos. Submit the photos to your instructor with an evaluation of your work.
4. Demonstrate how close-up lenses are used. Illustrate the demonstration with photos or slides you have taken using the technique.
5. Demonstrate how lens extension tubes are used. Illustrate the problems and limitations of the technique with photos or slides you have taken.
6. Demonstrate how bellows are used. Illustrate the demonstration with photos or slides you have taken using the technique.

14 VIDEOS AND MOVIES

After studying this chapter you will be able to:
- ☐ List the equipment needed for taking and showing videos and movies.
- ☐ Explain the principle of "persistence of vision."
- ☐ Describe the main components, controls, and operation of a camcorder and movie camera.
- ☐ Describe the main components of a movie projector and explain how it works.
- ☐ Apply the basics of editing and splicing.
- ☐ Operate equipment after reading the operating instructions.

People have been making movies for years. Before 1980, virtually all movies were made on film. Recently, the type of equipment has changed drastically. The shift has been to VIDEO equipment which makes images on magnetic tape, Fig. 14-1. Amateur movie cameras using film are no longer being manufactured.

VIDEO

Electronic movie making has become popular for many reasons. Images are produced electronically and recorded on VIDEOTAPE. A playback of the videotape can be immediate. There is no film to buy or process. Two hours of recording tape may cost several dollars. One hour of film in a motion picture camera with processing may cost several hundred dollars.

This part of the chapter will deal with CAMCORDERS. A camcorder, Fig. 14-2, combines the function of a camera and recorder in one unit.

Video movie making is very similar to the still camera field. A video photographer needs the following equipment to make and view a video movie:
1. Camcorder.
2. Videotape.
3. Lights.
4. A monitor or TV (television).

Fig. 14-1. Video cameras make invisible images on magnetic tape. An electrical signal from the camera is made into a magnetic field by a device called the head. The magnetic pattern is placed on the tape as the tape travels past the head.

Fig. 14-2. A camcorder makes movies electronically. (Pentax Corp.)

THE CAMCORDER

All camcorders share basic features and characteristics with still cameras, Fig. 14-3. Every camcorder is a camera and video-cassette recorder (VCR) built into a single unit. The lens sees the image and focuses the light. The image from the lens is processed electronically into a solid state sensor or imaging tube. The electronic signal is then fed into the HEAD, Fig. 14-4, of the built-in VCR. The head transfers the signal to the videotape with a magnetic field. Refer again to Fig. 14-1. During playback, the head reads the magnetic pattern on the tape and sends the signal back to the TV and is shown as a picture. Sound is received at the same time through a microphone. AUDIO or sound is heard during playback through the built-in audio circuitry of the VCR.

The essential parts of a camcorder are:
1. Lens.
2. Imager.
3. Viewfinder.
4. Sound System.
5. Power System.

Regardless of its format every camcorder follows the same recording principles. The heart of the system is a rotating drum with recording heads mounted on it. Tape passing over the drum and in contact with the heads converts an electronic video signal from the camera's image sensor into magnetic pulses. The pulses "write" information about the image on the magnetic tape by rearranging the magnetic particles.

Each head gives half the information making up one frame of the recording. Since the drum sits at an angle,

Fig. 14-4. The heads in a camcorder are very tiny. They fit into a rotating drum. Up to 4 heads may be present. The tape is guided past the drum at an angle. This allows the magnetic pattern to be recorded in a long continuous curve, maximizing the amount of information.

the video signals are recorded diagonally across the video tape.

The sound track is a linear strip along one edge of the tape. In some camcorders a fixed head records the sound. In hi-fi models, the heads are mounted on the rotating drum. The audio signals are encoded in the picture track.

THE LENS

Camcorders are equipped with zoom lenses. They allow you to go from a wide angle shot of a group to a close-up of a person. A common zoom range is 9-54 mm, Fig. 14-5. This is a 6 to 1 ZOOM RATIO or may

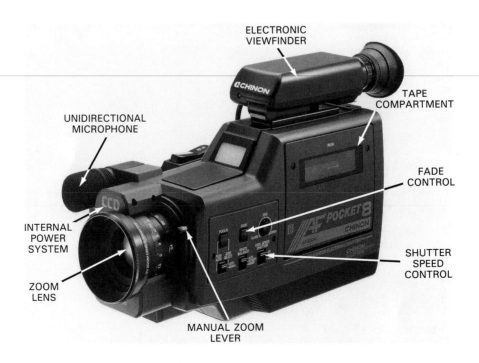

Fig. 14-3. Camcorders all have the same basic parts. (Chinon)

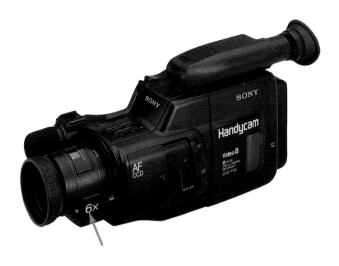

Fig. 14-5. This camcorder has a zoom lens with a zoom ratio of 6 to 1 (6X). (Sony)

VIEWFINDER

Virtually all camcorders have electronic viewfinders. This is like a little TV set with a magnifying lens over the eyepiece. The viewfinder allows the user to see the image as the lens sees it. The viewfinder also functions as a monitor for instant playback.

Viewfinders usually display information. This may include a battery warning light, tape counter, tape speed, and end-of-tape warning. Indicators may also be present for manual focusing.

The viewfinder, Fig. 14-6, may be positioned on the side or at the rear. A side finder may allow you to rotate the eyepiece for low-level shots.

be stated as 6X. More advanced models may have zoom ratios of 12 to 1 or more. Camcorders have POWER ZOOM which means the control is motorized.

As with a still camera, the lens speed of f-stop is very important. A "faster" lens allows you to work in lower light. An f/1.2 lens is faster than an f/1.8 lens. Both are common maximum apertures.

IMAGER

The IMAGER is an electronic device that captures the focused light from the lens. It translates light into electronic impulses. Virtually all modern camcorders have solid state imagers. Solid state devices are chips or integrated circuits. They are less prone to vibration and damage by being pointed at a bright light.

Imagers are usually MOS (metal-oxide semiconductor) or CCD (charge coupled device). Both can produce excellent video images. These devices are about 1/2 in. in diameter. Image points or PIXELS are formed on the imager. The more pixels, the finer the image. Some imagers contain 400,000 or more pixels.

Each imager has a built-in filtration system. This defines the primary colors: red, green, and blue. These are positioned over the imaging surface in strips. A good imaging and filtration system will give clean whites, deep blacks, and vibrant colors. Spillover from one color to the next should be minimal.

Imagers are also rated by LUX. Lux is a term to rate the minimum illumination accepted by the imager. Many camcorders are rated at 7 lux. This would allow recording at dusk or a scene lit by several table lamps. Some are rated at 1 or 2 lux for recording in near darkness. As light gets low, color disappears and the picture may be unacceptable.

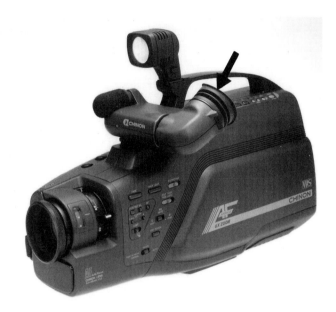

Fig. 14-6. This viewfinder can be rotated to take ground level shots. (Chinon)

SOUND SYSTEM

Camcorders have a built-in audio or sound system. Most work well if close to the sound source. Many also have an external mike jack. This allows plugging in an external microphone for the subject to hold. Narration or music can be added during editing with many built-in MICROPHONES.

Other types of microphones are also designed for use with camcorders. The built-in microphone is omni-directional. It will pick up sound from any direction. Other types that eliminate this problem include: unidirectional, cardioid, supercardioid (shotgun), and lavalier microphones.

Unidirectional microphone

When placed near a subject, the unidirectional microphone will pick up sound mostly from the direc-

tion it is aimed. Its pick-up angle is narrow. Thus, it will not register unwanted background noise.

Cardioid microphone

This type is a compromise between the unidirectional and the omnidirectional. Its response pattern is heart-shaped. It will pick up sound from the front and sides, but not from the back.

Supercardioid or shotgun microphones

The supercardioid microphone has an extremely narrow pick-up angle. It can, thus, be aimed from a greater distance than others without picking up background noise.

Lavalier microphones

Though omnidirectional, this microphone picks up little background noise because it is clipped to the subject's clothing where it is shielded from extraneous sounds. One difficulty is that it will pick up the rustle of clothing if not placed so it will not rub against the subject's clothes.

POWER SYSTEM

Rechargeable nickel-cadmium (Nicad™) batteries are usually supplied with the camcorder. These supply power for the power zoom, tape drive, imager, and other electrical functions. A typical battery pack holds up to hours of use. Many are interchangeable so other battery packs can be used during a long day of shooting.

Some power systems accept an AC adapter to run off household current.

VIDEOTAPE

Camcorders may vary in the recording technique or format. Each uses a different type of videotape, Fig. 14-7. Current popular formats include:
1. 8 mm.
2. Super VHS.
3. VHS.
4. VHS-C.

8 mm FORMAT

The 8 mm format is very compact and versatile, Fig. 14-8. It has a very small cassette. Audio reproduction is excellent. This format is very popular with travelers. The tape must be copied to VHS for viewing in a VCR or the camcorder must be plugged directly into a television set.

VHS

The VHS format, Fig. 14-9, is the same as most VCRs use for television recordings and movie rentals. The

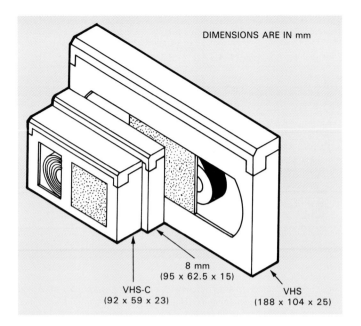

Fig. 14-7. Different formats use different size videotapes.

Fig. 14-8. 8 mm format is very compact and can fit into the palm of a hand. (Sony)

format requires a larger size of camcorder and is usually rested on the shoulder. The VHS format camcorders may be simple or have features for editing and special effects. Up to eight hours of tape are available in a cassette.

SUPER VHS

Super VHS or S-VHS, Fig. 14-10, is similar in size to VHS and is used by professional and advanced amateurs. This is a high-quality system of image and audio reproduction.

Fig. 14-9. VHS camcorders use the same tape size as most modern VCRs. (Olympus)

Fig. 14-11. VHS-C is a compact version of VHS which uses a smaller videotape cassette. (Panasonic)

Fig. 14-10. Super VHS or S-VHS uses a tape the same size as VHS but yields superior image and sound reproduction. (Olympus)

VHS-C

VHS-C is a compact version of VHS, Fig. 14-11. Like 8 mm, the camcorder is small in size. With a special adapter, a VHS-C tape can be played in any VHS VCR. This format uses a tape of 30 minute high-quality recording or 90 minutes of lower quality in slow speed.

VIDEOTAPE CONSTRUCTION

Videotape has four basic layers, Fig. 14-12. The base layer is made of a plastic called polyester. This is very tough. the base is coated with a metal or metal-oxide layer. This layer is magnetic. Recordings of the sound and picture are picked up and stored here, Fig. 14-13. It

Fig. 14-12. Videotape has four basic layers: A—Carbon backing. B—Polyester base. C—Magnetic oxide. D—Topcoat.

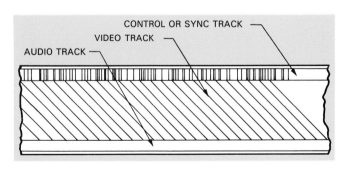

Fig. 14-13. Invisible information is formed on videotape for pictures and sound.

"remembers" the strong magnetic fields formed by the heads in the camcorder. Under the polyester base is a layer of carbon. This prevents a buildup of carbon within the recorder and cassette. A protective topcoat minimizes wear and helps the tape slide through the camcorder and VCR without static.

VIDEOTAPE SELECTION

Blank videotape is similar to film. It is the recording medium for pictures and sound. It is very important to select the proper type.

Videotape comes in a wide range of performance characteristics. These affect both audio and picture quality.

Tape grades have terms such as "Super," "Pro," "High Grade," or "High Definition." None of these labels are standard among manufacturers. They do indicate a step up in quality from basic videotapes.

The plastic case of the video cassette is also very important. Higher grade tapes often have better shells and inner mechanisms to withstand repeated use.

Tapes are available in various lengths for different recording times, Fig. 14-14.

VIDEO RECORDING TAPES (in minutes)

VHS	Standard play (SP)	Long play (LP)	Extended play (EP)
T-30	30	60	90
T-60	60	120	180
T-90	90	180	270
T-120	120	240	360
T-160	160	320	480
VHS-C	Standard play (SP)	Long play (LP)	Extended play (EP)
TC-20	20	40	60
8 mm	Standard play (SP)	Long play (LP)	
P6-30	30	60	
P6-60	60	120	
P6-90	90	180	
P6-120	120	240	

Fig. 14-14. Videotapes are available in different lengths. Recording time will vary upon recording speed. Standard play gives the highest quality images and sound.

FOCUSING

When working with a manually focused camcorder, three steps will get proper focus:
1. Set the zoom lens to a close-up shot of the subject.
2. Turn the focus ring until the image is sharp in the viewfinder.
3. Zoom to the shot wanted.

Using this method, the subject will remain sharp through the entire zoom range. Keep in mind that the camcorder must be refocused for each new subject.

A second way of focusing may be useful in certain situations. Look at the calibrations on the focusing ring. Estimate the distance to the subject and set the focusing ring at the appropriate number. This may be useful when the subject is not yet in the frame but the operator knows the spot where the subject will enter the frame.

Autofocus cameras simplify focusing. Generally they focus on whatever is centered in the viewfinder. However, on wide shots with the subject off center, the camera may focus on something else. In such cases, the operator can refocus on the subject and keep it centered. If the camcorder has a manual override, the operator can use it to refocus by hand.

COMPOSITION

Composition for videos follows the same rules as still photography. First, select subjects that tell a story. If the video is being shot to show a new home, concentrate on points of beauty or attractiveness. Avoid putting the main subject in the middle of the frame. Mentally place lines in the frame that divide it into thirds both horizontally and vertically. Place the subject at any point where lines intersect. With practice, this will become second nature to the operator. At times this rule is broken for good effect. With practice the operator will recognize when.

When shooting a moving subject allow extra "lead room" in front of the subject so it will stay in the frame. If the subject is talking to someone off camera, leave space for the subject to "talk into."

LIGHTING

Most camcorders can record in low light situations. If the light is too low, colors will record poorly and dark areas will record video "noise" or interference. Video cannot handle excessive contrast. It performs best with somewhat flat light. Portable lights are available that clip on a camcorder, Fig. 14-15. They may put out about 30 watts and have a rechargeable battery. If the area is small, one or two floodlights will brighten up dark backgrounds.

Large studio lights can also be utilized as with still cameras. (See Chapter 7 on Lighting.) These can eliminate shadows and make the scene look more natural.

BOUNCE LIGHTING

Sometimes bounce lighting is used for quick setups. There are several ways to do this:
1. Place one light behind the camera pointing to the ceiling. Its light is reflected off the ceiling onto the subject and the room.
2. Aim the light at a corner. This diffuses the light even more than bouncing it off the ceiling since light reflects off three surfaces instead of one.
3. Additional lights can be used to spread the light over a larger area. Adding one light doubles the

Fig. 14-15. This portable light fits on top of a camcorder. It uses the same type rechargeable battery that is used in many camcorders. (To Cad America)

amount of light. However, to double it again will require four lights. A larger area will be covered if lights are bounced off adjoining corners.

4. A light can be bounced off a photographic umbrella or a large white reflector card.

CONTROLLING OUTDOOR LIGHT

Outdoor light causes deep shadows in eyesockets and under hat brims. People backlighted will not have enough light on their faces. A fill light can be created with white reflecting cards, hand held or placed off camera. On trips, natural reflectors such as snow or water can be used. Light colored walls, glass windows, and buildings are also sources of fill light. With study and practice, other light sources can be discovered and used.

CAMERA ANGLES

Consider angles when shooting with a camcorder. Shooting from a low angle makes a subject look more imposing, lending it power and strength. Using a high angle makes the subject appear insignificant or weak. Eye level shots establish a one-on-one relationship with the viewer.

HOLDING THE CAMCORDER

Holding the camcorder steady takes some practice. There are several ways to improve steadiness.
1. Brace the body against something solid. Back up against a tree or a door frame.
2. Place the camera on a tripod. Remember that this limits mobility of the camera.
3. Sit cross-legged bracing elbows on the knees.

4. If standing without any supporting structures nearby, stand with legs apart for better balance. Keep elbows tucked into body. Use both hands to steady the camera.

CAMERA MOVEMENTS (PANNING)

Beginners tend to overdo camera movement. Learn how and when to move the camera. While shooting, determine if motion is necessary or if simply changing shots will add more interest. If motion is considered best, know where the motion will end. Keep the shot relatively wide. Practice the motion beforehand. Try it at different speeds. Usually, slower is better, as all motion is magnified by the camcorder. When motion stops, hold the camera steady for a few seconds before changing or moving to another shot.

Panning should never be done over more than 90 degrees. It is hard to maintain balance over wider arcs.

EDITING

Editing can become quite complicated, especially for professional results. Two basic methods are available.
1. Some camcorders contain editing capabilities. These include features such as DUBBING for adding naration and background music. Time lapse functions allow animated videos and mini speakers to monitor sound during playback.
2. Connecting two VCRs allows editing as does a VCR and camcorder. Many controllers are also available to control the operation of these units.

VIDEO PRECAUTIONS

BATTERIES

Rechargeable nickel cadmium batteries are used in camcorders. They require care to keep them in top condition. Make sure they are fully charged before use. Keep a spare set if you are shooting an important event.

In cold weather, batteries will not operate as long. A spare set should be kept warm under a coat. Make sure nothing touches the contacts. A shorted battery can cause intense heat and serious burns.

WATER AND HUMIDITY

Protect your camcorder from water and humidity. Place in a clear plastic cover if shooting in the rain, snow, or at the beach.

Condensation may form while going from one temperature extreme to another. This may happen in the winter when bringing a cold camcorder into a warm room. Wait several minutes for the condensation to disappear. Moisture on the tape and heads can cause damage and expensive repairs.

MAGNETISM

Electronic recordings use magnetism. An undesired magnetic field can ruin recorded tapes. Avoid placing near magnets such as stereo loudspeakers or on top of a TV.

OTHER CAUTIONS

1. Store tapes vertically. Setting tapes on side can damage the edges.
2. Use freeze frame as little as possible. This increases tape wear.
3. Avoid high temperatures. Tapes set in the sun, on heaters, or other high-temperature places can be damaged. The plastic cassette can melt down if left in a closed car on a hot sunny day.
4. Do not touch the tape. Oil in fingers can attract dirt which will lesson sound and image quality.
5. Do not repair broken tapes. Glue or adhesive tape can damage equipment. If the recording is important, a video shop may be able to transfer the image to a new tape.

MOTION PICTURES

Motion pictures are important to study and many of these older cameras are being used.

The motion picture industry produces thousands of new movies each year. These movies still use film type cameras.

The motion pictures on a movie screen do not really "move." The appearance of motion is produced by rapidly projecting (showing) a series of still pictures on the screen. Each picture, known as a FRAME, is really seen individually because there is a black interval (space) projected between each picture, Fig. 14-16.

Since the eye retains (keeps) an image for a fraction of a second, the pictures blend or merge together and give the impression that the subjects are moving.

The retaining power of the eye is known as PERSISTENCE OF VISION. Motion pictures are based on this ability. Normal movement can be simulated (copied) by filming and projecting 16 to 24 frames per second (fps). SLOW MOTION results from speeding up the camera from 64 to 128 fps and projecting the film at normal speed. SPEEDED UP ACTION is gotten by slowing the camera to fewer than 16 to 24 fps. Projector speed remains constant.

With modern motion picture cameras, Fig. 14-17, it is not hard to make "movies." Some cameras are fully automatic. The film magazine need only be inserted into the camera. Notches on the magazine set the film

Fig. 14-17. Making movies is easy with a modern camera. (Chinon America)

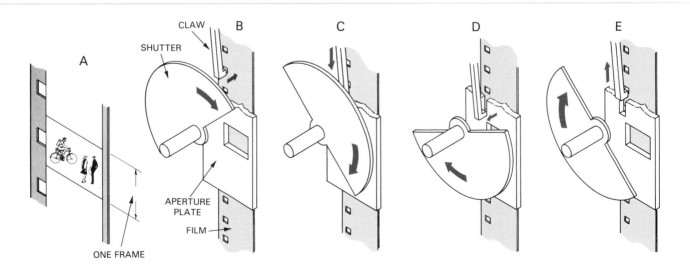

Fig. 14-16. A motion picture is really a series of single pictures or frames being rapidly projected. A—Single frame or picture and perforations for motion. B—First, claw enters film's perforation. C—Second, claw pushes down one frame while shutter blocks out light. D—Third, claw retracts. E—Fourth, claw returns to repeat cycle. Open shutter allows frame to be projected.

speed for you. On other cameras, the film speed must be programmed (set) by hand.

This chapter will deal with movies made on SUPER 8 mm and 8 mm films. Though not interchangeable in cameras, both film types can be shown on many projectors.

EQUIPMENT NEEDED

The art of taking movies is called CINEMATOG-RAPHY. A person making a movie is known as a CINEMATOGRAPHER. The amateur cinematographer needs the following equipment to make and view a movie.
1. Camera.
2. Film.
3. Lights.
4. Projector.
5. Screen.

THE MOVIE CAMERA

Movie cameras are offered as FIXED FOCUS, AD-JUSTABLE FOCUS, and AUTOFOCUS models. The adjustable focus is the more versatile if you want the sharpest focus at all distances and in dim light.

A movie camera consists of five main parts. These are shown in Fig. 14-18.
1. Lens.
2. Viewing system.
3. Focus control.
4. Exposure control.
5. Power system.

THE LENS

Few modern super 8 and 8 mm cameras are made with fixed focal length lenses. Most are fitted with

Fig. 14-18. A motion picture camera has five main parts: 1—Lens. 2—Viewing system. 3—Focus control. 4—Exposure control. 5—Power system. (Bell & Howell)

zoom lenses. The zoom lens can be adjusted continuously from normal lens to telephoto, Fig. 14-19.

Some zoom lenses may have a ZOOM RATIO of 6 to 1. That is, the maximum focal length is six times the minimum focal length. A 7 to 42 mm is such an example. This means an object being photographed will be enlarged six times when filmed in the maximum telephoto position (42 mm).

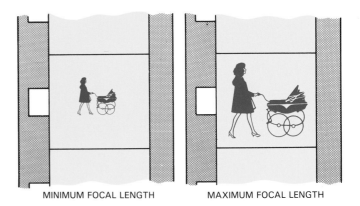

MINIMUM FOCAL LENGTH MAXIMUM FOCAL LENGTH

Fig. 14-19. A zoom lens can make the subject appear closer or further away.

LENS SPEED

Lens speed is indicated by its maximum aperture or f/number. Some cameras have a lens speed as fast as f/1.2. This type of lens is designed to make movies by existing light. There is no need for floodlights. Less expensive cameras may have lenses as slow as f/3.5.

VIEWING SYSTEM

There are two basic viewing systems, Fig. 14-20.
1. Viewfinder.
2. Single lens reflex (SLR).

The viewfinder system is a separate viewing system that shows the operator what the lens sees. The viewfinder and lens do not see the exact same thing because they are separated slightly. The difference, as you know from other chapters, is parallax. Parallax causes no problem at normal shooting distances. Corrections must be made when making close-ups, however.

Single lens reflex systems are viewing systems that allow you to see through the taking lens, Fig. 14-21. The viewfinder shows the scene exactly as it will appear on the screen.

Some camera viewfinders also include valuable picture-taking information: f/stop, end of film warning and over/under exposure warnings.

FOCUS CONTROL

Clear, sharp movies will result only if the lens is focused properly. At present, there are four types of

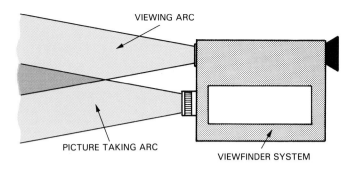

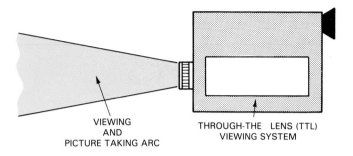

Fig. 14-20. Viewfinder and single lens reflex systems are the two basic types of viewing systems.

focus controls:
1. Preset.
2. Manual.
3. Rangefinder.
4. Autofocus.

Simple cameras are prefocused by the manufacturers. The cameras produce good pictures as long as the subject is at least 4 ft. (1.2 m) away. A subject photographed at a shorter distance will not be in sharp focus.

A manual focusing ring is found on some cameras, Fig. 14-22. Once the subject-to-camera distance is determined, the focusing ring is set to that distance. Symbols may also be used to indicate where the lens is to be set to make distant, group, and close-up shots.

The rangefinder system is built into cameras with SLR viewing systems. This allows you to control the focus exactly as you want it to appear on the screen.

Autofocus is the latest development in focusing systems, Fig. 14-23. Sharp focus is automatically achieved. It works fast enough so that you can pan from a close-up to a distant shot. (Panning is movement of the movie camera to keep a subject in view or to get a broader view of a scene.) Follow focusing of traveling subjects is also possible. Focusing can be done manually, if necessary, to handle unusual or tricky conditions.

EXPOSURE CONTROL

The correct lens opening is the key to a properly exposed movie. Most modern cameras have fully automatic exposure systems. Some older cameras, however, have a manual lever to set the lens f-stop for shade, cloudy sky, or bright sunlight.

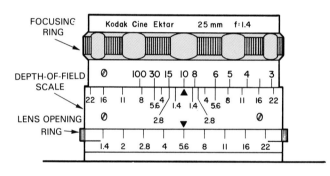

Fig. 14-22. Manual focusing ring is found on many of the better cameras.

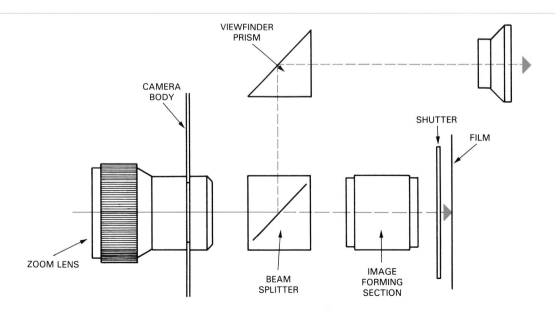

Fig.14-21. The single lens reflex viewing system allows you to see scene exactly as it will appear on screen.

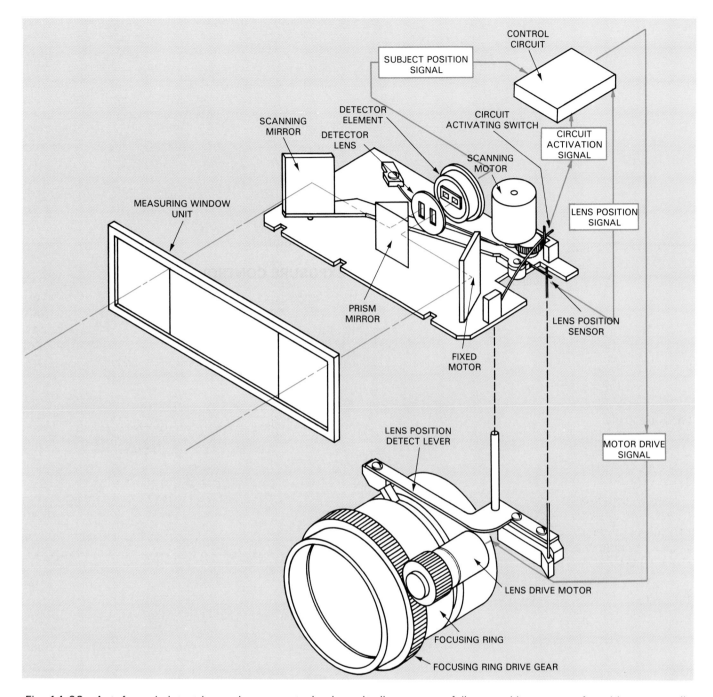

Fig. 14-23. Autofocus is latest in movie camera technology. It allows you to follow a subject near or far without manually adjusting the focus.

The camera must be programmed for the film being used. This is done automatically in most modern cameras when the film magazine is inserted, Fig. 14-24. A built-in filter must be flipped into place for filming in color under daylight unless "universal" Type G film is used.

POWER SYSTEM

Most cameras have battery powered motors to advance the film. Check battery condition before starting a shooting session. Remove the batteries when the camera will not be used for a long time.

Older cameras may have spring-driven motors to advance the film. Wind these motors after each scene. Otherwise, the motor may run down in the middle of the next scene.

THE PROJECTOR

Projectors, Fig. 14-25, differ greatly. Some can run both super 8 and 8 mm films. Others can handle only one size. Most projectors feature rapid rewind and/or automatic threading. (Threading means feeding the film into the projector mechanism and onto the second reel.)

Fig. 14-24. Camera is automatically "programmed" (set) for type of film being used when cartridge is inserted.

Fig. 14-26. Projector lens (arrow) is rated by its f-number and focal length. (Hanimex)

Fig. 14-25. Most projectors can handle both super 8 and 8 mm films by the slip of a switch. (Chinon America)

Fig. 14-27. Basic controls on a movie projector include forward, reverse, focus, and elevation adjustment.

Most home use projectors have two main features.
1. Lens.
2. Controls.

LENS

A projector lens, Fig. 14-26, is rated by its f-number and focal length. The smaller the f-number, the brighter the image projected on the screen. A projector with a zoom lens allows image size to be varied on the screen. It is not necessary to move the screen or projector to increase image size.

CONTROLS

Basic controls include forward, reverse, focus, and elevation adjustment, Fig. 14-27. Projectors with

FILM SPEED CONTROL allows slow motion. PAUSE CONTROL permits the projected image to be stopped to allow viewing a single frame at a time.

TABLE TOP PROJECTION

The table top projector, Fig. 14-28, is a variation of the conventional projector. The screen is built into the machine. Viewing is possible in a normally lit area. Room darkening is not necessary.

MOVIE FILM

Movie film is basically the same as that used in still cameras. The manual that comes with the camera will indicate the correct size and format. Usually, super 8, 8 mm magazines, or 8 mm rolls are specified. Each mazazine or roll contains 50 ft. (15 m) of film.

Most modern amateur movie cameras use the super 8 format. It has a larger image area than the older 8 mm film, Fig. 14-29. The projected picture is sharper and brighter. Super 8 film is purchased as a con-

Fig. 14-28. Table top projector eliminates need for screen. (Eumig)

Fig. 14-29. Super 8 picture format is 50 percent greater than older 8 mm format.

Fig. 14-30. 8 mm film is really 16 mm wide. Roll is cut down the center and spliced together after processing.

Fig. 14-31. Sound film has two magnetic stripes. Lower one is main recording strip. Some newer projectors use narrow "balance" stripe next to sprockets to record additional background sounds.

tinuous cartridge. The entire 50 ft. can be run without interruption.

The 8 mm film comes on a reel and must be threaded into the camera. After 25 ft. (7.6 m) of picture taking, the reel is "flipped" and film rethreaded so the remaining unexposed footage can be used. This film (8 mm) is really 16 mm wide, Fig. 14-30. After processing it is cut down the middle and spliced (connected end-to-end) to provide 50 continuous feet of movies.

Super 8 film is available with a magnetic strip for recording sound, Fig. 14-31. Naturally, the camera must be fitted with sound recording equipment.

There are three common types of super 8 color film.

1. Daylight.
2. Type A ("A" for artificial light). This film is balanced for floodlights. Many cameras have a build-in filter so this type of film can also be used for daylight movie making.
3. Type G. This is a new type of film that eliminates the need for floodlighting in many situations.

B&W motion picture film is also available. Processing is difficult to obtain. Except for special purposes or effects, it is generally uninteresting to an audience.

MAKING MOVIES

A good movie is interesting, colorful, in sharp focus, and shows motion. It is the job of the cinematographer to combine these four elements.

Interest can be created with motion. Still photographers record a thin slice of time. A motion picture records an entire segment of time with people or other subjects moving about.

Colorful movies are the result of good lighting, correct exposure, and colorful subjects. Choose subjects, if possible, with vivid (bright) colors.

A clean lens, careful focus, and a steady camera will produce a sharp movie. Cameras come in a variety of shapes and sizes. Follow the manufacturer's recommendations on how to hold your camera steady.

In addition, four other elements can be employed to hold the interest of an audience.
1. Action.
2. Tell a story.
3. Zoom.
4. Panning.

Action is the reason to make a movie. However, keep scenes short. Segments of 6-12 sec. are long enough. Several long scenes in a row will bore most audiences. Too many short scenes are also boring. For best results, use a mix of short and long scenes.

Add to the action by varying the camera angle or the filming distance. Try kneeling down and shooting upward or shoot the scene from a higher position. Look for uncluttered backgrounds. "Busy" surroundings draw attention away from your intended scene.

A movie must tell a story. Like any good story, it needs a beginning, a body, and an ending. These parts must flow smoothly together. Plan the movie in advance. Many books found in the public library will aid you in preparing the script. Homemade titles and/or shots of signs make good beginnings. See Fig. 14-32.

Zoom lenses allows you to move in close or back off from the subject. The subject or scene can be framed in the viewfinder without changing the camera-to-subject distance. Use zoom sparingly. Too much is annoying.

Panning is a method of shooting a scene that is too big for one shot, Fig. 14-33. It is done by slowly moving the camera across the scene. For best results, pause for a few seconds at the end of the pan. Panning too rapidly produces a blurred scene and a dizzy audience.

Fig. 14-33. Panning is effective for shooting a big scene such as the Grand Canyon. The movie camera is moved slowly across the scene.

SOUND

Sound is now available to the amateur cinematographer. A tiny tape recorder is built into the camera. It records on the magnetic track of the film for perfect synchronization (timing), Fig. 14-34. When recording, keep the microphone out of the picture. Avoid background noises such as traffic and lawnmowers. The sound units are designed to be used at no more than 5 ft. (1.5 m) from the source.

FILM EDITING

Most amateur moviemakers are satisfied to show their film exactly as it comes from the processing lab. The movie is nothing more than a series of unrelated episodes. Some of the scenes are too long, repetitious, out of focus, under or over exposed, or do not contribute to the story.

Editing removes the defective material and rearranges the remaining scenes into a series of related sequences. Editing is as important as shooting the film. It transfers the raw material into smooth, flowing action that will tell an interesting story.

Try to edit the film so it can be projected within a 20 to 30 minute period. To figure how long your film will run, multiply each foot (0.3 m) of film by about five sec.

SPLICER

Several pieces of equipment will make the job of SPLICING (joining) film sections together much

Fig. 14-32. Shooting a sign at your movie location provides a good title.

Fig. 14-34. Many movie cameras record sound. (Chinon America)

Fig. 14-35. A splicer allows you to piece together several scenes in a desired order.

easier. A splicer, Fig. 14-35, has pins to position the film for cutting and joining. Special tape or cement binds the film sections together. Follow the directions furnished with the splicer for best results.

EDITING MACHINE

An editing machine, Fig. 14-36, has a viewing screen that shows an enlarged image of the film. By turning the handles it is possible to move the film through the viewer as fast or as slow as you like. It can be stopped so a single frame can be viewed.

As you run the film through the viewer, write down the scenes you want to keep or discard. Do this several times before actually cutting the film into sections.

Start the actual editing by marking the film where it is to be cut. Wear white cotton gloves (made for the job) when handling the film. They prevent fingerprints and scratches on the film. Attach a small adhesive label to the end of each film strip. Identify

Fig. 14-36. An editing machine allows easy viewing and cutting of scenes. (Hanimex)

the scene on this label, Fig. 14-37. Store sections so they will not become scratched.

Arrange the various film strips in the order you want and splice them together. Mylar tape or a special film cement should be used for joining.

After all scenes are joined, clean the entire film with a commercial film cleaner. Caution: Do not use carbon tetrachloride. Wind the edited film onto a suitable size reel so it will be ready for viewing.

Fig. 14-37. Attach label to each strip of film while editing. This makes it easy to keep track of scenes.

WORDS TO KNOW

Video, camcorder, audio, zoom ratio, pixels, imager, lux, dubbing, cinematographer, editing, film magazine, follow focusing, frame, main stripe, mylar tape, paning, pause control, persistance of vision, projector, slow motion, speeded up action, splicing, threading, zoom lens, zoom ratio.

TEST YOUR KNOWLEDGE

1. A camcorder combines the functions of a _____ and a (an) _____.
2. List the equipment needed to make and view a video.
3. Explain the operating principle of the camcorder.
4. An _____ is an electronic device that captures the focused light from the camcorder lens.
5. List and describe the usage of the five types of microphone used with camcorders.
6. List the four different types of camcorders.
7. Name the main elements that an operator must pay attention to during videotaping.
8. Why should one be careful about storing videotapes near a magnetic field?
9. A movie camera with a lens having a maximum aperture of f/1.2: (Check the correct answer or answers.)
 a. Would not be too useful under low existing light conditions.
 b. Would be useful under low existing light conditions.
 c. Will need flood lighting to take pictures.
 d. All of the above.
 e. None of the above.
10. List the major reasons why super 8 format film is considered to be better than the older 8 mm format film.
11. When planning a motion picture, four (4) basic elements should be included. Briefly outline each element.
12. Moving a camera to follow a moving object is called _____.
13. Sound is available with some of the movie cameras and camcorders. Certain precautions, however, must be observed if sound is to be used for best effect. List these precautions.
14. How can editing improve a video or movie?
15. List the tools commonly used for editing home videos and movies.

THINGS TO DO

1. Carefully study the instruction manual that came with your camera or camcorder. Learn how to use the camera to best advantage.
2. Write a script for a video or movie explaining some phase of photography. Film it.
3. Research how animated movies are made. Prepare a paper on the subject.
4. Prepare a report on the history of movies.
5. Research how unusual and unique titles can be made for home movies. Demonstrate some of the techniques to the class.
6. Prepare a list of "do's and don'ts" for making home videos or movies. Have the list reproduced and distribute it to the class.
7. Design and set up a bulletin board display on movie or video equipment.
8. Write a term paper on the kinds of videos that are made today.
9. Special effects and trick shots add considerable interest to videos and movies. Prepare a report on how some of them are achieved.

15 HOW TO DISPLAY PHOTOGRAPHS

After studying this chapter you will be able to:
- ☐ Describe the materials and tools needed for mounting photographs.
- ☐ Discuss different types of mounting including dry mounting, cold mounting, wet mounting, and still projection.
- ☐ Mount photographs by any of the mounting methods.
- ☐ Frame a photograph using a custom frame or one of your own construction.
- ☐ Describe a procedure for developing and presenting a slide show by projection.

One of the most satisfying aspects of photography is displaying favorite photographs, 15-1. They can be displayed in many different ways by:

1. Making an enlargement of the photo and mounting it on a stable backing.
2. Framing the photograph.
3. Projecting transparencies on a suitable screen.

SELECTING A PHOTOGRAPH FOR DISPLAY

Whichever method of display is used, picture choice is very important. Some pictures are more in-

Fig. 15-1. Favorite photos can be displayed in a variety of ways.

teresting and spectacular than others. Look for an interesting facial expression, a unique subject, or an unusually attractive scene, Fig. 15-2. These are the pictures which should be displayed whether for your own pleasure or for public exhibition.

Both black and white and color photos are suitable for enlargement and display. The enlargement can be made by the photographer (you) or by a reputable photo dealer. Dealer enlargements are usually machine made by a high speed photo processing plant. While more expensive, you may want to have the enlargement made by a "custom lab." They will crop, burn-in, dodge and color correct the enlargement to your exact specifications. The results are well worth the extra expense. They cannot, however, make a bad picture into a good picture.

HOW TO MOUNT A PRINT

After the enlargement has been made, it must be prepared for display. It can be attached to a special backing called MOUNTING or MATTE BOARD, Fig. 15-3, or placed in a FRAME, Fig. 15-4.

MOUNTING BOARD

Mounting board is a heavy cardboard or foam board. It is available in many textures, colors, and weights (thicknesses) at most art and photo stores, Fig. 15-5. Select a mounting board which will accent and enhance (make more attractive) the colors and mood of the photograph.

There are several ways you can mount your prints for display:
1. Dry mounting with heat.
2. Mounting with spray adhesives.
3. Cold mounting with pressure sensitive adhesives.
4. Wet mounting with glue.

Caution: Use mounting materials designed for photo work. Otherwise, the mounted photos may, after a period of time, crack, develop stains, or lift from the mounting board.

Fig. 15-3. Photo displayed on mounting board. Note how the tone of the mounting board accents the photo.

Fig. 15-2. Select photos for display that are interesting, show an unusual scene, an interesting facial expression, or a unique subject.

Fig. 15-4. Some photos are best displayed by framing.

Fig. 15-5. Mounting board is made from heavy card stock or foam sheet. It is available in many colors and surface textures.

TACKING IRON

MOUNTING BOARD

MOUNTING TISSUE

PRINT

PROTECTIVE TOP SHEET (CLEAN WHITE PAPER)

Fig. 15-6. Use a tacking iron to attach the mounting tissue to each corner on the back of the print.

Dry Mounting With Heat

When using this technique, work on a day when humidity is low. This will reduce the chance of the mounting board warping and/or bowing.

The adhesive, dry mounting tissue, is a thermosetting (heat setting) resin. Both heat and pressure must be applied at the same time.

Caution: When mounting resin coated (RC) papers use a mounting tissue designed for use with that type of print paper. It must be applied at the exact temperature specified by the tissue manufacturer or you may melt the plastic coating of the print.

Cut the tissue to the exact size of the print. Place the mounting tissue on the back of the print. No tissue should project beyond the print edges. Use a hot TACKING IRON, Fig. 15-6, to lightly tack the tissue to each corner of the print. Attach one corner, then the opposite corner.

Positioning and attaching the print

Placement of the print on the mounting board is also important. It must not be done in a haphazard manner. See Fig. 15-7.

Position the print on the mounting board. Use a rule and/or a square as a guide so the print will be straight.

Lay a clean sheet of paper over the face of the print. This will prevent the iron from coming into direct contact with the print. Tack the print to the mounting board by pressing the tacking iron against the cover paper at the center of the print. Hold the iron in place until the heat penetrates both paper and print. The adhesive softens so it can penetrate into the mounting board, Fig. 15-8.

PREFERRED

AVOID

PREFERRED

AVOID

PREFERRED

AVOID

Fig. 15-7. Use care when locating a print on the backing board. Study these samples for best border relationships.

Fig. 15-8. Hold the tacking iron in place until the heat penetrates the paper and softens the adhesive so it can penetrate the mounting board. Caution: Use the heat range recommended by the adhesive manufacturer when mounting prints made on RC papers.

If no MOUNTING PRESS, Fig. 15-9, is available, use a laundry iron to attach the print. Set the iron at the temperature given by the tissue manufacturer.

Place the mounted print on a flat surface. Weight it down until it has cooled.

Spray mounting

Spray mounting adhesives are especially made for mounting prints, Fig. 15-10.

Caution: Photo mounting sprays must be used in a well ventilated area. Avoid breathing the vapors. They may be hazardous. Most sprays are extremely inflammable. Do not use them near sources of heat and flames. Upon skin contact, remove spray with soap and water.

Generally, only the back of the print needs to be sprayed with the adhesive. Two applications are recommended. The second coat should be applied at

Fig. 15-10. Spray mounting adhesives are especially made for mounting prints.

right angles to the spray pattern of the first coat.

Allow the adhesive to dry until it becomes tacky. Then position the print on the mounting board. Use a rule and/or square to assure that the print is square and located where you want it.

Use enough pressure to insure print contact with the mounting board. A hard rubber roller, Fig. 15-11, is recommended. Work the print from the center outwards, Fig. 15-12.

Pressure sensitive adhesives

Pressure sensitive adhesives permit cold mounting the print to a mounting board. You sandwich the adhesive between the print and a mounting board, and apply pressure. No heat is needed.

One technique uses a mounting sheet which has adhesive on both sides. The sheet permits the print to be moved about on the mounting board until the desired position is found. Until it is used, protective coverings are attached to each side.

Cut the adhesive sheet to print size. There must be no overhang.

Peel away the release paper from one side of the adhesive coated sheet. Place the adhesive sheet on the back of the print. It can be moved about until pressure is applied.

With a squeegee or roller, apply firm pressure on the back of the carrier (protective) sheet. When the

Fig. 15-9. Mounting press has temperature gauge and adjustable heat settings.

HARD RUBBER ROLLER

COLD MOUNTING PRESS

Fig. 15-11. After the spray adhesive has become tacky, position the print on the mounting board. Use a hard rubber roller or a cold mounting press to apply the pressure necessary to make the print bond to the mounting board.

adhesive is completely attached to the back of the print, remove the carrier sheet.

Position the print on the mounting board. Use a rule and/or square to align it. Place the release paper over the print and squeegee or roll the print to the mounting board. See Fig. 15-13.

Fig. 15-12. When using the hard rubber hand roller to mount prints, work the print from the center outward. A protective sheet of clean paper should be placed over the print before using the roller.

Fig. 15-13. A smooth plastic squeegee (shown) or hard rubber roller can be used to bond adhesive mounting sheets to the back of the print and the print to the mounting board.

Wet mounting with glue

Wet mounting is an inexpensive process. It can, however, be messy and time consuming. The technique makes use of wallpaper paste or a diluted white glue (Elmer's, for example).

Paste and white glue will not work on RC print papers because the paper is not porous. The adhesive cannot "grab" onto the paper. A special adhesive for mounting RC papers must be used.

Wet mounting has one drawback. The mount will bow if a backing sheet of the same print material is not glued to the reverse side of the mounting board.

FRAMING PRINTS

Many types and sizes of frames are available. Custom frames can be made from materials purchased at art supply stores and from wood molding purchased at most lumber yards.

When framing a print behind glass, do not let the print touch the glass, Fig. 15-14. In time the print will

FRAME

SPACER

MOUNTING BOARD

PRINT

GLASS

Fig. 15-14. When framing a print behind glass, do not allow the print face to touch the glass. In time the print will adhere to the glass.

adhere to the glass and be destroyed when removed.

To improve the appearance of a framed print, a technique called MATTING can be used. The print is surrounded with a mounting board apron, Fig. 15-15. Matting also keeps the print from touching the glass.

OTHER MOUNTING TECHNIQUES

Prints can also be mounted so that only the edges of the mounting are visible, Fig. 15-16. In this case, hardboard or plywood is used as the mounting board. The edges of the mount and the print should be darkened with paint, stain, or felt tip pen.

DISPLAY BY PROJECTION

Projection is a popular way to display transparencies. This is done by using a SLIDE PROJECTOR, Fig. 15-17. The projector is basically a bright light and a lens. The transparency is placed between the two units, Fig. 15-18, and projected onto a suitable screen. Several different lens sizes are available for most projectors. They permit a reasonably sized im-

Fig. 15-16. Prints can also be mounted flush on plywood or hardboard. Darken the exposed edges with paint, stain, or felt tip pen.

age to be projected wherever the projector is located.

To be projected, the transparencies must be mounted in cardboard, plastic, or metal and glass frames. They are called SLIDES, Fig. 15-19.

Several methods are used to hold and introduce slides into the projector. These include trays, cubes, and stack loader, Fig. 15-20.

PRESENTING A SLIDE SHOW

A slide presentation should be well planned and should present an interesting story. Organize the slides in a logical order. Include only good slides in the presentation. You do not have to project every picture taken when preparing the presentation. No one wants to see duplicate, dull, blurred, or badly scratched slides.

MOUNTED PHOTO

MATTED PHOTO

Fig. 15-15. Pictures to be framed are often matted. This involves surrounding the print with a mounting board apron.

Fig. 15-17. This projector uses a carousel to hold slides. (Victor Hasselblad)

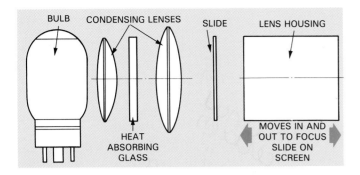

Fig. 15-18. In the slide projector, the slide or transparency is placed between the lens and light source.

Fig. 15-19. To be projected, the transparencies must be mounted in cardboard, plastic, or metal frames and are called slides.

More complicated slide presentations can be accomplished by adding music and sound, and by using two or more projectors. Special accessories permit an image from one projector to dissolve (fade) and be replaced by the "fade in" of a new image from the second projector. Any technique that makes a slide presentation more interesting should be used. Try it out before the actual presentation.

Slides must be inserted into the projector so the image is upside-down to the operator. The emulsion (dull) side of the slide must face towards the lens. Otherwise, the projected image will be upside-down and/or reversed.

Whenever possible, a slide presentation should be viewed and editing and corrections made before it is shown to an audience. Have a spare projection lamp on hand. Nothing "kills" audience interest faster than having to stop the presentation while someone searches for a lamp to replace the one that burned out.

WORDS TO KNOW

Frame, framing, matte board, matting, mounting board, mounting press, slide projector, slides, tacking iron.

TEST YOUR KNOWLEDGE

1. List the different ways photos can be displayed.
2. Picture choice for display is very important. What types of pictures should be displayed?
3. Explain why custom lab is sometimes the best place to get a photograph enlarged.
4. Prints can be attached to mounting board by one of several methods. What are they?
5. What precautions should be taken when mounting resin coated (RC) prints?
6. When framing a print behind glass, do not let the print touch the glass because: (Check the correct answer or answers.)
 a. Reflections will make it difficult to see the print.
 b. The print colors will be changed.
 c. The print will adhere to the glass and be destroyed when removed from the frame.

Fig. 15-20. Slide projector with a carousel type tray. The tray holds 80 slides. A stack loader is shown beside the projector. It is used for editing and when only a few slides are to be shown.

7. Describe the precautions that should be taken before presenting a slide show.

THINGS TO DO

1. Temporarily place a print on mounting boards of different colors, shades, and textures. Have the class help you determine the best combination for your particular print. Make a list of the reasons given why some combinations of color and texture look good and why some do not.
2. Mount two or more prints on a mounting board. Before attaching them, try many combinations to determine where the prints look best.
3. Frame a print.
4. Mat a print.
5. Develop a short slide show. Experiment with your class to determine the best time interval between slides, changes that should be made to improve the show. Have them prepare a short critique of your first effort compared to the final version.
6. Prepare a slide show with preselected music.

DICTIONARY OF TERMS

ABERRATION: A defect or flaw in a lens caused by the behavior of light. Aberrations are minimized (reduced) in compound lenses.

ACETIC ACID: The chemical used in stop bath to halt development and neutralize the developer. A 2 percent solution is generally used with negatives and prints. It is also called glacial acetic acid.

ACTIVATOR: A chemical solution that acts like a developer. It is used with a stabilization processor and special papers.

ADDITIVE PRIMARY COLORS: A method of filtration in color printing. Three separate exposures of a negative are printed through red, blue, and green filters onto a single sheet of paper.

AGITATE: The rocking motion during processing to keep fresh chemicals in contact with the film.

ANGLE OF VIEW: The largest angle of light rays passing through the lens, which will form an image of acceptable quality on the film.

APERTURE: The opening in a camera lens that regulates the amount of light reaching the film. The aperture may be fixed in size or adjusted by a diaphragm.

AUDIO: Sound portion of a video or video tape. May be dubbed in later.

BELLOWS: Light-tight folding sleeve used to join the lens to the camera body. One type is used on large-format cameras, providing adjustable lens-to-image distances. A second type is used for macrophotography.

BOUNCE FLASH: The aiming of a flash unit at a wall or ceiling to reflect light onto a subject. This avoids harsh shadows that result from pointing the flash directly at the subject.

BURNING-IN: A technique used in printing to add more exposure to a small area of the print.

CAMCORDER: A motion camera that magnetically records and plays back the photographed action.

CAMERA: A photographic device in which film can be exposed to yield a photograph.

CARTRIDGE: A plastic container for 110 and 126 format films.

CINEMATOGRAPHY: The art of taking motion pictures.

CLOSE-UP: The area of photography recording subjects 1/10 life-size to life-size. Common subjects include flowers, stamps, and coins.

COATED LENS: A thin layer of chemical substance placed on the lens to reduce stray light reflections.

COLOR HEAD: A device on top of an enlarger that provides variable amounts of yellow, cyan, and magenta filtration. It is a valuable aid in color printing.

COMPLEMENTARY COLORS: Opposite colors on the color wheel that make white light when added together. Primary colors include: red, blue, and green. Their respective complementary colors are: cyan, yellow, and magenta.

COMPOSITION: The intentional arrangement of different elements in the set-up of a photograph.

COMPOUND LENS: A lens consisting of two or more elements.

CONTACT PRINT: An actual-size print of a negative. It is made by placing the negative on the photographic paper and exposing to light.

CONTACT PRINTER: A device used to make contact prints. Aids alignment of negatives on top of photographic paper.

CONTRAST: The visual difference in density (blackness) between the light and dark areas on a print or negative.

CONVERGENT LENS: A lens that causes light rays to bend inward to a point. It is thinner at the edges and thicker in the middle.

CROPPING: The elimination of undesirable areas while printing.

DARKROOM: An area of the house or special room sealed off from light. This light-tight area is used to load exposed film or print photographs.

DENSITY: The amount of silver left deposited after exposure and development.

DEPTH OF FIELD: The range of distance in which everything appears in sharp focus.

DEVELOPER: A chemical that causes light-struck silver particles to form a visible image.

DEVELOPING TANK: A light-tight container that holds film and solutions during processing. A light baffle allows the addition and removal of chemicals and water during development.

DIAPHRAGM: The adjustable opening in a lens that controls the amount of light passing through to the film.

DILUTE: The watering down of a chemical to a desired concentration (mixture).

DILUTION FACTOR: Directions to dilute a chemical. A chemical requiring a 1:3 dilution means one part chemical for three parts of water.

DIVERGENT LENS: A lens causing light rays to bend outwards. It is thicker at the edges and thinner at the middle.

DODGING: A technique used while printing. It is a method of holding back light from certain areas during exposure.

DRY MOUNTING TISSUE: A heat sensitive material that binds a print to a mounting board.

DUBBING: Adding new sound effects or dialogue to a film or videotape.

EASEL: A device for holding a sheet of photographic paper under the enlarger while printing.

ELECTRONIC FLASH: A light source produced by a high-voltage discharge in a gas filled tube. The tube can produce thousands of flashes. It is also called a strobe.

ELEMENT: A single glass or plastic lens. Two or more elements make a compound lens.

EMULSION: The light-sensitive layer of photographic material. It consists of silver halide crystals. The emulsion may be suspended in gelatin (film) or coated on paper.

ENLARGEMENT: A print that is larger than the original image on the film.

ENLARGER: An optical device used to make an enlargement. It has adjustable focus and height adjustment to make various sizes of prints.

EXPOSED FILM: Film that has been struck by light and has a latent image formed on it.

EXTENSION TUBES: An accessory used in close-up photography. They are metal tubes that increase the distance between the film and lens.

FADE-IN: A term used in motion picture and slide projection. The viewfinder or screen begins completely dark. Gradually the image appears until completely illuminated. It is useful as a lead-in.

FADE-OUT: A term used in motion picture or slide projection. The viewfinder or screen is fully illuminated and is gradually darkened completely. It is useful as a closing.

FILL-IN FLASH: Additional light by electronic flash or flashbulb to supplement natural light. Dark shadow areas will be lightened.

FILM: A transparent, flexible base of cellulose coated with a light-sensitized emulsion.

FILTERS: Transparent optical devices which alter the quality of light passing through them. Usually a specific part of light is blocked.

FIXER: An acidic chemical which dissolves away the undeveloped silver halide crystals on film or photographic paper. The emulsion becomes stabilized.

F-NUMBER: The resulting number when the focal length of a lens is divided by the diameter of the aperture. The sequence of numbers represent the various openings between the maximum and minimum settings. F-numbers are really fractions so the large numbers allow less light to pass.

FOCAL PLANE: The plane in the camera where the film's surface is positioned.

FOCAL PLANE SHUTTER: A camera's shutter system consisting of sliding curtains. It is positioned slightly in front of the focal plane.

FOCAL LENGTH: The distance between the optical center of a lens and the focal plane when the lens is focused at infinity. The greater the focal length, the smaller the angle of view.

F-STOP: The marking on the ring or dial that controls the diaphragm. It is an indication of the amount of light passing through the aperture. A small f-stop, such as f/16, admits little light.

GELATIN: A transparent material which forms a base for film. Silver halides are embedded in the emulsion which coats the gelatin base. Also used to make a certain type of filters.

GRAIN: Clumps of developed silver halide on film or print paper.

GUIDE NUMBER: A number indicating the power of an electronic flash or flashbulb. It is dependent on the film speed. The guide number divided by the subject-to-flash distance equals the necessary f-stop.

HYPO CHECK: A chemical test for fixer. A white chemical formation indicates that the fixer is exhausted and must be replaced.

HYPO CLEARING AGENT: A chemical that rapidly removes hypo (fixer) from a photographic emulsion. It greatly reduces wash time for film and paper.

IMAGE POINT: The point at which light passing through a simple lens converges (meets). The film is placed at the image point.

IMAGER: Captures light from video camera lens and changes it to electronic impulses.

INCIDENT LIGHT: The light falling on a subject or surface.

INDICATOR STOP BATH: A stop bath that is specially colored yellow or orange. Exhausted stop bath turns blue indicating the need for replacement.

ISO: System of rating the emulsion speed of film by the International Standards Organization.

LATENT IMAGE: The invisible image formed on photographic emulsions by the reaction of light upon silver crystals. Chemicals in the developer

convert this image into a visible image.

LEDS: Light Emitting Diodes. Found in newer cameras, they may indicate shutter speed, f-stop, or warning signals.

LENS: A transparent object that has at least one curved surface. Used to focus light on film.

LENS CAP: A metal or plastic covering to protect the exposed front lens element.

LENS CASE: A padded leather or plastic container to protect a lens that is not in use.

LIGHT METER: A device to measure light for a correct exposure. It can be either built into the camera or hand held. It may be powered by a battery or chemical reaction.

LIGHT RAYS: Lines of energy that make up visible light.

LIGHT SPECTRUM: The portion of the electromagnetic spectrum that is visible to the eye. Includes the colors red, orange, yellow, green, blue, indigo, and violet.

MACROPHOTOGRAPHY: Extreme close-up photography. Images are larger than the original subject. Also called photomacrography.

MATTE BOARD: The material on which a print is mounted.

MICROPRISM: A special type of focusing screen found in SLR cameras. It is a grid of tiny prisms. A fragmented image is evident when the image is out of focus.

NEGATIVE: Image in which dark tones are recorded light and light tones are dark. Complementary colors of the subject are recorded in a color negative.

NEGATIVE CARRIER: A pair of metal plates with a "window" in them to hold a negative when it is in the enlarger.

NEGATIVE LENS: See Diverging Lens.

NORMAL LENS: A lens with a focal length approximately equal to the diagonal of the film format. The normal lens for a 35 mm camera is 50 mm.

PAPER SAFE: A metal or plastic light-tight container that holds photographic paper. It can be opened only under a safelight to remove sheets for printing.

PARALLAX: The difference in images seen by the camera's viewing system and the lens. It is a problem only at close distances.

PHOTOMACROGRAPHY: See Macrophotography.

PHOTOMICROGRAPHY: Photographing of subjects through a microscope.

PINHOLE CAMERA: A camera without a lens. Light passes through a tiny hole to form an image on film.

PIXELS: Electronic image points on the imager of a video or camcorder. They make up the image.

POLYCONTRAST® FILTER: Kodak's name for variable contrast filters. They provide an entire range of contrast with one type of paper. Used with variable contrast or Polycontrast® papers.

POLYCONTRAST® PAPER: Kodak's name for variable contrast paper. It provides a range of contrast while printing with the use of filters.

PORTRAIT: A photograph of a person, usually a head and shoulders shot.

POSITIVE IMAGE: Image in which the dark tones correspond to the dark tones in a subject and light tones correspond to light tones. A positive color image corresponds to the correct colors of the subject.

POSITIVE LENS: See Converging Lens.

PRESET LENS: A lens lacking an automatic diaphragm. The actual shooting aperture must be set manually.

PRINT: A positive image formed by projecting a negative onto photographic paper and processing the exposed paper in chemicals.

PRINT EXPOSURE METER: A light measuring device that indicates the correct exposure for making a print. Color meters indicate exposure and correct filtration.

POLARIZING FILTER: A transparent filter which allows light to pass in a single plane. Reflections are reduced and the sky darkens when the filter is rotated properly.

PRINT PAPER: Photographic paper used to make a positive image from a negative.

PRINTING: The process of transforming a negative into a positive image.

PROCESSING: The series of steps necessary to convert a latent image on film into a visible image.

RANGEFINDER CAMERA: A camera with an optical device for measuring distance. It is coupled to the lens for focusing.

RAPID FIXER: Fixer that will complete fixation of a negative or print in reduced time.

RC PAPER: Resin-coated paper. A print paper coated with plastic to prevent the base from absorbing chemicals and water during processing. It can be washed and dried rapidly.

RED EYE: The effect on color film resulting from the flash being placed too close to the lens. Blood vessels in eyes cause a red reflection.

REFLECTOR: A sheet of white material used to reflect light into a shadowed area. Also, the metallic cone behind a flashbulb or floodlight to throw maximum light.

REFRACTION: The bending of a light ray passing from one medium to another. Air to glass is an example.

REPLENISHER: Additional chemicals added to processing solutions to maintain the original characteristics.

RESOLUTION: The ability to distinguish between objects that are very close together.

REVERSING RING: An accessory that allows the lens to be attached backwards to the camera. It allows a life-sized image to be recorded on film.

SAFELIGHT: A special darkroom light that does not affect certain photographic materials.

SENSOR: A light-sensitive eye on some electronic flash units. It allows a circuit to compute the subject distance and "send out" the correct amount of light.

SHUTTER: A mechanically or electronically controlled device that regulates the length of time light is allowed into the camera for film exposure.

SILVER HALIDE CRYSTALS: Light-sensitive crystals found in photographic emulsions.

SIMPLE LENS: A single lens element.

SLIDE: Section of film which, when processed, shows the finished picture when held up to light. It is a positive transparency. It can be projected in a slide projector.

SLIDE PROJECTOR: A device used to project transparencies or slides onto a screen.

SLR CAMERA: Single Lens Reflex camera. The viewing system allows the user to see exactly what the lens sees.

SPLIT IMAGE: A focusing method in both rangefinder and many SLR cameras. An out-of-focus image will appear divided. Correct focus results in an image which is aligned.

SQUEEGEE: A rubber wiper, similar to a windshield wiper, for removing excess water from prints.

STABILIZATION PROCESSOR: A machine that will produce a finished print in 10 seconds. A special paper is passed through two chemicals.

STABILIZER: A chemical used with a stabilization processor which provides temporary paper fixing.

STACK LOADER: A mechanical device that attaches to certain slide projectors. It allows you to "drop-in" up to 40 slides rather than loading a rotary tray.

STOP BATH: An acidic chemical that stops the developing process. It neutralizes the alkaline developer before fixing.

STOPPING DOWN: Reducing the lens aperture.

STUDIO: A workroom set up for specialized photography. It may contain lights, reflectors, and backgrounds.

SUBJECT: The person or object of interest being photographed.

TACKING IRON: A special light-weight iron used to attach tissue to a print and mounting board.

TAKE-UP SPOOL: A second spool built into or placed in the camera to take up the exposed film moving across the camera.

TECHNICIAN: A skilled person working in a laboratory who handles film and print processes.

THYRISTOR: An electronic device that diverts unused electrical power, in an electronic flash, to a storing capacitor.

TELEPHOTO LENS: A lens that works like a telescope. A larger image results on the film.

TLR CAMERA: Twin Lens Reflex camera. A camera which uses a secondary lens system for viewing. A mirror reflects the image from the viewing lens to a ground glass screen.

TRANSMITTED LIGHT: Light that passed through a transparent material such as glass, plastic, or water.

TRANSPARENCY: A positive image that can be viewed when held up to light or projected. Also called a slide.

TRIPOD: A camera support with three legs.

TTL METERING: Through The Lens metering. An exposure meter built into the camera which measures reflected light from the subject passing through the camera lens.

TUNGSTEN LIGHT: Artificial light from a variety of sources such as floodlamps and regular household light.

UV FILTER: A filter blocking ultraviolet light.

VARIABLE CONTRAST FILTERS: Special filters that provide an entire range of contrast with variable contrast paper.

VARIABLE CONTRAST PAPER: Photographic paper which provides a range of contrast while printing with the use of filters.

VIDEO: A system of recording action electronically using a videocamera and a playback device.

VIEW CAMERA: A large format studio camera. The front and back of the camera are attached by a bellows. The sceen is composed and focused on a ground glass screen before inserting the film.

VIEWFINDER CAMERA: A camera with a window showing the approximate scene that will appear in the picture.

WETTING AGENT: A chemical used after washing negatives. Surface tension is lowered, resulting in even drying.

WIDE ANGLE LENS: A lens having a large angle of view and short focal length. It is good for scenes and groups of people.

ZOOM LENS: A lens with many focal lengths. Focusing remains unchanged while altering the focal length.

ZOOM RATIO: The difference between the shortest focal length of a zoom lens and its greatest length.

INDEX

Index

ACKNOWLEDGEMENTS

Special thanks to all who, in any way, assisted in the writing and illustrating of this text and in particular:

The authors' father, John R. Walker, for the drawings and much guidance.

Ben and Harry Cooper of Cooper's Camera Mart, Baltimore, Maryland, for loaning equipment, putting the authors in touch with manufacturers, and for their advice through the years.

Lion Photo Supply Inc., for loan of equipment.

Walter and Bob Martz of Martz Camera Shop, South Holland, Illinois for their generous loan of equipment and materials, and for their general advice and assistance.